Henry Moore in America

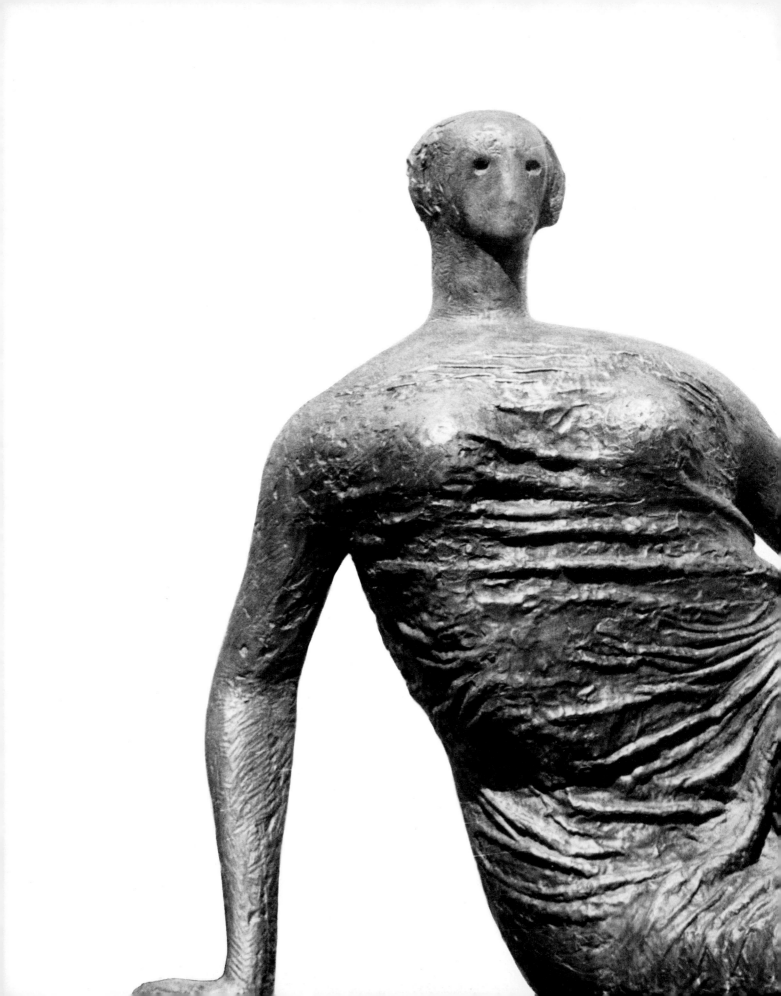

by Henry J. Seldis

Henry Moore in America

*Praeger Publishers
in association
with the
Los Angeles County
Museum of Art*

For Mark

Published in the United States of America
in 1973
by Praeger Publishers, Inc.,
111 Fourth Avenue, New York, N.Y. 10003
Library of Congress
Catalog Card Number 73-78377
Copyrighted © 1973 by Henry J. Seldis
All rights reserved
ISBN 0-87587-054-6

Published by
Praeger Publishers
in association
with the Los Angeles County
Museum of Art
Designed by Ken Parkhurst
& Associates, Los Angeles
Printed in
the United States of America

Table of Contents

HENRY MOORE, O.M., C.H
TELEPHONE: MUCH HADHAM 2566

HOGLANDS,
PERRY GREEN,
MUCH HADHAM,
HERTS.

April 15th/73.

Dear Henry,

For more than 30 years my friendships and connections in America have played a crucial role in the growing international acknowlegement of my work.

From Curt Valentin's first exhibition in the Buchholz Gallery, in New York, in 1943, to the imminent completion of the "MOORE CENTRE" in Toronto, I have been encouraged by support from the United States, & from Canada — & I am very grateful.

Therefore, I welcome the publication of your book.

as ever

Henry Moore

Acknowledgments

Essentially this book became a reality through the close and generous collaboration of Henry Moore, his friends, and associates. It was their tape-recorded conversations and their trust in letting me read through their correspondence that allowed me to proceed.

A grant from the Rita and Taft Schreiber Foundation was most welcome in supporting my research. Los Angeles Times editor William F. Thomas and his predecessor Nick B. Williams approved necessary leaves of absence. Valuable assistance was rendered me by Ralph Colin, executor of the Curt Valentin estate, and by Pearl L. Moeller of The Museum of Modern Art library.

Mrs. Betty Tinsley and David Mitchinson of Mr. Moore's staff gave constant help and advice. I am most grateful for the friendliness shown me by the artist's wife, Irina, and his daughter, Mary.

Both this publication and the *Henry Moore in Southern California* exhibition received the enthusiastic backing of Kenneth Donahue, Director of the Los Angeles County Museum of Art, and the Museum's trustees, especially President Franklin D. Murphy.

As guest curator I wish to extend my deep appreciation to all the lenders to this exhibition and to the members of the museum's staff, especially Exhibitions and Publications Coordinator Jeanne Doyle and Registrar Patricia Nauert and their assistants.

Neither book nor exhibition could have been realized without the dedicated cooperation of LACMA staff associates Lilli Cristin and Joanne Jaffe, and secretary Diane Stutts, nor without the help of Mrs. Sidney Kern of the Museum Service Council. Ken Parkhurst who designed this book and Craig Ellwood who created the exhibition's installation have my special thanks.

Brenda Gilchrist of Praeger has been most helpful and patient during the progress of this publication. My friends Anna Bing Arnold, Rudolph Baumfeld, Dr. Maximillian Edel, and Ed and Inge Maser offered special encouragement. Last, but not least, I thank my wife Anna for her steadfast devotion through these hectic months. H.J.S.

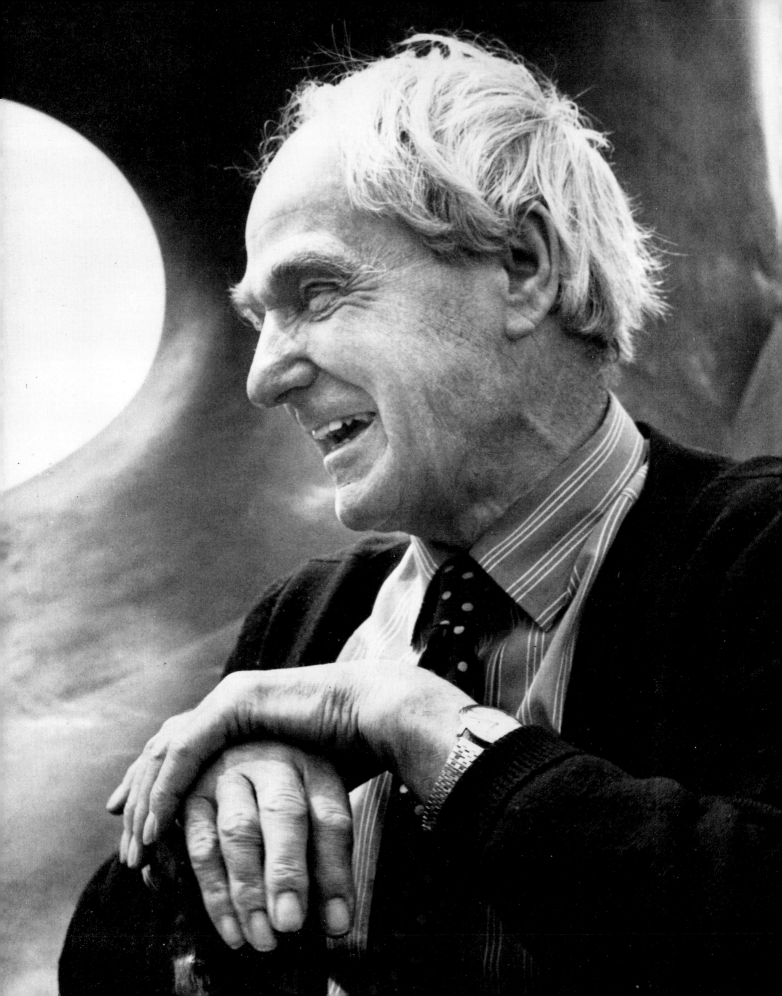

Recollections and Reflections

From time to time I have tried to analyze my own affinity to Henry Moore's art and my ever-growing admiration for it. Not that there aren't some Moores I like far better than others. Yet, on the whole the artist has seemed to steadily develop not only his distinct genius for creating convincing metaphorical forms but a powerful vocabulary that is of its time, though also timeless.

There have been many moments when the confidence of his creativity has helped me avoid the temptation to grow cynical in the face of the unprecedented onslaught on human lives and values that has been dominant in the world since my childhood.

Only four years after my narrow escape from Nazi Germany, I had been reading Thoreau's *Walden* in an effort to come to grips with some spiritual values of my adopted country when I happened upon an exhibition of Moore's drawings held at the Curt Valentin Gallery in 1943. His *Shelter Drawings,* especially, struck me as such convincing demonstrations of man's essential indomitability that for the very first time I gained a modicum of hope that Hitler would not rule the world, after all.

By the time James Johnson Sweeney's selection of Moore's work opened at the Museum of Modern Art in December 1946 that dim hope had become a triumphant certainty. It struck me that, like Thoreau, Moore was (and he continues to be) a revolutionary who has never disassociated either himself or his art from nature.

As abstract as Moore's work appeared at first acquaintance and as independently inventive as his latest architectonic pieces now seem, he has always found inspiration in nature, particularly in the human figure. Therefore, his sculpture is always at one with nature.

Now as before, Moore has been excited by his observations of objects such as bones, stones, trees, pebbles, shells, elephant skulls, and many other animal forms. Together with his primary concern with the human figure, such emphasis has made his the most organic of all twentieth-century sculpture.

Ever since his fame spread from England to America, as long as thirty years ago, his work has been the subject of intense art historical, critical, and even psychoanalytical debate. But even now the artist himself finds it impossible to tell you just how he arrives at his extraordinary plastic metaphors. For more than ten years now it has been my good fortune to carry on many conversations with Henry Moore and to see our cordial professional relationship grow into a warm friendship. But I have never yet learned from him exactly how, for instance, he began relating the female figure with mountains in his work, or how he started connecting the holes and spaces in a figure with caves in a hillside, or how animal forms became mixed up so frequently with human forms in his sculpture.

Yet, he has often referred to the probability that all these connections result from his interest, as a sculptor, in all forms around him and from his ability to see similarities, parallels, and fundamental connections among diverse things. More than anyone else before or in his time, Moore has used metaphor in scultpture to explain and reveal new interpretations of aspects of nature that very few of us would otherwise see.

Moore has long been aware that it is the artist who keeps our eyes alert and our minds alive to the meaning of nature and to the wonderful variety and synthesis of its shapes and forms. And, while he is thoroughly conversant with the history of art and precise in his occasional verbal descriptions or comments about his own work, he knows that for an artist to be too conscious of what he does may not always be such a good thing. His life is centered on his sculpture, and in the last analysis what we find in it is a reflection of his own tremendous spirit.

If Moore frequently does not hesitate to introduce elements of brutality into his work, its total meaning remains one of affirmation, of hope, or at least of survival. Thoroughly aware of man's bestial tendencies, Moore does not allow himself, or us, to forget the positive

human potential. Over and over again, his forms refer to mankind's fertility, to man's innate dignity—signified by his stance—and to the necessity of having hope. Quite often he seeks to express the tremendous power for goodness that exists somewhere in human nature.

All aspects of the history of sculpture, even those furthest from the European tradition, have seeped through the filter of his genius. But, as his work has evolved, it has shed every evidence of early eclecticism and has amalgamated all the great visions of the past with his own profound insights and inventions. The result is a still-expanding personal idiom. Moore's sculptural and pictorial language simultaneously demonstrates his catholicity and his uniqueness.

Dubbed an anachronism by art's fashion mongers, Moore continues to surprise less narrow-minded observers of the contemporary art scene by the astonishingly fresh and dynamic creations that spring from his mind and hand in his advanced years. An indominatable optimism and tenaciousness can be readily recognized in this man. But even the most harmonious of his creations are no more without tension than life itself.

Moore might have been describing his own work when he once wrote about primitive art—one of his early sources of inspiration —that:

« . . . its most striking quality is in its intense vitality. It is something made by people with an intense and immediate response to life. Sculpture and painting for them was not an activity of calculation or academism but a channel for expressing powerful beliefs, hopes, and fears. It is art before it got smothered in trimmings and surface decorations, before inspiration had flagged into technical tricks and intellectual conceits.»

Through the intervention of my friend David Thompson, then the art critic of The Times of London, Henry Moore invited me and

my wife, Anna, to come out to his home one grey day in the early summer of 1962. On the train I described to her the many Moore exhibitions I had seen before our marriage two years earlier. She talked about her spontaneous and excited reactions to the Moores we had gone to see at the Tate the day before.

An air of fertility and tranquility enveloped us as we drove from the village station of Bishop's Stortford, thirty miles north of London, through lush fields of oats and barley to the unpretentious, reconstructed, and enlarged sixteenth-century farmhouse which is the center of the creative and domestic life of Britain's greatest living artist.

On arrival Moore came out to greet us most cordially, and soon my wife was comparing notes on plants and flowers with his wife, who, like my own, is an avid gardener. Over the years a number of California natives have been added to Irina Moore's gardens which seem to have expanded as her husband's studios have in the interim.

Front view of "Hoglands" which has been Moore's home for over 30 years in quiet Hertfordshire area.

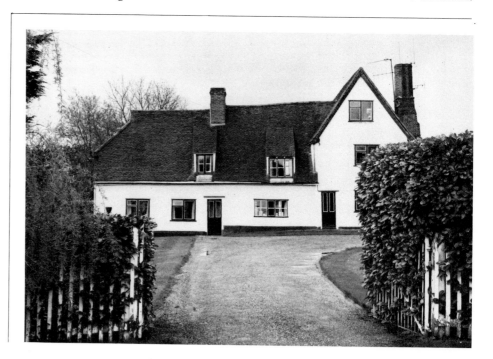

An intense, wiry man, Moore moved swiftly and quietly through his very own realm, putting this stranger at ease by his directness, his willingness to entertain searching questions, and his innate friendliness. To discuss the monumental sculptures looming against the sky on his parklike property behind the house; to examine countless found objects in his small, cluttered maquette studio which used to adjoin his living quarters and has now become his very own printshop; to laboriously help in moving large turntables carrying works in progress in the first of his enormous studios that keep going up barely in sight of the house; to see him point out with joyous excitement some peculiar qualities of primitive art as demonstrated by his fine Pre-Columbian collection—all these immediately became partial explanations of Moore's creative pattern, freely offered to the genuinely curious visitor.

Over the years—especially during periods when I spent as much as a week at a time at Much Hadham—I have been astonished and even dismayed at how readily Moore makes himself accessible to all sorts of visitors while obviously swamped with work and often complaining of the imminent deadlines he faces for certain projects.

Only during my last visit this Spring did I dare to casually raise this issue and the related one of the many hours he regularly spends each month as a trustee of the National Gallery and other major cultural enterprises—England, unlike America, having long recognized the necessity of including its leading artists in the governance of its cultural institutions. «It's not altogether altruistic, you know,» said Moore, «who knows whether I would feel the necessary pressure if I knew that I could spend every bit of my time in the studios. Perhaps we all need to create situations for ourselves where every moment counts when we are at work.» Besides, he would be the last to deny his natural gregariousness.

On a grey day, much of the light on Moore's acres seems to come from the verdant plants and trees all around. Against the overcast sky

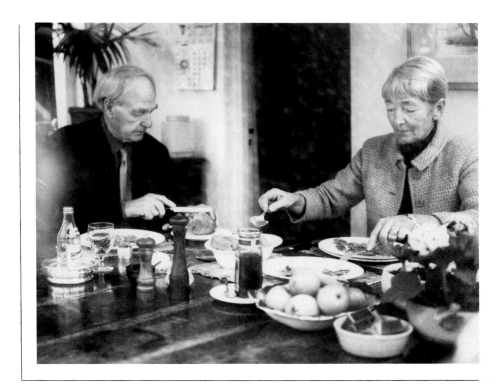

Henry and Irina Moore take lunch on their sun porch in Much Hadham.

the large Moore pieces—widely set apart—create a memorable drama which adds a lofty spirituality to their essential earthiness. They seem to belong where they are, but when a giant crane loads one into a truck for delivery to a London gallery or for the first leg of its journey to an American museum, one does not fear that any of these distinctive sculptures might lose its persuasiveness through the change of locale. That day Moore told me:

«A successful piece of sculpture must work well everywhere. As I work on a piece, I am not concerned with making it suitable to the outdoors or the indoors—except under very unusual circumstances. A fine person cannot just be good at a party, he must behave consistently everywhere.

«To display sculpture to its best advantage outdoors, it must be set so that it relates to the sky rather than to trees, a house, people, or

other aspects of its surroundings. Only the sky, miles away, allows us to contrast infinity with reality, and so we are able to discover the sculpture's inner scale without comparison. Such viewing frees the imagination.»

Though even the smallest of Moore's bronzes often projects an unmistakable monumentality, the physically colossal works he has created in bronze and in stone during the past fifteen years are the realization of a dream of an artist who did not come to fame until he was in his mid-forties, nor to affluence until he was nearly sixty.

This explosion of scale in Moore's recent work is not the result of theoretical considerations. Rather, it results from Moore's ability finally to add sufficient space to his original property so that enormous indoor-outdoor studios complete with warehouse loading platform and several other spacious but smaller work spaces could be constructed. As Moore told me on that first visit:

«In the thirties my work had to be kept extremely small in scale because it was limited in size and weight by what Irina and I could move about by ourselves. Now that I have a new studio, several helpers, and even a large crane that can be rented nearby, only my own imagination need limit the size of my sculpture.»

His first two and three piece *Reclining Figure* sculptures had been completed only recently and were arousing as much speculation as admiration in the art press. Moore told me that he had completed these pieces after making scores of drawings and a maquette for each work.

«In the maquette the figure was joined, but then it dawned on me that it would not only be easier to cast separate halves but that your eye, your mind, would fill the gap. The multiple experience that could

be achieved by moving the separate pieces about in relation to each other provides an unpredictable combination of views from many lines of vision. To do a four part piece, however, might push the division too far and lose the essential unity of the composition.»

More than ever before Moore's sculptures of the sixties combined elements of figure and landscape with recollections of the Impressionist's «Eretrat» paintings in a metaphysical and poetic manner. As Moore explained in 1962:

«A sculptor must be free to take from every source without fear of amalgamating his visual experiences in his artistic transformations. Why should only the poets be allowed to say 'the mountains skipped like rams?' My sculpture is becoming less representational, less an outward visual copy—and so, what some people would call more abstract—but only because I believe that in this way I can present the human psychological content of my work with the greatest directness and intensity.»

He emphasized that «the observation of nature is a crucial part of an artist's life» protecting him from working only by formula. Exuberantly pointing to a giant tree on his property, Moore spoke of its «paleolithic fertility.» Later, as we sat down to tea, a chance remark revealed his reluctance to view such overwhelming natural spectacles as the Grand Canyon «because it is difficult enough for an artist to compete with nature without such memories.»
Shortly after my initial visit with Henry Moore, my description of that visit appeared in *Art in America.* I also became peripherally involved in an exhibition of his work—largely from the Charlotte Bergman Collection, which Donald Brewer was organizing at the La Jolla Art Museum. The exhibition was later seen at the Santa Barbara Museum of Art and at the Municipal Art Galleries in Los An-

geles in 1963. In answer to a letter in which I conveyed the Mayor's renewed invitation to come to Los Angeles for the November opening, Moore wrote:

«I am sorry I cannot accept the Mayor's invitation to come to Los Angeles for the November opening of the exhibition because I have now started the large figure in its final size, twenty-two feet, which I am doing for the Lincoln Center in New York, and it is many times larger than any work I have ever undertaken. It is giving me a lot of purely practical problems.

«I already have two or three unavoidable interruptions with visits I have to make to Europe . . . although these are only short visits abroad, they are all interruptions and disturbing; both before leaving and after returning one is distracted from work by them. I know I should find the visit most exciting and exhilarating, but it is the disturbance to one's mind and work which must be taken into account, too.»

Over the years, as I have come to know the artist better, his unflagging need to work and his exemplary devotion to his wife and daughter have impressed me deeply. The range and depth of his interests are truly amazing. His innate kindness is apparent. He does not take on Olympian airs or play at being the *grand maître.* Rather, there is an unmistakable practicality and simplicity about him. That is not to deny the complexity of his inventions, the basic romanticism of his sculpture idiom, nor to forget his moments of irritation as well as of laughter.

Not long before the opening of the brilliant exhibition organized in 1968 by David Sylvester for the Tate Gallery, to honor Moore on his seventieth birthday, I was visiting at Much Hadham once again. Having spent most of the early afternoon in lively conversation and in showing me his newly expanded studio spaces, Moore suddenly

remembered that he had promised Sylvester to have a look at the outdoor part of the installation. We walked around to an area where one of his youngest helpers was polishing a bronze. «John, I wonder whether you'd get cleaned up to drive me to the city in a half hour's time,» Moore said. John did not quite manage to hide his chagrin. «What's the matter,» asked Moore, «do tell me.» «Of course, I'll drive you there,» said John, «it's just that this was to be our final football game of the season.» «Never mind, then,» said Moore turning away quickly, «you just win your game, and I'll find another way into town.» It was only then he remembered that my car was waiting and accepted my invitation to drive back with me.

When we had arrived at the fenced-in outdoor area of the Tate, which had been redesigned for the purposes of the anniversary exhibition, a guard barred our way through a temporary gate Moore and I were about to enter. Thinking that I knew something about the behavior of famous artists, I was sure he would identify himself and demand entrance. But I had not yet learned to understand his reluctance to throw his weight around. «Come along, Henry,» he said, «we'll go in through the basement entrance where the guards will know me.» And so we did.

It was during that ride that he spoke of his Yorkshire miner father and the miners' struggles for decent wages and social justice, the simplicity of his upbringing, and the disappointments of his own early career. Though not given in reply to any direct question, his reminiscences served as an answer to the widely-heard question as to why he had once again refused to allow himself to be knighted as his government had urged. While he has accepted the two highest decorations his country can offer—having been invested by the Queen as a Companion of Honor and a civilian member of the Order of Merit, over the years I have come to believe that he will always prefer to remain Henry Moore rather than to become Sir Henry. Comments I have occasionally heard him make about famous British artists ele-

vated to lifetime baronetcies or peerages indicate to me that he believes such titulary honors are superfluous to any modern artist whose merit has been widely acknowledged.

Yet, as his stationery indicates, he is proud to be among the handful of living Britons who hold the C.H. and the O.B.M., just as he has delighted in the international awards, prizes, and honorary degrees that have come to him on both sides of the Atlantic. There is nothing immodest about his acceptance of these honors, as is indicated by this passage in a letter he wrote to an American friend in July 1955 « . . . all three of us are very well. Irina and Mary will be going to see the Queen hang the C.H. ribbon around my neck in a fortnight's time. I thought it would be something for Mary, who is now nine years old, to see.»

Despite the days in London devoted to what Moore regards as his duty towards the cultural institutions of which he is a trustee and the frequent, often very brief trips to France, Switzerland, or Germany, a daily work routine dominates the rhythm of Moore's creative life at Much Hadham. An early riser, Moore will have had a couple of cups of tea and listened to the news on the BBC by the time he comes downstairs for breakfast at about 8:30. During breakfast he will read some of the more important mail, though it may go unanswered for weeks.

Once his assistants, who arrive from London at about 9:30, have gone to work on various projects, Moore will go to see what they are up to, putter around in his maquette studio, or go over important business matters with his devoted secretary Betty Tinsley and his young archivist David Mitchinson until it's time for more tea at eleven.

After that he will bicycle or drive down to the bottom of his property. There his assistants might be at work enlarging a medium-size maquette or creating a huge polystyrene prototype for a large bronze or marble. This they do in an ingeniously-devised tent-like

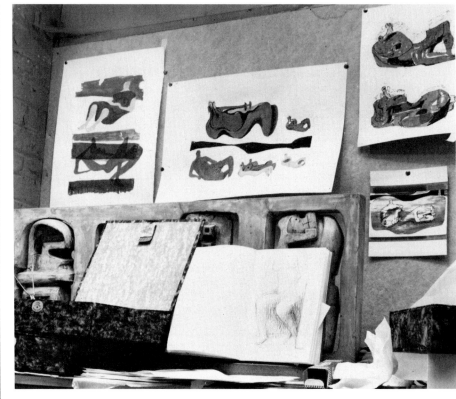

Moore sketchbook propped up against Time-Life *plaster with lithography proofs pinned to the wall at Much Hadham.*

structure, erected whenever necessary on his park-like lawn near the large studio with its loading dock. It is Moore's eye and his decision on every detail that guides the work of these assistants, and he hovers over a work in progress with an intense paternal air, very often making his own corrections.

At one o'clock Moore and Irina, who often spends the morning in her greenhouses, are served a simple lunch prepared by Mrs. Betty Darby on the sun porch facing the lawn out back. Sometimes they are joined by a visitor. Occasionally, the presence of more than one guest necessitates a more formal serving, usually of a great piece of roast beef, in the dining room where Moore has been heard to say that it is sometimes easier to carve marble accurately than to slice just the right portion of beef.

Nowadays Moore will usually take a rest after lunch, reading the newspaper, a current book, or taking a brief nap. By 3 p.m. he will again be supervising his assistants, or if the light is good, he will be in his nearby studio photographing a recent work or one that has just come back from exhibition and had not been available to him for a while. The artist has long made it a habit to photograph each of his finished sculptures, often many times over.

Some afternoons are spent drawing in his new, larger maquette studio at the far end of his property, others talking to dealers, collectors, or critics whom he has invited out for the afternoon. Only rarely does he put in even a brief appearance as school classes and art study groups arrive by bus several times a week and are shown through the Moore realm by one of the assistants or by Mitchinson.

There is tea at four each day, and then Moore usually repairs to the office where with Mrs. Betty Tinsley he makes important phone calls, arranges for future visitors, and reluctantly tackles the topmost tip of the ever-present mountain of mail, answering as many of the most important letters as his secretary can persuade him to dictate.

Then he may spend another hour working on a wax, or in consultation with his foreman and old friend Frank Farnham about the shipment of a large piece to the Noack Foundry in Berlin, or dealing with some other logistical problem that must be tackled.

By 6:30 it is time for a drink and a chat in the large living room which contains most of Moore's small, but excellent and varied, collection. Often he and his wife will take supper on trays before the television, although on a recent evening the artist got himself into white tie and tails to attend a dinner party the Queen was giving at Windsor Castle for the President of Mexico. At lunch that day there was considerable banter about the possibility that his starched shirt front might pop up and hit him in the head. It didn't happen, and Moore reported the next day that he had thoroughly enjoyed himself and that «simply everyone was there, from the Prime Minister to the

Queen Mum.» He wasn't entirely sure whether he had worn his decoration with the correct side showing but was certain no one would have noticed.

Although he had stayed up until the early hours, he kept a morning appointment with a dentist who only managed to somewhat worsen the toothache that had bothered him all week. He then lunched at his favorite London spot, the Café Royale, and seemed fresh and cheerful when he met me under the portico of the British Museum for a brief visit.

While the Pre-Columbian and African sculptures he so greatly admired when first visiting the British Museum as a young man are now on view at Burlington House, many of the Egyptian, Assyrian, and Greek sculptures that had such a great initial impact on him are still there, although not necessarily where they had been in his early London days. Entering the vast halls filled—in reverse chronological order—with Egyptian sculptures, Moore said:

«You can imagine how impressive this place was for a young Yorkshire provincial who had seen little but the Leeds Museum full of Victorial stuff. In looking at the carving of an Egyptian sarcophagus, I first realized the strength of that hand fighting the material. The Assyrian reliefs did not impress me so much because their telling of tales seemed to me merely very skillful journalism in sculpture. It was the early Egyptian sculpture with its sense of permanence and immortalization that impressed greatly while I soon came to understand that the work done in later dynasties became staid and academic.
«Look at that static quality of this 18th Dynasty *Seated Man and Woman*! One knows that they are able to sit there forever but that they would not be able to get up and run around.
«It's quite possible that this pair's impact on my subconscious had something to do with my making the *King and Queen* many years later. And look with what strength one paw lies on the other in this

marvelous Egyptian lion. It makes the Trafalgar Square lions look like puppy dogs!»

Later, looking at some of the Elgin Marbles in the Duveen Galleries—whose proportions Moore deplores—we stopped at the famous sculpture of the river god Ilissus. This sculpture surely must have had as much, or perhaps even more, influence on Moore's continuing involvement with the reclining figure than the image of the Mexican rain spirit Chac-Mool, one of the great Pre-Columbian works that so impressed Moore in his early visits to the British Museum.

«This is where one learned that sculpture can adhere to anatomical truth without abandoning important elements of invention. Look how this figure projects the hardness of bone and the tenderness of skin. Even if it was to be placed way up high where no one would ever see the back, the sculptor created the figure in his studio, working at eye level, man to man, so to speak. Looking at this sculpture, I came to realize how very much a reclining figure can contain. And look how tight the drapery is pulled over the knee in this *Seated Demeter* which was sculpted in 330 BC.

«These great Greek sculptors knew that it is the task of sculpture to take a great material like stone and make it come alive. They also knew how important it is to convey the attitude of the body. There may be no direct link between all the various depictions of the figure you can find here at the British Museum. But you do finally realize that people sit down the same way all over the world. There are fundamental poses and common attitudes. To absorb but not to copy these principles—that's the way to learn one's own form language.»

Moore carries the regularity of his work routine to the Tyrrhenian beach town of Forte dei Marmi where he spends two or three months each summer. Nearly every morning he leaves his unpreten-

tious home there at about nine o'clock. He drives his Italian-made open jeepster to the Querceta marble works of the venerable firm of Henraux which quarries the Carrara mountains that Michaelangelo used. After two or three hours' work with a veteran Italian stone carver, whom Moore calls his extra pair of hands, he will meet up with his wife and his vivacious daughter Mary (who has been fixing up a house for herself nearby). Together they proceed to the Hotel Byron beach to take the sun and «a bathe.» Here we have had many carefree days during the weeks preceding his seventy-second and seventy-third birthdays which we celebrated with him *en famille*. A sandwich brought to the beach or a picnic lunch at home is followed by a siesta. Then there is likely to be some visitor come to talk about a book or a commission. In the evenings the Moores frequent several modest and pleasant *trattorias* where the wine flows freely, and the artist occasionally indulges in giggling games with children of friends. I recall quite a number of bouts between him and my son Mark, then eight, which were designed to make one's opponent laugh or talk first.

Nothing is quite as vivid during our Italian visits as the ride up to the marble quarries of Carrara. In a car driven by Henraux executive Mario Mariani we ascended through tunnels and dirt roads to the top of Mt. Altissimo. Moore, who makes this trip several times each summer, spoke with the excitement of a novice visitor about:

« . . . the staggering work it must have been for Michelangelo to get these marbles down from here. There is a tremendous feeling of scale that you get here, more than anywhere else.
«Look at this sheer, steep quarry wall. It's as if the whole of a skyscraper has been sliced up vertically. The men scrambling up that little ladder are so dwarfed in scale that the whole picture reminds me of Paul Klee.
«Last year we came to look for just the right kind of marble for a piece of mine that is now being finished down below. I was looking

In Carrara mountains Moore
searches for marble near quarries
used by Michelangelo.

for white marble, but not so white that it would not be marked at all. I wanted it to have some bit of nature in it, some natural markings. Even so, one of the blocks we finally chose had to be abandoned since a bad vent was found in it as it was being cleaned up. So the crew had to start out all over again. Driving over these roads, made by Henraux in more than a century's time, one begins to understand what a staggering amount of man's effort has gone into getting at this marble.

«It's very dangerous work now. But just think how very much more dangerous and difficult all this must have been in Michelangelo's time. That greyish space you see up there is the quarry where he worked. The very best marble is always found at the highest points. That's where the greatest geological pressures occurred millenia ago after an unimaginable number of shellfish that had once rested at the bottom of the sea had been volcanically pushed up into the mountains and solidified.

«And the colors. One can find marble that is completely black and marble that is completely white and nearly every color in-between. It's simply terrific.»

Back down at Querceta in the immense Henraux marble yards, electronically-controlled monsters work all day and night cutting huge blocks into slate for architectonic and industrial use.

A large Moore piece is being polished in the relatively small area set aside for the artist's use. Looking at it one can easily see why this stone has been precious to sculptors through history. And, there can be no doubt about the immense vitality that this great modern artist has brought out of the ancient material. He has given it life.

Watching Moore oversee the installation of seventeen marble carvings at Knoedler's and forty bronzes at Marlborough before the dual New York exhibition in 1970, I remembered that even back home at Much Hadham he separates the carvings from his cast sculptures. Moore worked exclusively as a carver until he was in his forties

and now enjoys far greater opportunities to work in stone than ever before. During that New York visit he said:

«There is no need for still another retrospective. But the two shows do give people a chance to see most of the most important pieces I've made since 1961. I deliberately waited for these shows until everyone could get over that seventieth birthday idea. It doesn't really matter

Playing in travertine marble Memorial Piece, *children illustrate the artist's architectonic intentions.*

about one's age. It's only the work that keeps going on that counts. But I don't think I could ever be persuaded to live in this hectic place —not even if someone offered to add ten years to my life.»

In writing this book, it is my hope that some of the highlights of Moore's long and fruitful relationship with people in the United States and Canada will add to a better understanding of the man and his work. No attempt was made to document every one of his numerous important transatlantic contacts, but special attention has been paid to his earliest American connections.

Amid the clamor and despair reflected in so much of twentieth-century art, Henry Moore continues to affirm the significance and meaning of life. He seems to understand fully what his great friend T. S. Eliot meant when he asserted that «what happens when a new work of art is created is something that happens simultaneously to all the works of art that preceded it. The existing monuments form an ideal order among themselves, which is modified by the introduction of the new (the really new) work of art among them.»

And, as a result of the total absorption he continues to find in his work, Moore may well have learned what Henry David Thoreau discovered during his self-imposed isolation at Walden: «if one advances confidently in the direction of his dreams, and endeavors to live the life which he has imagined, he will meet with a success unexpected in common hours. He will put some things behind, will pass an invisible boundary; new, universal, and more liberal laws will begin to establish themselves around him and within him; or the old laws be expanded, and interpreted in his favor in a more liberal sense, and he will live with the license of a higher order of beings. In proportion as he simplifies his life, the laws of the universe will appear less complex . . . if you have built castles in the air, your work need not be lost; that is where they should be. Now put the foundations under them.»

First Transatlantic Contacts

More than three quarters of Henry Moore's work is in America. Looking back, at seventy-five, the greatest artist to come out of England since Turner asserts that his emergence as an internationally-famous sculptor and draftsman came primarily through his 1946-47 Museum of Modern Art retrospective, organized by James Johnson Sweeney, and through the people and circumstances that led to this key exhibition.

Born the seventh of eight children to Yorkshire miner Raymond Spencer Moore and his wife Mary Baker on July 30, 1898 at Castelford, Henry Spencer Moore showed an early aptitude for drawing and an appreciation of carvings in the Gothic churches so prevalent in his native Yorkshire. While attracted to the idea of becoming an artist, Moore entered Teachers Training College on the advice of his father. It was not until 1919, having been demobilized after three years in the army, including war time front line service, that Moore entered Leeds School of Art.

It was its director Sir Michael Sadler, the friend and patron who was eventually to give the first Moore sculpture to New York's Museum of Modern Art more than twenty years later, who introduced Moore to modern art through his own collection of Cézanne, Rouault, Matisse, and Kandinsky and inspired the artist's life-long involvement with so-called primitive, ethnic art through the African sculptures he owned.

Awarded a scholarship at the Royal College of Art in 1921 and having traveled six months through France and Italy, Moore became a member of London's Royal College of Art faculty in 1924, two years before a few of his early pieces were first shown in a group exhibition at St. George's Gallery, London.

Moore was thirty at the time of his first one-man show at the Warren Gallery, London; the exhibition caused quite a local controversy. Still the dawning of a substantial national reputation must be traced to a one-man exhibition of thirty-four sculptures and forty-

one drawings held in 1931 at the Leicester Galleries while his first tentative ventures onto the international scene came with his participation in London's International Surrealist Exhibition in 1936 and in Alfred Barr's «Cubism and Abstract Art» show at New York's Museum of Modern Art that same year and his participation in a show in Amsterdam in 1938. That year also saw his first large *Recumbent Figure* in Hornton stone, which was exhibited in the 1939 New York World's Fair, spent the war in the garden of The Museum of Modern Art, and is now one of the most important works in the exceedingly large collection of Moores at London's Tate Gallery.

Only at forty-one had Moore reached sufficient prominence to be able to give up teaching and devote himself entirely to sculpture. One of the most significant results of this development came with his creation in 1939 of the *Reclining Figure* in elm wood, formerly owned by Gordon Onslow-Ford, now at The Detroit Institute of Arts.

Henry Moore had come to wide critical acclaim by the time the war broke out. His appointment to be an official war artist resulted in his poignant series of *Shelter Drawings* which brought him the wide popularity that he enjoys in England to this day.

This assignment came to Moore through his long-time friend, the brilliant art historian Kenneth Clark (now Lord Clark of Saltwood) who, along with the late Sir Herbert Read, the great critic and a close friend of the artist, probably did more than anyone else to spread the belief in Moore's genius. In a recent conversation with me, Lord Clark recalled:

«Even before the war, Henry had a very large following in England. I mean there were artists like Jacob Epstein and Eric Gill, museum directors and curators, and a good many critics and collectors who believed him to be enormously inventive and had come to see all sorts of things in Henry's work which were about to go off in every direction. Nobody had the least doubt that he was a great artist even before

the war and then, during the war, all those shelter drawings were enormously influential. During that time he became a highly popular artist because of these shelter drawings. I would have said that by the end of the war the English public had the impression that Henry's shelter drawings were the greatest thing—by way of art—that had come out of the war. I think they would have added probably Graham Sutherland's 'Drawings of Devastation.' Popularly those were thought to be the two great artistic achievements to have come out of the war here in England. So Henry Moore was not only admired by a limited public of connoisseurs and intellectuals. I am referring to the general public. Those images of people in shelters were popular images of war; so I would have said that, as far as widespread esteem goes, Henry was popular before his first American show.»

Lord Clark does not dispute the artist's own contention that although a half dozen influential figures on the British art scene, like Read, Sir William Rothenstein, and himself, believed in him very strongly from his first public showing on, his international reputation, not only in America but on the European continent, was based very much on the success that The Museum of Modern Art's 1946 retrospective achieved; this fame grew through the critical and popular acclaim The Museum of Modern Art show gathered as it traveled to Chicago and San Francisco in 1947. An impressive but less comprehensive Moore exhibition toured Australia the same year. The Museum of Modern Art show was preceded by an important 1943 exhibition of forty watercolors and drawings and one sculpture that Curt Valentin—who was to be the key figure in Moore's spreading popularity in America for the remaining eleven years of his life and became one of the artist's closest friends—staged at the Buchholz Gallery in New York. Valentin, who had fled from his native Berlin to New York in 1937, had already given important shows of European sculptors—some of whom, like Jacques Lipchitz, had found

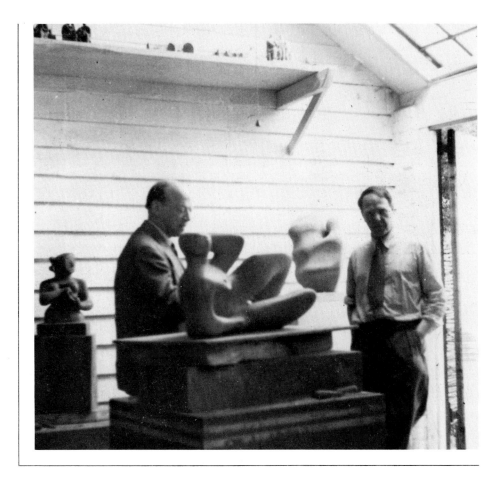

Dealer Curt Valentin admires early carving at Much Hadham while conversing with the artist.

refuge in New York. It was Lipchitz among others who urged Valentin to try to assemble a Henry Moore show. In a letter dated May 1, 1943—ten days before this all-important show's opening—Valentin wrote to Moore:

«The only piece of sculpture I shall show along with your drawings will be the *Reclining Woman*. Jacques Lipchitz was most helpful in designing a new pedestal for it.»

Reviews both in the daily press and in the art magazines were generally favorable to Curt Valentin's first Moore show, although

they also reflected a certain amazement that a shift of focus in the vocabulary of modern art should suddenly have come from England «of all places,» as more than one critic wrote. In *Art News* of May 15 Martha Davidson wrote:

«Through the courtesy of the British Council of London and modern facilities enabling forty drawings and watercolors to be squeezed into two tubes and flown across the Atlantic, the American public enjoys at the Buchholz Gallery its first substantial view of England's foremost abstract sculptor—Henry Moore.

«Deprived of materials and dislocated by the War, Moore had during the past two years concentrated on making drawings. Though primarily notes of a sculptor, they are also appealing as works in themselves. Here the human body is reduced, as in Moore's three dimensional productions, to abstractions smoothed and hollowed out as driftwood or stone worn by time and water.

«Placed singly or in rhythmic groups in a great crepuscular ambience and suffused with sensitive color tints, these crayons and pastels evoke a vague sense of nostalgia. Pages of sketched figures sitting, reclining or standing, show Moore mastering harmonious group relations and giving rhythm not only to sculptural forms but to surrounding space.

«Several drawings of draped females reconstructed as herculean bodies terminating in stump-like heads have, as Sir Kenneth Clark notes in the catalogue, 'the fateful air of antique tragedy.' They also have a hideous, almost malicious manner of transforming women into things composed of all body and no mind.

«Moore turned seriously to drawing during the 1940 bombings of London. Although entirely removed in subject from the terrible realities of that year, the emergence of the heroically hideous females may be attributed to the artist's reactions as he sat working in the air raid shelters. The direction pointed in these is towards future sculpture containing more human emotive values.»

Revealing a rather strange notion of whom she considered to be the leading innovators in art of the moment, Maude Riley, writing in the May 15, 1943 *Art Digest* said:

«Henry Moore has not been considered in this country collaterally with Picasso, Chirico, Rouault, Marin, Ozenfant, Flannagan, de Creeft, Leger and other such contributors to intelligent trailblazing in the arts. But he should have been. England has not added a leaf to the flowering tree for so long, one forgets to look for foliation from that direction.

«But Moore takes his place in the avant garde this week through the Buchholz Galleries' presentation of his drawings and through an article written by Herbert Read, English critic . . . I point to the article and to Read's book *Henry Moore, Sculptor, an appreciation* because the minor medium of drawing is hardly strong enough to rest a case upon. Even so, Moore's drawings, many of them studies for future sculptures, make a powerful brief for the rights of the Englishman to sober consideration. . . It takes no pointedly persuasive 'interpretation' to convince the average visitor that many of these 'Figures in a Setting' are in underground air raid shelters and that the women standing silently on guard are waiting for the cessation of bombings from above . . . you feel that they have been there for days and that the strength of England is in their solid stand . . . the sculptor is unable at present to work in the round, having been bombed out of two studios. Moore's sculptures, when he makes them, and we see them, will not necessarily follow these projects but they will be of the moment. For here's a man who interprets immediacy. And that's why he is making a dent upon his times.»

If the 1943 Buchholz Gallery exhibition gave New Yorkers their first good look at Moore's graphic work and encouraged The Museum of Modern Art to organize a full-fledged retrospective three

and a half years later, that museum's moving spirit and founding director Alfred Barr already was the first American art authority who met Moore in England in 1928, the year before the museum's open-

Moore's Large Torso: Arch *frames artist and Museum of Modern Art guiding spirit Alfred Barr in* MMA *garden.*

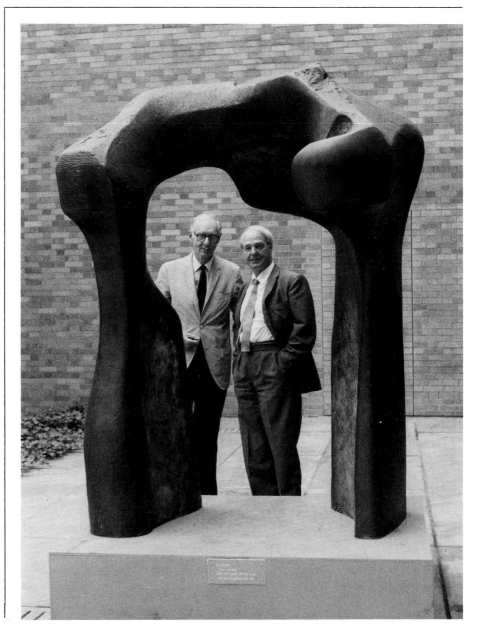

ing. Barr was in Europe for a number of months. A curator at the Victoria and Albert Museum took the fledgling American museum director to visit the up-and-coming English sculptor at this Hampstead studio-home.

The Victoria and Albert curator was very much interested in direct carving which everybody was responsive to in those days. What Barr remembers particularly about that first visit was Moore's open admiration for Mayan sculpture, especially the Chac Mool (Rain God) which influenced the first reclining figures he was then beginning to create.

When Barr saw the 1934 wooden piece *Two Forms* in London, he asked that it be included in his Museum of Modern Art exhibition «Cubism and Abstract Art» to be held in 1936. Since he very much wanted the piece to be part of the museum's permanent collection, Barr asked Moore whether there might be someone in England who would make it possible for The Museum of Modern Art to obtain the work.

From England Sir Michael Sadler sent money to Barr because he wanted The Museum of Modern Art to purchase the work. Yet, he did not want it to be a gift, although it is now so credited. It was actually purchased through his funds. Apparently Moore was most interested in this first Museum of Modern Art purchase. In writing to the artist Barr enclosed a copy of a letter of acceptance sent to the donor and thanked the sculptor for his part in lowering the price for the benefit of the American public. Writing to Sir Michael on May 20, 1937, Barr said:

«Our Trustees were delighted to accept this distinguished work and were especially happy at having received for the museum this evidence of support by a distinguished English collector in the work which we are doing. Permit me to add my personal thanks, as I have since 1927 been an admirer of Moore's work.»

Two years earlier both James Johnson Sweeney, who was to organize the pivotal Museum of Modern Art show eleven years later, and Daniel Catton Rich, who was to welcome the exhibition when it came to his Art Institute of Chicago in 1947, were already in correspondence with Moore.

Sweeney, who remains one of Moore's staunchest friends, wrote on May 13, 1935 thanking the artist for having sent him a book about his sculpture:

«I have seen examples of your work in various collections but never as much as I would have liked to have seen. Unfortunately, circumstances did not permit me the opportunity. On my next trip to London, however, I hope I may have the pleasure of calling on you.»

Having also received a copy of Herbert Read's first book on Henry Moore, Rich, then the associate curator of painting at the Art Institute of Chicago and later its distinguished director for many years, wrote Moore a similar letter at the same time.

If it had been up to John A. Thwaites, who later became a noted art critic but in the thirties was a member of the British consular staff in Chicago, the first important Moore exhibition would have been held in Chicago in 1937 instead of in New York ten years later or at Washington's Phillips Memorial Gallery in 1946.

Thwaites tried to persuade the Foreign Office to support an exhibition of Moore's sculpture in the United States. He received a memorandum from headquarters, signed by Rowland Kenney, which pointed out not only that the Foreign Office had «no official money for this purpose» but added that such support could conceivably come only from the British Arts Council. The British Arts Council then considered the United States of America outside of its sphere of activities «as we have always understood that the Americans object most strenuously to any form of foreign propaganda.»

Unfavorable is a mild term for the rather vitriolic review which gave Moore his first important art journal criticism in America. Writing in the May 9, 1931 *Art News* London Letter, Louise Gordon-Stables commented:

«Epstein begins his foreword to the catalog of the exhibition of Henry Moore's sculpture at the Leicester Galleries with the pronouncement 'Before these works I ponder in silence,' and then illogically proceeds to entangle himself in a maze of words which to interpret defies the most conscientious of readers. A more noncommittal 'appreciation' I have never read. It neither explains Mr. Epstein's reaction to the carvings nor supplies any intelligible interpretation to the figures.

«Distortion, particularly of the feminine form, characterizes Moore's work. There is a Sumerian method of attack, but not the impressiveness that we associate with the relics that have come down to us from some 2,000 years B.C. We are now at nearly 2,000 years A.D. and may be forgiven if we find the same method by no means so expressive of our time.

«In many cases the material chosen is unpleasant both in color and surface. For example, a figure of a reclining woman is of a greyish stone, marked with those brown amorphous flashes that remind one of the stains left by a drainpipe or a defective gutter on the stone beneath. The use of concrete is interesting but here again the tone of the concrete has not always been happily selected. Perhaps the most acceptable work is to be found in the masks and in the heads of low relief, where the formalism adopted offends less than the deliberate distortion practices in the figures in the round. . . .»

In 1939 the first important Moore sculpture, an elm wood *Reclining Figure* completed by the artist the year before, entered an American public collection. It was purchased for the Buffalo Fine

Snake, *1924*
Marble
h. 8 in. (20.3 cm.)
The Artist

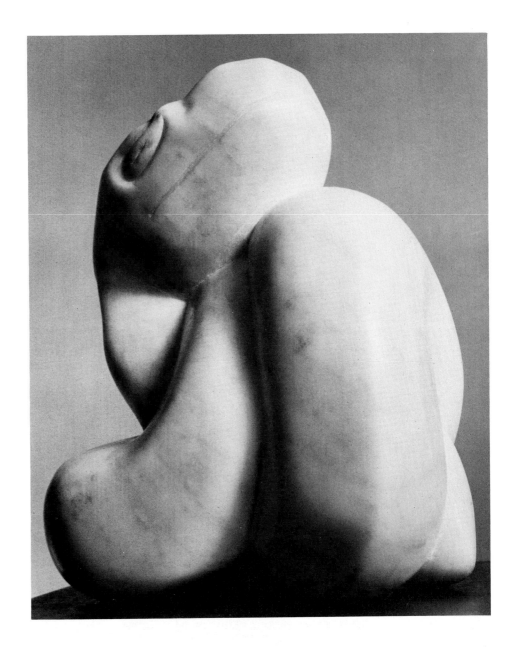

Reclining Figure, *1930*
Bronze
l. 7¼ in. (18.5 cm.)
The Artist

Reclining Figure, *1930*
Green Hornton stone
l. 21 in (53.3 cm.)
The National Gallery of Canada, Ottawa

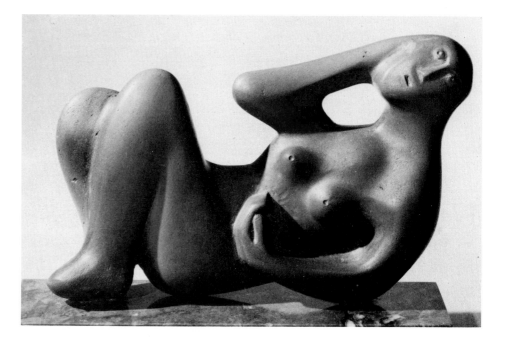

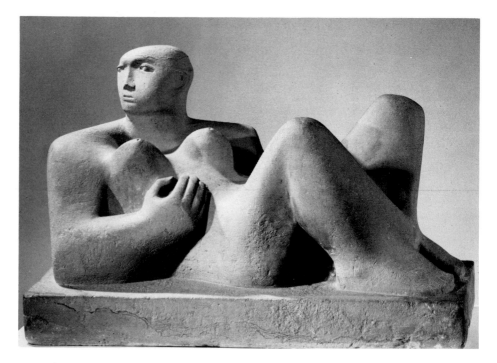

Two Forms, *1934*
Pynkado wood, oak base
l. 21 in. (53.3 cm.)
Collection, The Museum of Modern Art,
New York
Sir Michael Sadler Fund

Composition, *1934*
Bronze
l. 17½ in. (44.5 cm.)
The Artist

Hole and Lump, *1934*
Elm wood
h. 22⅛ in. (56.2 cm.)
The Artist

Two Forms, *1934*
Bronze
h. 7¼ in. (18.5 cm.)
The Artist

Reclining Figure, *1935-36*
Elm wood
l. 35 in. (88.9 cm.)
Albright-Knox Art Gallery,
Buffalo, New York
Room of Contemporary Art Fund

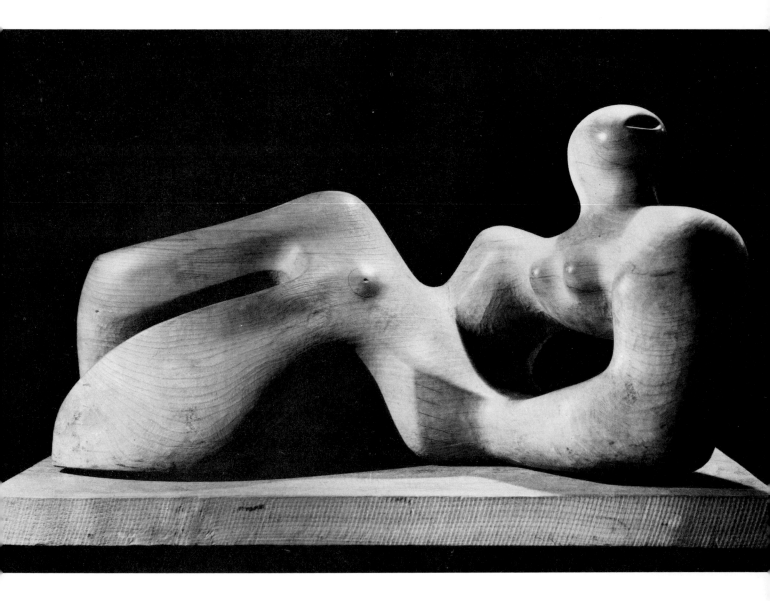

43

Head, *1937*
Stone
h. 14 in. (35.6 cm.)
The Artist

Stringed Figure: Bowl, *1938*
Bronze and string
l. 22 in. (55.9 cm)
Mr. and Mrs. Ted Weiner

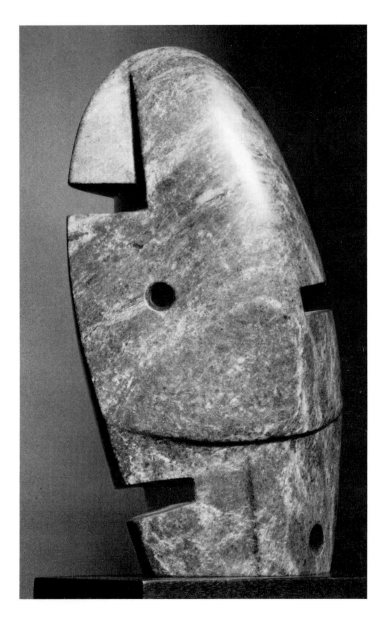

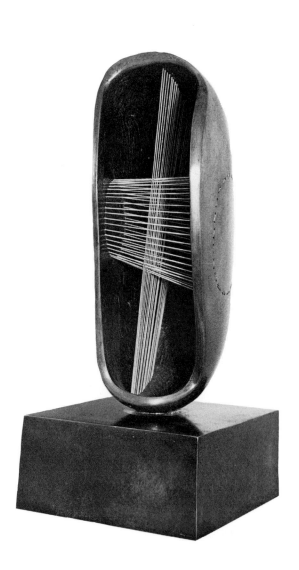

Mother and Child, *1939*
Bronze, string, and wire
l. 7½ in. (19.1 cm.)
Dorothy and Richard Sherwood

Reclining Figure, *1939*
Bronze
l. 11⅜ in. (28.9 cm.)
The Artist

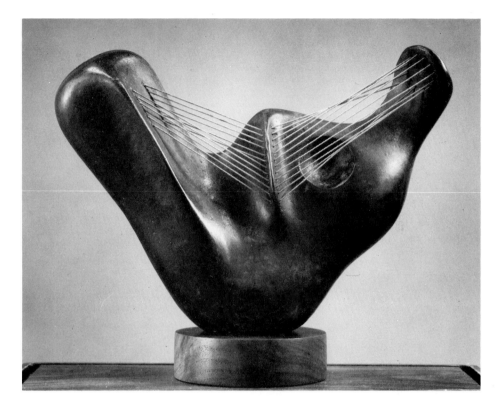

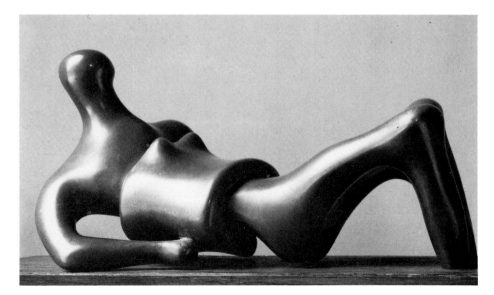

Reclining Figure, *1939*
Elm wood
l. 81 in. (205.7 cm.)
The Detroit Institute of Arts

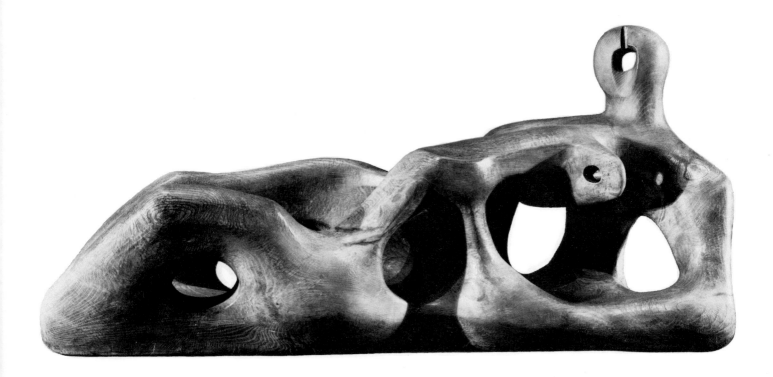

Stringed Figure, *1939*
Bronze and string
h. 10¼ in. (26.0 cm.)
Mr. and Mrs. Billy Wilder

Three Points, *1939-40*
Bronze
l. 7½ in. (19.1 cm.)
Private Collection

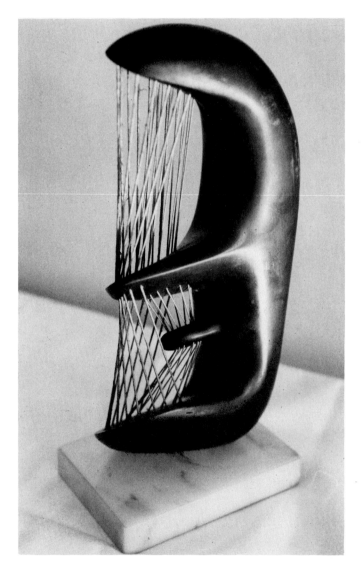

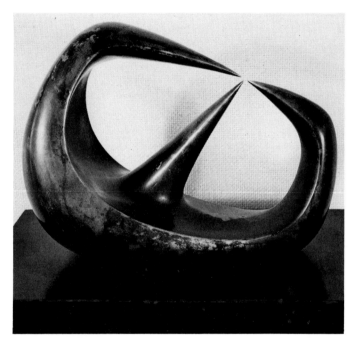

Family Group, *1944*
Bronze
h. 5½ in. (14.0 cm.)
The Fine Arts Gallery of San Diego

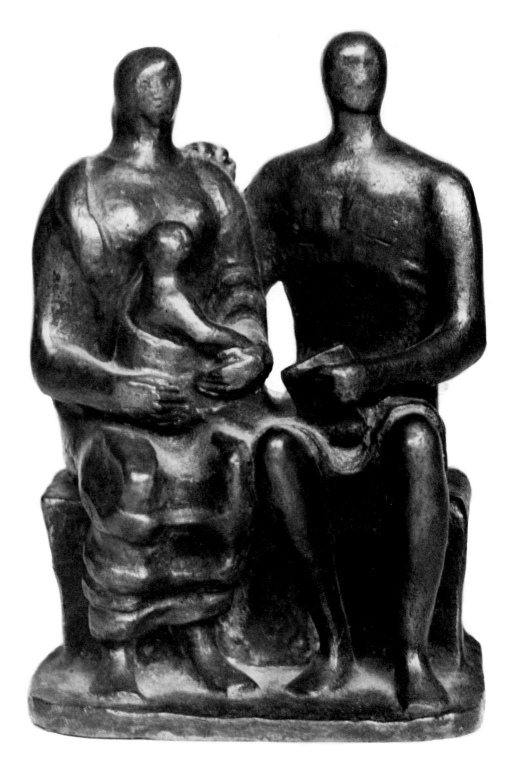

Arts Academy (now known as Albright-Knox Art Gallery) by its director Gordon Washburn (now director of Asia House in New York) who recently wrote:

«Actually my only unique relationship with Henry Moore is due to having bought the first sculpture he ever sold to an American museum —I was at the Albright Art Gallery as its director, and we had established a 'Room of Contemporary Art.' Seymour Knox and his family were the supporters, with a few other Buffalo patrons, at the beginning. So I travelled in the summer when we had money to spend for the art although my wife and I paid our own way for the travel. On one of those occasions in the late 1930s, I went to see Moore and negotiated for that early *Reclining Figure* still in the Albright-Knox Museum which has bought several other works by him since.»

On August 2, having returned from Europe and upon receipt of a letter from the artist thanking him for the payment he had received for this work, Washburn wrote to Moore:

«Although the figure is here in the gallery, it has not yet been shown except to friends who are particularly interested. These people have all been particularly interested over the purchase and I am sure that the figure will arouse much interest in your work on the part of the people in this country who are not yet acquainted with it.»

According to Moore, Kenneth Clark had urged The Museum of Modern Art to buy the now famous Hornton stone *Reclining Figure,* now at the Tate. In 1939 the artist had bought it back from his friend, the architect Serge Chermayeff, who had built a home in Sussex before disastrous business conditions forced him to leave England for the United States where he settled and flourished in Chicago.

In the comfortable living room of his sixteenth-century country home, that along with a series of studios is the center of his ever-expanding enclave at Perry Green, Much Hadham in Hertfordshire, Moore recently recalled:

«Chermayeff was building himself a new house and wanted me to come to see it. During our visit he asked whether I might do a sculpture that he could put there. Not exactly a commission for a certain design—I have never done that—but he had liked some of the stone pieces I was then doing. The depression was so bad in the 1938/39 period, in the selling of art, in architecture, and in everything else that I sold him the piece for 300 pounds but agreed that he would pay me 50 pounds a year for the next six years, because he couldn't afford any more. He paid me the first 50 pounds at once which was about the cost of the stone. Then I carved it, and he put it in his new Sussex home. A while later he came to me and said 'I am sorry Henry, I have to give you the sculpture back. I am having to sell the house and am thinking of moving to America. And I don't want you to think that I am selling your sculpture which hasn't been paid for along with the house. And I think the only thing to do is to give you your sculpture back if you won't mind returning the 50 pounds.' Which I did. Then Kenneth Clark suggested to The Museum of Modern Art that they buy the piece, but when, for some reason, they were unable to do so, K., who was the buyer for the Contemporary Art Society that year, bought it for the Tate through them. But just before the war broke out—in the summer of 1938—I was invited to be represented in the New York World's Fair art section by this *Reclining Figure.* It was about the biggest thing I had done up to then. And to me it was a very big sculpture, because the handling, the moving, and everything about a work is a big problem for the sculptor who has no help and whose studio space is limited. Unable to bring it back over here, since the war had started when the World's

Fair came to a close, it was put on display in the garden of The Museum of Modern Art all through the war right to 1945. That's why the stone is weathered somewhat, because it stood five New York winters and this stone is an English stone which is all right even on the coldest days in the mild climate of Devonshire, where I have a piece of the same stone, which had lasted outdoors, more or less undamaged, for about the same period.

«I was due for an exhibition at the Leicester Galleries in 1939, which was postponed a bit because of the outbreak of the war, but I still had it in the Spring of 1940. In it they showed which was for me then, the largest wooden *Reclining Figure*—now in Detroit. Once more K. Clark recommended to Alfred Barr that The Museum of Modern Art ought to buy it. But again, all those war difficulties and the fact that people couldn't get over here to actually see the sculpture made them decide not to purchase it. But it did get to America with Gordon Onslow-Ford who bought it for 300 pounds which paid for the deposit on this house. And that's why we have been here ever since, because that was the tenth of what we were going to pay for this house in its original state.»

Thirty years later, Onslow-Ford was to sell Moore's now-famous and very valuable elm wood *Reclining Figure* to The Detroit Institute of Arts, through the Marlborough Gallery in New York, as this remarkable painter-poet liquidated much of this notable art collection in order to establish the Bishop Pine Preserve—in an isolated valley near Inverness in Northern Marin County, California—where he now lives and where Moore visited during a very brief stay in San Francisco in 1958.

Onslow-Ford, a member of the original Surrealist group, was forced to end his lengthy residence in Paris by the outbreak of the war in 1939. It was around this time that he first visited Moore, but he had seen and admired his work earlier at the London Gallery

owned by Moore's old friend Roland Penrose and managed by the Belgian Surrealist poet E. L. T. Messens; Onslow-Ford remembers:

«Messens, who was very close to the Belgian Surrealists Magritte and Delvaux, got into the art business by chance when Magritte's dealer in Brussels went bankrupt and Messens simply decided to buy 200 Magrittes. Unlike André Breton and his group in Paris, who wanted to transform the world by bridging the gap between dream and reality, the Belgian Surrealists were really a more esoteric sect. Magritte, for instance, meant to shock people by being conventional rather than revolutionary, wearing starched shirts and stiff collars. I think that when Herbert Read and Henry Moore became interested in Surrealism they thought of it as a popular movement that might show people that they had to change the way in which they were living. I do not believe that Surrealism was ever central to Moore although he sometimes showed with the Surrealists. He did not share Breton's feeling that there was no other alternative in art at the time and that Surrealism was *the* great hope. In comparison to the Surrealists—who were often amateurs trying something that couldn't have been done before, Moore came from a traditional art background and had a thorough professional training. Even at his most experimental, Moore—unlike the Surrealists—has been always involved in continuing the tradition of European man, and his changes have been humanistic changes.

«Moore was the first artist to find and express that aspect that connects the rolling hills of the English countryside with contours of the female figure. It was not any particular woman as a muse that inspired Moore, in my opinion. Woman becomes central in his work as she enters a different dimension like an endless, voluptuous rolling landscape of an extremely enigmatic nature. It is very important to understand that it was Moore who was the first one to find and recreate the anthropomorphic landscape of the mind. In his work

you can also see how the form and color of the English earth—which is very powerful without being overwhelmingly dramatic—gets into your blood as a child in England. And there is also the pride of craftsmanship one could find in even the smallest villages in England that is reflected in all of Moore's work. I remember as a child noticing just how well everything was made.»

Aside from the large, important example of Moore's human landscape now at Detroit, Onslow-Ford also owned a small lead 1939 figure—which he had dubbed «the fire engine.» It somehow disappeared from his apartment in London during the war. Reminded that it was his purchase of the elm wood figure which enabled Moore to move to Hertfordshire, Onslow-Ford recalls his first visit with the artist who was then living in a small cottage near Canterbury:

«I recall that he had his drawing board set up in the kitchen and that the living area also served as his sculpture studio. He showed me several amazing sketchbooks from which not a single page was missing—which meant that no one had bothered to buy even one of these splendid drawings. Since then we have seen each other frequently. To me Henry Moore is not only one of the greatest artists alive and probably the greatest sculptor England ever produced but an absolutely marvelous human being. The integrity of his visual poetry is simply amazing.»

It was James Johnson Sweeney who as The Museum of Modern Art's director of painting and sculpture wrote to Moore in 1944 proposing that the museum organize a major retrospective of the artist's work. This was the consequence of an exhibition at Curt Valentin's Buchholz Gallery in 1943—for which the British Art Council arranged a diplomatic courier flight. The previous year Valentin, who had fled to New York from Nazi Berlin and proceeded to introduce

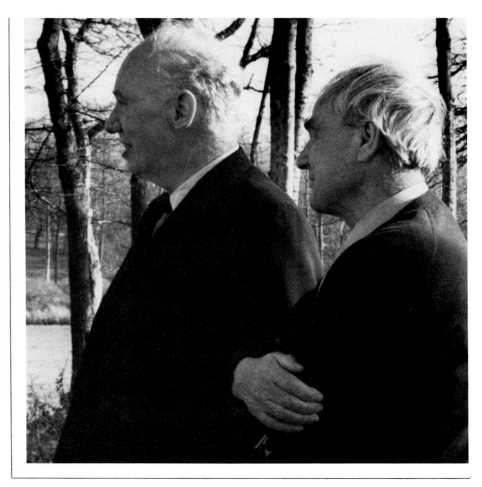

James Johnson Sweeney, organizer
of 1946 Museum of Modern Art
Moore Retrospective, enjoys moment
of rest with the artist.

many top European artists to the New York public, wrote to Moore asking to be his American dealer. Moore remembers Valentin's first contact very well. Later they were to become very close friends as well as associates until Valentin's sudden and untimely death in 1954.

«One day I got a letter from Curt Valentin by morning post. I didn't know the name, but he wrote that he had the Buchholz Gallery and wanted to buy some drawings for an exhibition in his New York place. Several people from whom I enquired spoke highly of him. Some knew him in Berlin and then in New York, and everyone

54

thought well of him. And unlike my present habit, I answered the letter the very same day. I think because I had been busy doing drawings and was about to be away from home for a few days' vacation. He asked whether he could have 40 drawings for sure, and I answered the letter straight away and said yes.

«And by the afternoon's post—because even in those wartime days of 1942 we had two posts though we now have one—came a letter from another New York dealer suggesting the same thing. If I had not already answered Valentin that morning I would have agreed to his suggestion since I knew all about him.

«But in a way I have always been glad of this coincidence because I doubt whether anyone could have said at that time that there was any other dealer in the world so keen on modern sculpture as Curt. So I think it was very lucky in a way that the morning post brought Curt Valentin's letter and the afternoon post a different one.»

The dealer with whom Moore had chosen to associate himself in America turned out to be the most forceful persuader of the virtues of modern sculpture that his adopted country had ever encountered. A shy, yet gregarious, man, known for his wit as well as his deep concern for art and artists, Valentin received impeccable training at the Alfred Flechtheim Gallery in Berlin which he eventually came to direct in the late twenties when its owner began to devote most of his time to the parent gallery in Düsseldorf. Here he came to know and represent sculptors like Georg Kolbe and Ernest Barlach and to develop such an admiration for Rodin that he was to ship a cast of *The Burghers of Calais* to New York in his early days as a dealer there not knowing whether sales from his Rodin exhibition could even cover such shipping costs. At Flechtheim, Valentin also found the example for the uniformly and meticulously designed catalogs that were to distinguish his own New York gallery from many others and make it a meeting place for curators, collectors, critics, and artists alike.

One of the few gentiles among many German dealers who were to come to America and have a profound influence on its art scene, he came to New York in 1937 because of his revulsion with Nazism. His place on West 46th Street was devoted more to rare books and prints than to paintings or sculpture, but when he moved to new premises on 57th Street in 1939, the emphasis shifted entirely to art and reflected a special passion for sculpture and German Expressionism.

Old friends remember him as a shrewd and persuasive art dealer, whose integrity and generous nature gained him the confidence and friendship of major collectors and museum directors throughout the country. A gregarious man who traveled a great deal, Valentin, who was later to spend many Christmases with the Moores in Much Hadham, was probably motivated in these frequent holiday visits not just by his great admiration and growing affection for the sculptor but by the great warmth and essential simplicity of Moore family life in the country.

At first Curt Valentin's New York gallery was called the Buchholz Gallery after the one he had come to direct in Berlin after leaving Flechtheim. But in a remarkably short time Curt Valentin's name became so well known in American art circles that everyone going to the Buchholz Gallery privately called it Curt Valentin's Gallery. His exemplary publications always bore the CV imprint, so that the name change came almost by natural evolution and, perhaps, also through Valentin's desire to further separate himself from his traumatic experiences in Hitler's Germany.

According to a number of surviving colleagues and competitors who knew Valentin well, he was unique in the fact that he had no enemies among dealers. They readily agree with the assessment of Jane Wade who worked for the Valentin Gallery for several years before his death and helped carry it on for some time after that «it took Curt's push and drive, conviction and enthusiasm to really put

every sculpture in the American home. He literally came here with a few cents in his pocket and started on nothing at a most difficult time. His really great achievement was to do something that the established dealers had been afraid to do, which was to sell sculpture and push sculpture not only for the marble halls of the museums but for the private home—a concept practically unknown before Curt. It just wasn't done.»

Veteran Beverly Hills dealer Frank Perls, who knew Valentin as early as 1927 in Berlin, recalls that when the noted Philadelphia collector Sturgis Ingersoll indicated some interest in buying Picasso's large sculpture *Man With Goat* from Valentin but wondered where he might find sufficient space for it in his home, the dealer suggested that he put it in his garden. «And that was the beginning of a wonderful outdoor sculpture collection and probably the start of private sculpture gardens in this country,» Perls says.

Valentin sold a great many works by Maillol, Arp, Marini, Lipchitz, Marcks, and Calder as well as Rodins and Moores, but according to Jane Wade «it was Moore and Rodin, not necessarily in that order, but as a coupling, that were to Curt the greatest of the artists he was handling. He always spoke of Moore in terms of adoration and affection. As you know, they became very close friends although they did not meet until The Museum of Modern Art exhibition in December 1946. They became intimate friends for the rest of Curt's busy and creative life.»

Early in 1954 Valentin became seriously ill and was hospitalized. On February 22 of that year, Moore wrote to him:

«We have been thinking about you a lot and hoping you are feeling much better but that you are taking care, if you are better, and not getting back to the Gallery too soon. I had a letter from Jane Ritchie, saying that they can't keep you flat and that you have too many visitors and telephone calls, so do please be sensible, for all our sakes.»

57

A few weeks later Valentin was to receive another letter which Moore concluded by writing:

«We are delighted to hear that you are now back at the gallery, although only part-time. Don't try to be back full-time too soon. Sturgis Ingersoll and I were saying to each other on Sunday how much your keeping fit matters to all of us, even from a purely selfish point of view. So take care of yourself. Everybody here sends their love.»

Curt Valentin died on August 19 in Forte Dei Marmi during a visit to Marino Marini whose work he had also introduced to America. Moore learned of his death by telegram just as he was leaving for a seaside vacation. He flew to Italy for the funeral and found a modicum of consolation in learning from the Marinis that «Curt's last three weeks (except for the final few days) were some of the happiest of his life.» But even now he speaks of his dealer-friend often and with great feeling. On September 13, 1954 Moore wrote a commemorative statement:

«Curt Valentin has been my sole agent in America since 1942. But it was not until I came to New York for my exhibition at The Museum of Modern Art in December 1946, that I got to know him in person. It is from then that I began to count him as my friend as well as my dealer. I spent a month in New York, he looked after me as if I were a near relative. Every morning at 8:30 a.m. he telephoned my hotel to know my program, my problems, and in what way he might help throughout the day. I marvelled that such a busy man could show so much thoughtfulness. Since then our friendship has yearly grown stronger.
«In addition to our twelve years of correspondence, I saw him at least twice a year, in the summer and again in December. For the last six

years he spent every Christmas day here at Much Hadham with me and my family.

«His death has been a terrible shock to me.

«As a dealer he will not be easily replaced, for no one will be both such a good business dealer and at the same time have such ideals and taste in art. Certainly there will be no dealer with a more burning love for sculpture. All other art dealers I know have 20 exhibitions of paintings to every one exhibition of sculpture. . . . He will be a great loss to the cause of contemporary sculpture.

«He treated his Gallery as an artist should his work. He kept as true as he could to his ideals and made no compromise for the sake of financial success. He sold only the work of the artists he believed in. This helped to make him unique as a dealer and to give his opinion such authority.

«He kept to only a few artists and these he called his 'boys.' They were his family and he looked after them and felt towards them like a father. I have had personal proof any number of times, that no trouble was too great for him to take in their behalf.

«To try to work out why one loved him so much is not easy. He was naturally shy, and never demonstrative. Walking by his side he would, on rare occasions, rest his hand on one's shoulder—only for a brief moment—but to me it expressed a deep warmth and affection.

«I begin to realise all the more now that he is dead how much he meant to me. How much, all the time, one unconsciously counted on his steadfast support, on his being there, tirelessly working for the cause of the painters and sculptors he believed in.

«I loved him very deeply and shall miss him terribly.»

It was Perry Rathbone, who was then the assistant director of the International Art Exhibition at New York's 1938 World's Fair who first showed Valentin the important Hornton stone *Reclining Figure* that represented Moore in that outstanding display and kindled

the dealer's initial enthusiasm for the sculptor. Later, successively as director of the City Museum of St. Louis and as director of the Boston Museum of Fine Arts, Rathbone was himself to become Moore's very close friend. Having known Valentin extremely well through his entire American experience, Rathbone feels strongly that the dealer's concentration on spreading appreciation for sculpture did not spring for his caring for this particular art form more than for paintings, prints, and drawings, but from the fact that others cared for it less. He simply found sculpture very much neglected in his adopted country. Rathbone correctly insists that the renascence of appreciation for sculpture in America was very largely Curt Valentin's doing.

Boston Museum of Fine Arts director Perry Rathbone served as official host when Harvard University awarded Moore honorary doctorate in 1958.

After Valentin and Moore had finally met on the artist's arrival in New York for a month's stay because of The Museum of Modern Art exhibition, Valentin's friendship extended to sending foodstuffs and other rationed items to England. In a letter, written in March 1947—over a period of a week as was apt to be Moore's habit—the artist first writes «we got the first parcel from Dover Food Stores about a week ago, and Irina was delighted,» adding at a later date «yesterday two more parcels came from Dover Food Stores, so Irina is further delighted.»

Moore also recalls that while it was impossible for him to obtain a new car in England at that time, Valentin managed to comply with his request of obtaining a Hillman Minx for him in New York. There was an anxious moment when Moore thought that his request had been misunderstood since a cable from Valentin arrived saying «Your mink is on the way.»

Valentin gave Moore ample warning of New York's hectic art scene partying when he wrote in March 1946 «poor Herbert Read has to rush from one party to the other. I met him at four parties already. It is true that parties are a disease in New York. I hope I can protect you when you come in December. I probably can't.»

Attorney Ralph Colin, Curt Valentin's close friend and executor, decided to hold the 1954 Moore exhibition after Valentin's death and later advised Moore and other artists associated with the Valentin Gallery who would best represent their interests after the estate and the gallery were liquidated.

«I had met Henry Moore sometime prior to Curt Valentin's death but we were not well acquainted then. But after Curt died, I felt a great responsibility of doing all I could to get Curt's artists placed to their very best advantage. Curt had had a very special relationship with his artists. It wasn't just a business arrangement, he had become close friends with all the artists he represented.

«I tried to assess where each of them would be placed best. It was in that connection that I began to know Henry better. I wrote to each of the artists, told them what I was planning to do and asked them whether they wanted a recommendation from me, or whether I should mind my own business and let them make their own choices. Most of them did want advice and recommendations from me, including Henry. So I recommended, at that time, that he go to Knoedler's. It wasn't that I was sending everyone there. I sent Marini, for instance, to Pierre Matisse and Calder to Perls. But considering Henry's great eminence and the need for space to show his large new work and because of his rapidly growing reputation, I felt that Knoedler's would provide the kind of background that would best suit him. After talking to the Knoedler people, he decided to let them be his American representatives at the time.

«It was as the result of that correspondence and of the meetings we all had together when he came over here that he became confidential with me, developed a feeling of trust, and so we became good friends. Our friendship has been amplified in two different ways: on our annual European trip we always make it a point to visit with Henry at Much Hadham or in London and, now my daughter (Lady Harlech) lives in London and through her own circles has become quite friendly with him.»

Colin, executive director of the Art Dealers Association of America, has also been a sort of watchdog for Moore in America—looking out for possible fakes and at one point getting an injunction against an outfit that had been selling reproductions of Moore's large *Family Group,* situated in The Museum of Modern Art Garden. Although they used their own artist and did not claim that Moore had executed these sculptures, Colin thought it would be harmful to have second-rate Moores around that could possibly be mistaken for the real thing. He called the matter to the artist's attention, brought suit

and obtained an injunction which obliged the firm to destroy their model and refrain from selling any more of these Moore-like sculptures. This, of course, reinforced the friendship Colin had established with Moore.

«I find Henry to be a very warm human being, a person who is always genuinely interested in the person he is talking with. He is involved in ideas not necessarily related to his work but to everything that's going on in the world. I always feel relaxed in his presence. There is no sense of competition or trying to get a word in edgewise as you talk with him. He's there and listening. You talk to him as you would to any other good friend. You don't feel that he's an Olympian, that you have to be careful what you say or that you have to bow and scrape. There's none of that. Unless he's acting, and I doubt that very much, he is as interested in what you have to say as you are in what he has to say. That is, I think, quite rare for a person who is as outstanding an artist as he is.

«I don't think for a moment that Henry underestimates himself. I think he realizes how important he is both in his work and in his influence on the whole English school. The excitement that England has developed about the arts of our time really stems from Henry, in my opinion—in the sense that he created an atmosphere of willingness to look anew at things. He has no false modesty. But he is a man who can be aware of his own importance without rubbing your nose in it every minute. He just assumes it's there. There's no kidding about it. He knows it, you know it, everyone knows it—so it's assumed and you go on from there. But you don't have to talk about it.»

Colin believes correctly that the general acceptance of modern sculpture especially into private collections, would have been delayed by perhaps as much as ten years if it had not been for Curt

Valentin's extraordinary powers of persuasion and the confidence that museum directors and curators had in him.

«Very few of the collectors I came to know from the early thirties on had any interest in sculpture. They looked on it as awkward. They didn't know where to put it in their home. So there was a built-in resistance to the purchase of sculpture. Curt just blew that away by persuading them to have top sculpture in their homes and gardens from a Henry Moore *Rocking Chair* piece, eight inches high, to over life size Rodin figures. He just brought them into the country and sold them. He had a deep conviction about it and he had to use all of his considerable powers of persuasion on many of his customers who were originally interested only in the German Expressionist paintings that were his original stock in trade.

«More than any other dealer I have ever known Curt had the confidence of the museum world. Unfortunately museum people, by and large, tend—in my opinion at least—to deprecate the role of the dealer, to look at him purely as a merchant, a money snatcher. But there have always been certain dealers, like Valentin, who are the first to break the ice, to bring new artists and new ideas. Nobody ever had the vaguest idea that Curt would ever take him for anything, that he would try to sell him something that should not be sold. It was for that reason, I'm convinced, that he was able to put across his idea of sculpture.

«He was the most unromantic looking man you could imagine but a most lovable kind of person. Short and fat like a Teddy Bear, Curt had more women in love with him than anyone could imagine. Although he was a very sensitive man, he exuded confidence.»

The 1946-47
Museum
of Modern Art
Show

It was in answer to one of James Johnson Sweeney's letters regarding preparations for The Museum of Modern Art 1946-47 exhibition which Moore regards as the key event in establishing his reputation internationally, that the artist wrote him in August 1945:

«Perhaps now that the war is completely over, the isolated, cut-off feeling we've all had, particularly here in England, may quickly go. It's so good to be hearing again at first hand something about what's happening in France, and to think that it may be possible before long to travel about again more freely.

«Though I myself think that I have been particularly lucky throughout the war. Happiest thing of all is that I have been able to go on working all through—although not all the time at exactly what I would have liked—that is I've not been free to give the majority (and proper proportion) of my time to my real work of sculpture. But that's not longer so.

«At present I am working on some clay things (which I shall have cast into bronze and then work on the bronze itself) while waiting for a large block of stone I've ordered, and a large lump of wood for two slightly over life size carvings I want to do. (But wartime conditions still prevail and though both wood and stone were ordered two months ago, there's no promise of quick delivery yet.)

«I am sending you photographs of some recent work just for your interest, although none of it is available. Because of not being able to do a great deal of sculpture during the war, what I have done was either commissioned or has been sold—except work in progress.

«How nice it will be when we meet again. I expect that will first be when you should come to England—though we hope very much to come to America—one day.»

Sweeney had first met Moore in 1932 at his Hampstead studio and had seen quite a bit of both the artist and his work before the war.

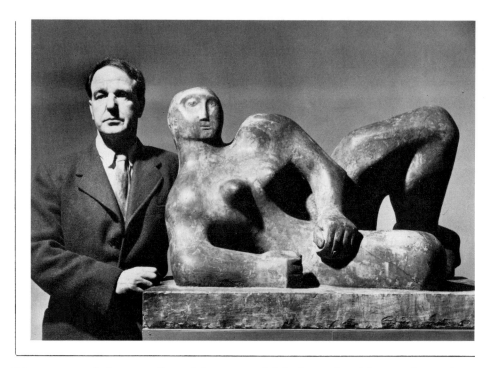

At opening of 1946 Museum of
Modern Art exhibition Moore with
concrete Reclining Figure 1932
now in St. Louis.

He proposed the 1946-47 Museum of Modern Art Moore show during his tenure as director of that museum's Painting and Sculpture Department, selected its content, and wrote its catalog. But he had resigned from that position by the time the works arrived in New York for installation. Looking back on his long friendship with the artist, Sweeney says:

«From the very first I liked the direct treatment that he advocated and practiced at the time when I first met him in 1932. I felt, too, that he believed in the traditional approach, the personalized tradition. Possibly also, I was interested in his involvement with primitive art, particularly the pre-Columbian, because at that time I was very interested in it, as I still am and he still is. But it was not this common interest that brought us together. I went to see Henry Moore as the artist that was the most important in England at that time. He lived in Hampstead and Ben Nicholson and Herbert Read lived nearby.

66

Also Moholy-Nagy who had left the Bauhaus. We all went to see a new T. S. Eliot play together in a small theater behind Buckingham Palace the first time we met.»

There is no doubt in Moore's mind that the earlier encounters he had with men like Alfred Barr and James Johnson Sweeney and the enthusiasm Curt Valentin built for him even before the two of them met resulted in the exhibition that was far more crucial to his future international reputation than has generally been recognized:

«For the 1948 Venice Biennale—the first one after the war—the British Council decided to have just my sculpture and Turner paintings which was a very sensible thing. But I doubt that one would have won the Biennale sculpture prize that year without the real groundwork and the real impetus that The Museum of Modern Art retrospective provided. Really the foundation where the international side of one's career is concerned—that international thing happened through The Museum of Modern Art exhibition.
«Now I notice in counting up that a good three-quarters of my work is in America. At least two-thirds of what I consider to be my most successful earlier drawings were all disposed of to Americans by Curt Valentin. And then, in more recent years there has been the development of the Moore Center in Toronto and many large public displays of my sculptures throughout the United States.»

That Sweeney was only one among an ever growing number of art professionals who have continued to admire the growth of Moore's genius is evident from comments he made recently as he paused to recall the organization of The Museum of Modern Art retrospective:

«I have never found hostility towards Moore except among younger people who say he is not bold enough and I am not surprised that

certain fashion-conscious curators might now label his work anachronistic. Some of the younger artists and curators said that about Picasso, too. In fact, they say it almost about anyone a generation before them. At the time of the Moore show here, he was still some sort of avant garde figure to some extent. But he was an Englishman. He was not a Frenchman. And Englishmen give an impression of conservative experimentation when they are being experimental and they never seem to stir the excitement a French explorer does. The French make a more distinct effort to assimilate the tradition and give it out in an unfamiliar guise whereas the English—English artists in particular—are conservative. They like to show it.

«Some people talk about Moore in the way they talk about Turner as being romantically and metaphorically involved in landscape. I think that with Moore such involvement is just a jumping off place. Kurt Schwitters was interested in fragments of paper, matchsticks, ribbons, trolley car tickets, and things of that sort. But what really interested him were the color and shapes that these pieces of rubbish had and that's where he found his Merz characteristic. Moore may emphasize the tradition of English landscape but what he really is interested in are its shapes and colors. In recent years he has gone farther, in my opinion, that at any stage between our Museum of Modern Art exhibition 25 years ago and now.

«I believe that in the past few years Moore somehow has found a certain fashion of liberating himself from his enormous, overly generous kindness to other people. I mean he served on so many committees and hated to say no. Thanks to his enormous energy he was able to do all these extraneous things. Nevertheless, for a while all these side interests were distracting to the intensity his sculpture might have had, and did have when he was a young man and enjoyed the blessing of not being a public personage when he was not yet widely recognized. Once an artist gains wide recognition, he is presented with distractions from all sides. If he is generous, kindly and

sociable, as Moore is, he tries to do everything he can do for everybody. I never hear Moore say a mean thing about anybody.

«These distractions of having become famous that came to him after The Museum of Modern Art show and after winning the Venice Biennale prize in 1948 sometimes led him to do somewhat less challenging things. They were always good and acceptable. But his most recent pieces are intense not only by virtue of a difference. I think something has happened to him inside, that he is relieved about something. Furthermore he's found himself somewhat isolated in Italy for several months each summer. Perhaps this astonishing new release of sculptural energy has come from that—from a certain relief he is experiencing.

«I think that the business of acting as a trustee of the Tate Gallery and the National Gallery, and doing nearly everything that anyone asked him to do in the art world, was based on the fact that he was going through a phase where he was able to create certain sculptures very easily. But when you do something easily you are not opening a new door because it's always hard to open a new door. For a while it was easier and quite natural for him to go through doors he had already opened. What I think is new about his latest work is the intensity or the tension he establishes. I think that in the period when he was pleasant but less exciting you didn't find such tensions as you now see in such enormous and rugged pieces as the travertine *Stone Memorial.* That's where he achieves a tremendous new vitality.

«Artists like Picasso had a great deal of superficial influence. But others like Calder or Mondrian had no direct influence. I think Moore has had a great influence, not through the style of his work, but as sort of an example to England. Suddenly, here was a modern English artist who received international acclaim breaking the isolation in which modern art in England found itself before. Beyond that his self-sacrifice and scrupulous approach was, I think, a good model for those who would follow him. Furthermore, he was not leaning to-

wards the academic, as the English are apt to do. He encouraged a break from the academic tradition. This break came through Moore's personalization of forms which came from the Pre-Columbian at one point and from the landscape at another point. He sees this sort of humanized landscape, or human forms, in the hills around him. He's talked to me about it for years back to 1939 anyhow.

«I don't think he has ever gotten over his discovery of the landscape relationship to the human form. He often talks about the broken headland concept which is evident in his strongest pieces. Perhaps it is less an idea than an intuitive understanding of this relationship. Often artists do something intuitively and find the explanation later. Being intuitive, Moore allows a concept to grow and finds an explanation later, an explanation often designed to allow people to better understand his work.

«But then there is this about it: when you use words about a visual art, you're creating literature about it. You're doing a little poem about it. In doing his sculpture Moore does not use words. Later, when he talks about it in terms of its relationship to the broken headlands, reclining women, and Mother Earth, that's literature, thoughts expressed about works after he has completed them.

«To get back, for a moment, to the matter of Moore's influence. By now there are a lot of people who worked with Moore as young sculptors. He always refused to teach them directly, in any way that they would be immediately influenced by his own inventions. It was just a matter of seeing him work and helping him with the work. So he doesn't have any imitators even among people who have worked with him for years. This is certainly the best way of teaching anyone to become himself.

«There is no sense to the allegations made against Moore in recent years by those who regard his work to be redundant and would tell you that he is doing the same thing over and over again. An artist has only one piece of work to do. He keeps on coming back to it and

giving it more and more variety. I think T. S. Eliot wrote one poem. And there's a fundamental Picasso. Of course, there are endless variations, he was so productive. But look at Mondrian. You see him from an early *Tree* right to the *Boogie-Woogie* paintings, and it's a straight line. He used to destroy a great many things. Mondrian would say: 'well, Picasso sells them all but I throw them away when I'm not satisfied with them. But there's nothing against Picasso for selling them.' I'd say, 'well, but that's not very good.' Mondrian would answer 'what's wrong with that if people are foolish enough to buy them? That's not Picasso's fault. Time will edit them.'

«Time has been very good to Moore, I think. For somebody his age —who is in a way an isolated figure—he still has a good deal of critical esteem everywhere. I think he deserves it because he has such fundamental personal strengths and qualities which have little to do with landscape, or England, or primitive art but with the intensity of relationship he creates—which is a sculptor's job just as it is an architect's job. No wonder his latest pieces are architectonic in themselves. «I do believe that Moore was helped by our 1947 Museum of Modern Art exhibition and his saying that it gave impetus to his international reputation is not purely kindness on his part. Still it is an example of his generosity of spirit that he happily believes so many years later that his first museum host—because it was his first full-fledged museum retrospective—is to blame for some of his success.»

Writing after Sweeney's Museum of Modern Art Moore exhibition had traveled to Chicago and San Francisco, Sir Herbert Read— Moore's oldest and staunchest supporter—was more assertive about that exhibition's central role in the artist's rise to international fame.

«In Henry Moore England has produced an artist of such significance that his work is now the subject of world-wide interest. We in England have confidently awaited this development, but it was only when

The Museum of Modern Art in New York held a large exhibition of his work early this year that full recognition was given his achievement. A sculptor cannot take the world by storm in his early years to accumulate the quantity and variety of work needed for exhibition and international circulation. But Moore has now reached this stage, and his reputation can safely rest on his existing oeuvre.»

In every way 1946 was a miraculous year for Henry Moore. On March 7, 1946, his daughter was born and named Mary after his mother and sister. The artist was forty-seven years old; his wife, Irina,

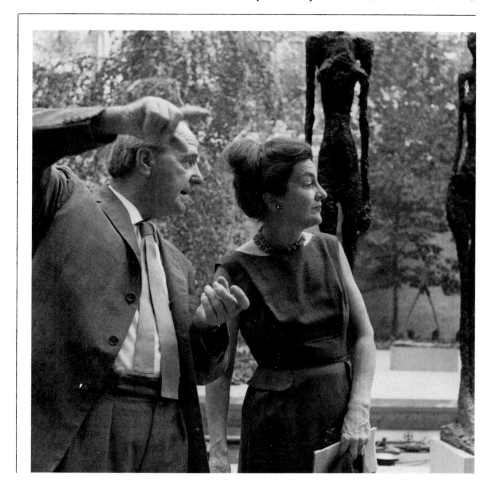

was thirty-nine. Many of the most playful and tender works in Moore's over-all oeuvre were inspired by this happy event.

He was not to spend the first Christmas with his child however, since his first visit to New York, occasioned by The Museum of Modern Art opening and related events, lasted nearly a month. It was to be his longest stay ever on the American continent. Even now Moore looks back on that month as one of the most exhilarating and most exhausting periods of his busy, but otherwise essentially domestic, regulated life.

He arrived on the SS America in New York on December 1, together with his close friend Eric (Peter) Gregory, publisher of Lund, Humphries and a foremost collector of British contemporary art. They were met on arrival by Curt Valentin and his crew. Having stopped off to drop their luggage at the New Weston Hotel, they were driven directly to The Museum of Modern Art. Here preparations for the December 17 opening of Moore's first museum retrospective, consisting of fifty-eight sculptures and forty-eight drawings borrowed from galleries and private owners in England and America, were still underway at a frantic pace, having been somewhat disrupted by the resignation from the museum by James Johnson Sweeney who had organized the exhibition and written the catalog essay.

Dorothy Miller, who was to become director of painting and sculpture at The Museum of Modern Art as a successor to Sweeney, recently recalled:

«Sweeney had already written the essay, but the catalog section and some things about the illustrations were not yet finished, so I was asked to take the catalog over and see it through the press. René d'Harnoncourt (later to be the museum's distinguished director), who had joined the staff only about two years before, took over the problem of installation and I helped him with that. René was at home with the flu on the day that Henry arrived and I was asked to greet

him when he came to the museum. René wanted me to take him at once to his apartment to look over the floor plan he had prepared for the Moore show. So Henry and I got into a cab together to drive up there and somehow I'm sure we both felt that we'd known each other forever. This is what he was like, and still is. We got to René's and spent the afternoon sitting on the floor looking over the installation plan for his exhibition. As I recall, Henry approved of everything, but I don't remember the discussion in any detail at all.

«On first impression Henry Moore seemed to be the most wonderfully friendly human being. Completely open. I remember in that taxi, he squeezed my hand and said 'I'm very nervous about all this,' or something to that effect. But he was wonderful right from the beginning.

«He came to the museum a lot during the installation. He was there every day despite of his busy social schedule. Going by René's design for the installation and pedestals, I simply worked with Henry trying things out and making an occasional shift from the original plan.

«René and I worked many nights on the show because it was a big job that had to be done probably in a week's time after the painting of the walls and so on had taken place. I remember one marvellous little incident about Henry when we were working there on the third floor. Nelson Rockefeller was giving a dinner party in his honor, and while Henry may have known about that before he left England, it is quite possible that the party was cooked up just shortly before the opening. At any rate, Henry didn't have a tuxedo so first Curt Valentin brought his tuxedo over to the museum, and Henry retired behind a large pedestal while I stood guard and he tried it on. It didn't fit him, Curt being a bit more portly. So, then my husband, Holger Cahill, sent up his tuxedo to be tried on. That wouldn't do either so Henry had to go over to Broadway and rent one. He did, however, wear my husband's shoes. We always remember that and still laugh about it together.»

Moore, who correctly anticipated that The Museum of Modern Art exhibition would mark a turning point in his career, remembers that there were some disturbing overtones, along with much positive excitement, on his first arrival in New York:

«I arrived at just an odd and difficult period at the museum because Sweeney had resigned out of disagreement with somebody there. The exhibition had all been arranged between us. All the correspondence had been between me and Sweeney who was also writing the catalog. But when I got to America, it was René d'Harnoncourt and Dorothy Miller who were staging it. People were saying 'Henry, you should insist that the exhibition is put on by Jim Sweeney or refuse to have it.' But it was Sweeney who said no to that. I remember him telling me 'I have left the museum. I don't want to enter into any kind of squabble about the show or to make any problems for you.' He insisted to let things work themselves out. Very nice of him. Of course, he took me around and I saw a lot of him and his wife Laura.»

There is a small brown notebook with daily entries—often altered and added to—that attests to Henry Moore's claim that his month in New York in connection with the retrospective exhibition was the most crowded he can remember. It records meetings with many artists including old friends like the sculptor Alexander Calder, architect Walter Gropius, and painter Marc Chagall; visits with American artists like John Marin, Georgia O'Keeffe, and Arshile Gorky; interview with critics Henry McBride and Alexander Eliot; and lunches with curators and dealers including Sweeney, Alfred Barr, Marion Willard, plus sidetrips to Boston, Washington, and Gordonville, Virginia where he spent Christmas with George Dix and his wife, a charming Anglophile couple.

«Of course, I spent a good deal of time at the museum helping with

the installation of my show but there was also a hectic round of social-
izing. Curt was a pretty good drinker and I remember an evening
with e.e. cummings in Greenwich Village where a smashed table
landed on his foot. But in the morning he would rise early with the
day's program worked out for me. He would see to it that some
flowers were sent to anyone I had seen the night before to thank them
for their hospitality, and he would straighten out all sorts of engage-
ments I had gotten all muddled up. Somewhere along the line I met
a lot of top artists I had not known like Arshile Gorky, Jackson Pol-
lock, and Mark Tobey. There wasn't really time to sit down and have
serious conversations with them because there was too much going
on and too much I wanted to see, too, like The Metropolitan Museum,
the Barnes Collection, the Duncan Phillips Collection and Dumbarton
Oaks, the Pierpont Morgan Library, and the Fogg Museum. But I
remember The Museum of Modern Art gave a party for the artists
just before the opening of the exhibition, and as sometimes happens,
I lost my voice. During the first World War we were hit by gas at
Cambrai and since then my voice goes out occasionally especially
when I am very tense and exhausted. So quite clearly it was hopeless
to carry out conversations with a good many artists I had looked for-
ward to meeting. It came back the next day. Perhaps it was a bit of
defense mechanism, after all.

«Let me give you some of the most vivid memories I have of that
visit, not necessarily in order. I remember it was the night before that
New York month was coming to an end and Jim Sweeney gave a
little farewell dinner party in his beautiful white flat, and at the dinner
party there were seven or eight of us. Among them was Francis Tay-
lor who was the director of The Metropolitan Museum. I said to him,
'one thing that I am going to be sorry about tomorrow is that I've
not spent half the time I wanted at your museum because of all these
hectic engagements. I really haven't looked at the sculpture there
properly at all.' He abruptly left the dinner table and when he came

back, I knew he had telephoned the museum because he said 'I've arranged that in about an hour's time they'll be waiting for us. We can all go and you, Henry, can have a private viewing of The Metropolitan along with all your friends here.' So we went off in two cars and the whole of The Metropolitan was opened up, but I only wanted to see the sculpture part. We were there from about one o'clock to three o'clock in the morning. This impressed me no end because I thought 'my goodness, this would never happen in England. Never would the director of our National Gallery feel free to turn on all the lights in the middle of the night no matter whom he might wish to please. If lights were seen on in the middle of the night at the National Gallery in London there would be questions in Parliament the next day or something like that!' Anyhow this was a wonderful farewell evening seeing the Egyptian, the Etruscan, and all the other marvelous sculptures at The Metropolitan.

«Before leaving England I knew that I wanted very much to see the Barnes Collection in Pennsylvania because I had heard how fabulous it was with its 80 Renoirs and so on. In fact I was carrying an introduction to Dr. Barnes from my friend Kenneth Clark. When I got to New York one of the first things I told Alfred Barr was that I wanted very much to see the Barnes Collection. He said: 'don't show or send any letters of introduction from museum directors or critics. Barnes just hates them. It would be much better if you tried to contact him personally.' And so I thought, this is the only thing to do. Next day I was somewhere in the museum with Dorothy Miller discussing some details of the exhibition when she received a phone call from René d'Harnoncourt who said 'I know that Henry wants to see the Barnes Collection. Barnes is just about to come to my room now. I've had a message that he's coming to see me right away. Why don't you ask Henry to come into my office in a few minutes so that I can introduce them to each other.' So Dorothy and I went down there a few minutes later, and sure enough, there was René and Dr. Barnes with two of his

body guards who looked just like Chicago gangsters. D'Harnoncourt said 'Dr. Barnes, may I introduce Henry Moore.' And I said 'I'm so pleased to meet you, Dr. Barnes, because I was about to write to you since I would love to come, if I may, and see your fabulous collection.' And for about a minute there was dead silence. Then he said 'such exaggerated flattery makes me sick.' I was taken aback and didn't say a word in reply. Even his body guards looked aghast. So did everyone else in the room except Barnes, of course, who let another minute go by—it seemed more like five minutes to us—and then he said, 'well, when would you like to come?' I said, 'well, anytime you like because I really do mean I want to see your collection. What I said was true. I have heard fabulous reports about it.' He then looked at his diary and he picked the exact day of the opening of my exhibition and said, 'come on the 17th.' At first I was a bit startled but told him, 'all right, Dr. Barnes, I'll come providing that I can get back here by seven o'clock because the opening of my exhibition is on the same day.' He said, 'I'll see to it.' So I went there on that day and he sent someone to the station at Philadelphia to meet me and from then on in he couldn't have been any nicer. He went around the whole collection with me. Then he let me wander about while there was some session going on with a number of students. He asked me whether I would say a few words to them. I agreed as long as it was only a sentence or two to tell them how pleased I was to be there and how lucky they were to have such a long time to visit and study the collection. And then he gave me lunch, presented me with one of his books on Renoir and a bottle of whisky. He put me back on the train himself, certainly in time for me to be back at the hotel to change for the opening. So, this is my Dr. Barnes story.

«He was fine. I think his dislike wasn't of artists at all. It was the art world he always quarreled with. I discovered afterwards that Alfred Barr had never been admitted to the Barnes Collection. Barnes just feuded with museum people and critics.»

Between museum visits and parties there was always some shopping to be done for Irina and little Mary, sprees in which Marjorie Morse and Jane Sabersky, both associates of the Valentin Gallery, were most helpful. Moore also spent a day in Washington where he enjoyed long visits to the National Gallery, the Duncan Phillips Collection, and to Dumbarton Oaks where he admired a good many Pre-Columbian pieces owned by Mr. and Mrs. Robert Woods Bliss.

Scribbled pencil entries in Moore's rather chaotic little notebook show that on a typical day—December 12—Moore managed to spend the morning at the museum, lunch with Alfred Barr, visit Ala Story's British-American Art Center with George Dix, the Pierpont Morgan Library with Hanns Swarsenski and Peter Gregory, the Frick Collection with Curt Valentin, pay a call on his old friend Peggy Guggenheim, and stop off at Bill Hayter's etching school on the way to dinner at Allene Talmey's of *Vogue Magazine.*

In a recent note written by Swarsenski, the eminent Boston art scholar, he vividly recalls the visit to the Pierpont Morgan Library:

«I had arranged for that visit with Miss Belle da Costa Greene, the director of the Library. I had asked her to show us the more important English Romanesque illuminated manuscripts, such as the Judith Missal, the Life of St. Edmund and the leaf from the Winchester Bible. Belle Greene received Henry most warmly and then we spent more than one hour looking at and admiring the miniatures. In front of one of the miniatures in the Life of Edmund, Moore loudly exclaimed: 'Here England was great and it will be great again.' He left deeply moved.»

On Thursday, December 19, Moore and Gregory went to Boston where they were met at the Boston Museum of Fine Arts by the great scholar-collector Paul Sachs. Here they spent a good deal of time seeing that institution as well as the Fogg and Peabody museums.

*Carvings dominated galleries at 1946
Museum of Modern Art show
installed by René d'Harnoncourt.*

*Sensation of 1946 Moore show at
Museum of Modern Art was 75-inch
elm wood* Reclining Figure *1945-46.*

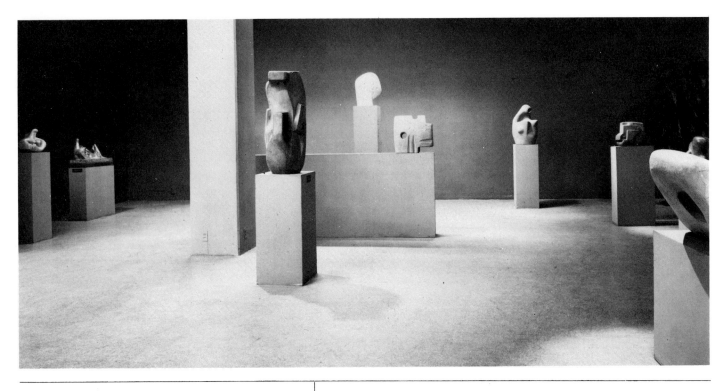

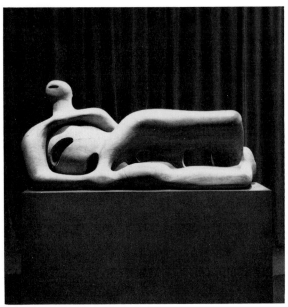

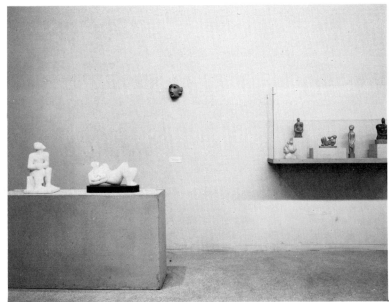

There was a warm reunion for Moore with Bauhaus founder Walter Gropius who had settled in Massachusetts after some years spent in England following his escape from Germany.

By the date of his Boston visit Moore had recovered from the hectic activities of the exhibition's opening two nights earlier which Dorothy Miller remembers as very crowded and very gala.

«All our openings during the war were naturally extremely informal, and this was a pleasant thing. I always like to go to our informal evenings better than to our fancy ones. At Henry's opening a very funny thing happened. René d'Harnoncourt loved to put sculpture rather low in his installations. I don't know why that was, since he himself was six foot seven, one would rather expect him to put things a little too high for the average person. But when we walked into the Moore galleries the night of the opening, there were hundreds of people there but none of the sculpture was visible because it was surrounded by a mass of human bodies. Only one piece, a stone head, was way up high on a pedestal. I remember that my husband, Arshile Gorky, and I went to that opening together from downtown. We were all feeling very gay and mischievous and we laughed heartily about the fact that it was an exhibition of people.

«Ala Story, Margaret Mallory, and Erica Anderson were making part of their film about Henry that night. I'm in it. It's my only appearance in any film. As soon as I got through the front door, somebody pounced on me and said, 'you must be in this. Walk up the stairs to the third floor with Henry, talking, and then pause on the landing about the pieces that are there.' I remember particularly that we talked about that beautiful elm wood *Reclining Figure* that the Albright Art Gallery had bought. It was right in the center of the landing. I must say that Henry seemed extremely happy that night. And that made it all worthwhile. It is nice to know that he still has such good and vivid memories of that show and that visit so many years later.

«Truthfully, I don't remember anything specific about Gorky's reaction, but I think everyone in general was deeply impressed with Moore and his work. It was something we hadn't seen here at all before, except for the smaller shows at Curt's, the Albright piece and the few sculptures we had shown at the Modern. It was really his first big exposure, his first top-notch museum show.»

Spending a weekend at Alice Harding's in upstate New York, Moore visited the Franklin D. Roosevelt home at Hyde Park but did not meet Mrs. Roosevelt. Having spent a quiet, warm, and friendly Christmas with the George Dixes on their Virginia farm, near Washington, Moore and Gregory returned to New York for two days of hectic shopping and gallery visiting.

There were books to get, suits to buy, and the crowded notebook also shows that Moore bought his wife not only a necklace but a pressure cooker and that in addition to a toy tea set there was baby food to be bought for little Mary. And Moore eagerly obtained exhibition catalogs that were still unavailable in England, although his own was not to be ready until the New York run of his exhibition was almost completed. All in all, the two travelers had piled up quite a few things to take back home. Dorothy Miller remembers that Henry Moore and Eric Gregory departed by boat at mid-afternoon on December 27, 1946:

«At whatever festivities were taking place the night before, it became evident that these two men were going mad because they couldn't pack their bags with all the things they had bought to take back to people in England. So Margaret Barr and I volunteered to go there early the next morning and pack for them. When we got to their rooms at the New Weston, we saw that it was indeed an impossible task. The first thing we saw was that they needed at least two more suitcases so we ran out and bought them. Then we organized things

and got them packed just in time to have a hasty lunch with Curt and the two travelers, and then we saw them off on the ship.»

On March 15, Valentin—who correctly foresaw the exhibition to be a tremendous stimulus to Moore acquisitions in America that continue to this very moment—wrote to his new friend:

«Your exhibition at The Museum of Modern Art closes tomorrow. What a sad day! I am sorry that I will no longer be able to go and look at your work once in a while. But I will go once more, this afternoon or tomorrow. As you know by now, the exhibition was a great success and honestly admired by a great many people. As usual the catalog just came out yesterday. It looks well and I asked to have copies sent to you immediately.»

There was, of course, extensive press coverage of the Moore exhibition even before it opened. In a tremendously enthusiastic advance piece *Art News* editor and publisher Alfred M. Frankfurter astutely pointed to the spiritual and aesthetic connections Moore has always had to the fourteenth-century sculpture of Giovanni Pisano and the twentieth-century poetry of T. S. Eliot. Excerpts from his preview exemplify his rather lavish prose:

«Thirty years ago, while he was still alive, Rodin would have been pointed to without question as the influence which would mold the coming hundred years. Fifteen years ago, his pupil, Brancusi . . . would have been so named. Today we can see clearly that what seemed the vast revolutionary strides of both these artists were but pointing the way, and that a sculptor, who like Bernini was a baby as the new century came in, is the one whose inherent greatness of vision and the innate power to realize it in full makes him the formative force of the 20th century.

«He is, of course, the Englishman Henry Moore, who, though he has been fragmentarily seen in America over ten years, now receives his first adequate exhibition over here . . . in the twentieth century whose endless complexity of vision has caused it to lose its sights, the blind eye must create the empty forms, create the reality which is now here to be seen amid the dense confrontation before the open eye. If the sculptor wants to create as well as to sculpt, he must transcribe the unseen, exchanging the exterior aspects of beauty for the inner austerity of truth. If he takes this not as licence but instead as discipline, he must follow a narrow path indeed, for discipline implies laws made by tradition, no mean handful to be overthrown.

«Out of this premise rises the eminence of Henry Moore. The proof lies in the level, however varied, arrived at in his sculpture of the last ten years or so, which occupies the forefront of this exhibition. Corollary are his earlier sculptures as well as his drawings and watercolors, more familiar to Americans, which together constitute the evidence of his origins.

«. . . his earliest works at once show two characteristics: his intense feeling for the functional quality of his material, and the influence for the cult of the 'primitive' especially Pre-Columbian American sculpture, then prevalent in Paris. By 1930, however, he had assimilated this influence so thoroughly that now it appears to have been rather one impulse toward a way of thinking about sculpture than a direction of style.

«During the past decade, in any case, it is evident only as a single root of his mature style. In this period Moore has practiced, side by side, what may, for ease, be labeled an abstract . . . and a naturalistic means of expression. Yet both are based on an identical philosophy, and their punctuation, so to speak, depends exclusively on their final function—no less . . . than a like duality on the part of T. S. Eliot in . . . the abstract quality of *Ash Wednesday* and the naturalism of *Murder in the Cathedral*.

Three Standing Figures, *1945*
Bronze
h. 8¾ in. (22.2 cm.)
Mr. and Mrs. Hal Wallis

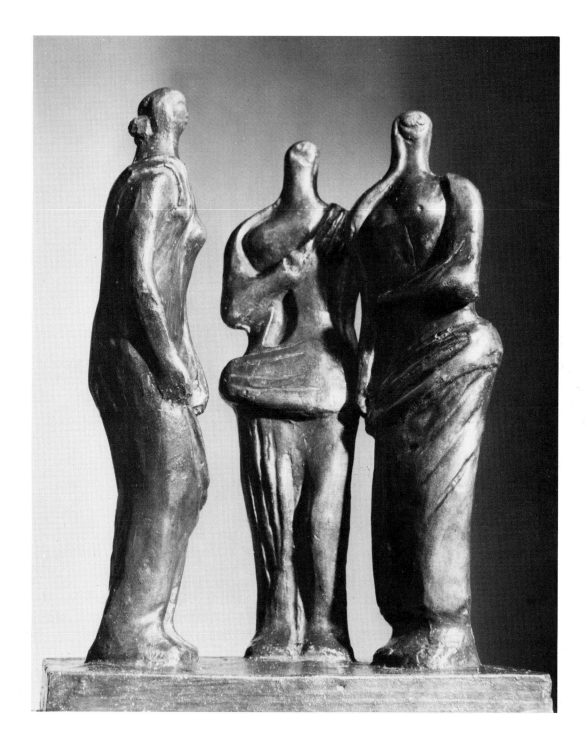

Reclining Figure, *1945*
Bronze
l. 16 in. (40.6 cm.)
Mrs. Leona Cantor

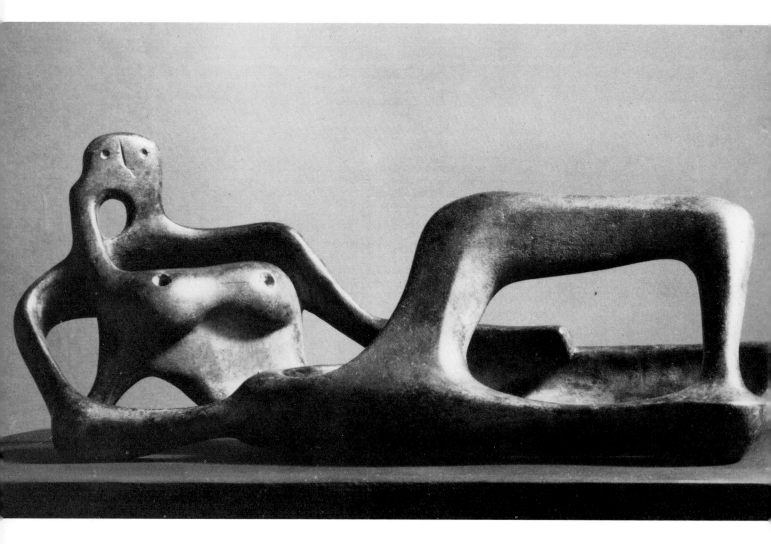

Family Group, *1947*
Bronze
h. 16 in. (40.6 cm.)
Mr. and Mrs. Frederick S. Weisman

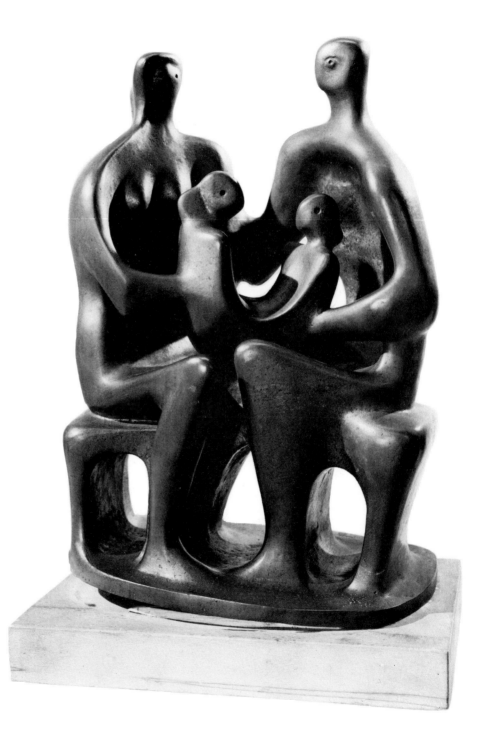

Double Standing Figure, *1950*
Bronze
h. 87 in. (221.0 cm.)
Vassar College, Poughkeepsie, New York

Rocking Chair No. 3, *1950*
Bronze
h. 12½ in. (31.8 cm.)
Private Collection

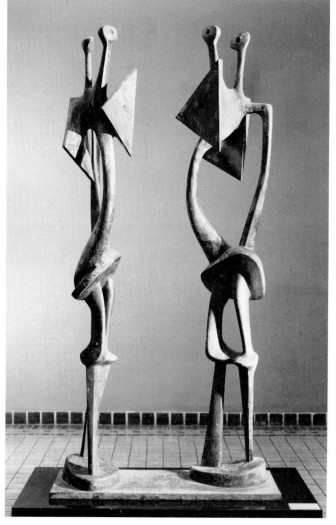

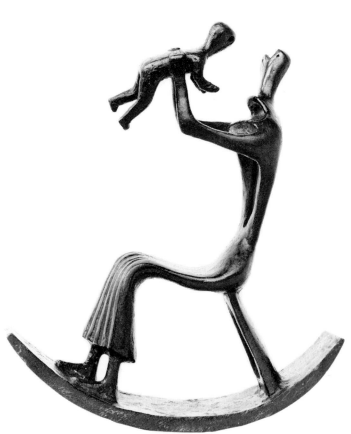

King and Queen, *1952-53*
Bronze
h. 64½ in. (163.9 cm.)
The Joseph H. Hirshhorn Museum
and Sculpture Garden,
Smithsonian Institution

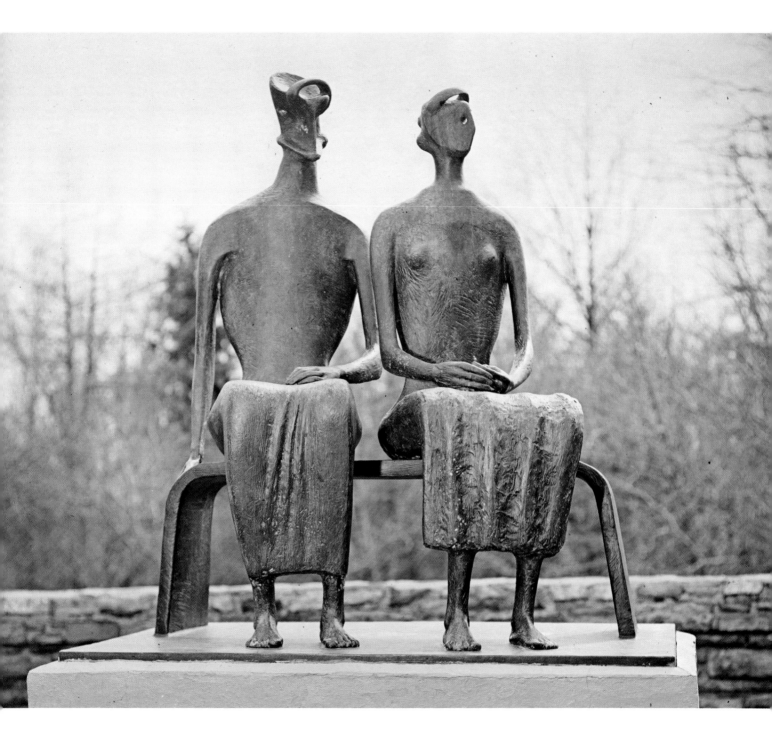

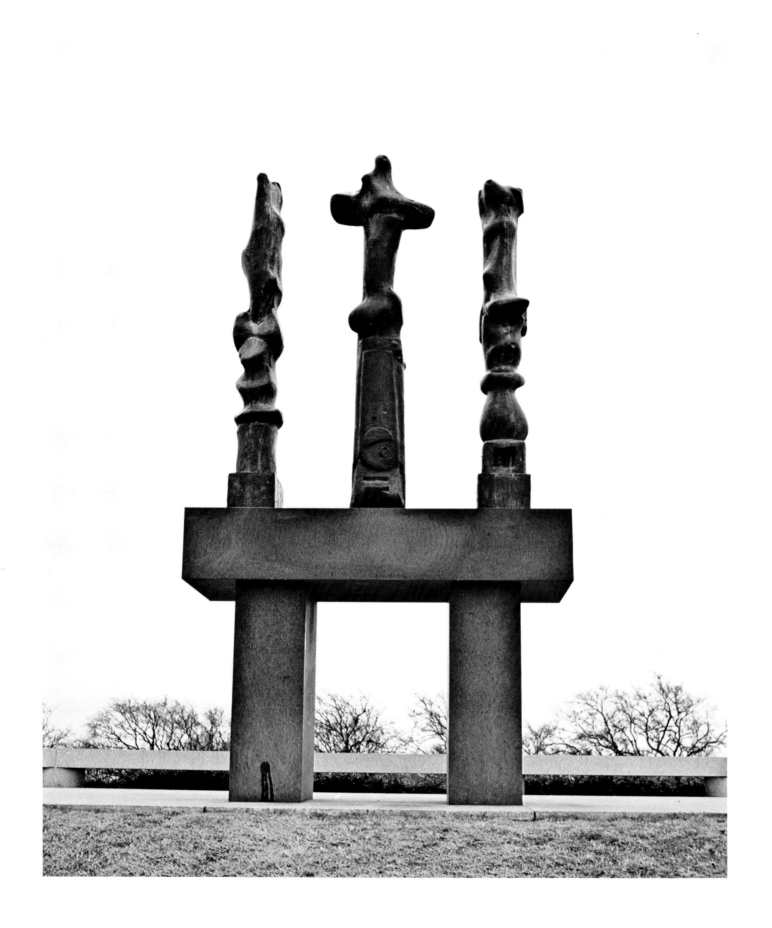

Upright Motives, *1955-56*
Bronze
l. 126 in. (360.0 cm.)
Courtesy Amon Carter Museum of
Western Art, Fort Worth, Texas

Reclining Mother and Child, *1960-61*
Bronze
l. 86½ in. (219.7 cm.)
Rita and Taft Schreiber
Beverly Hills

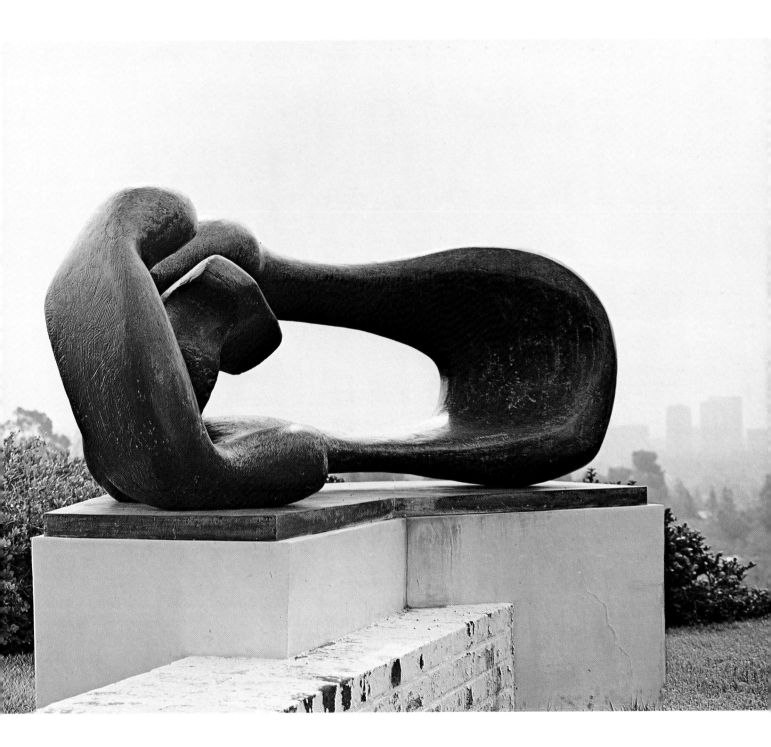

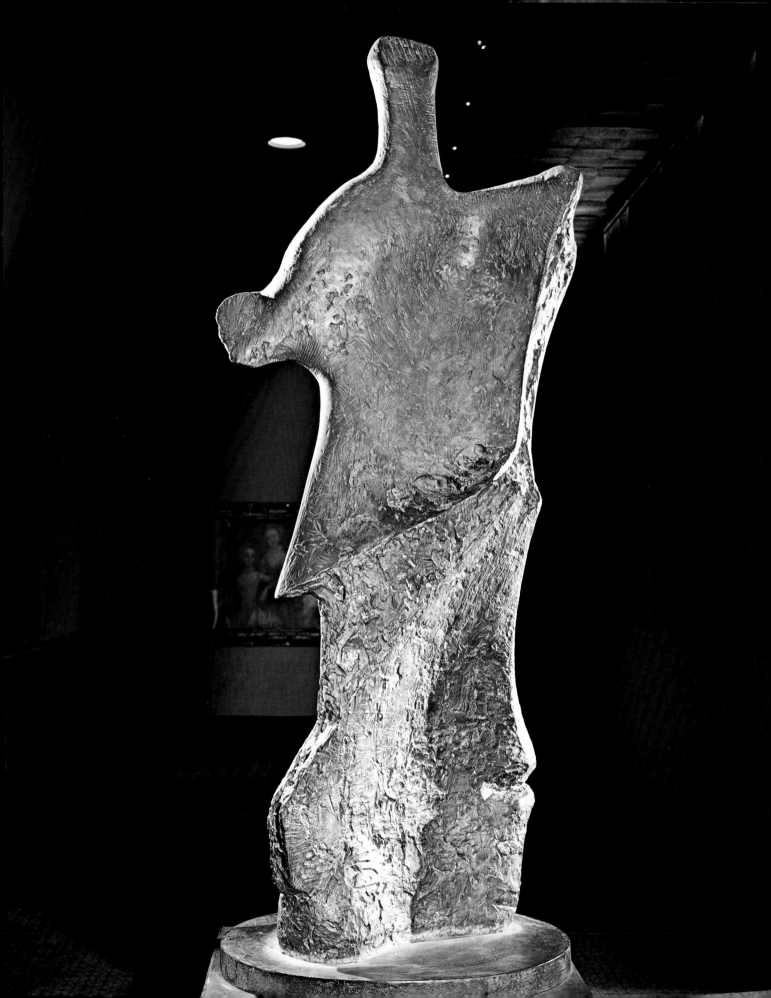

Standing Figure: Knife Edge, *1961*
Bronze
h. 112 in. (284.5 cm.)
Norton Simon, Inc. Museum of Art

Helmet Head No. 2, *1950*
Bronze
h. 13½ in. (34.3 cm.)
Dorothy and Richard Sherwood

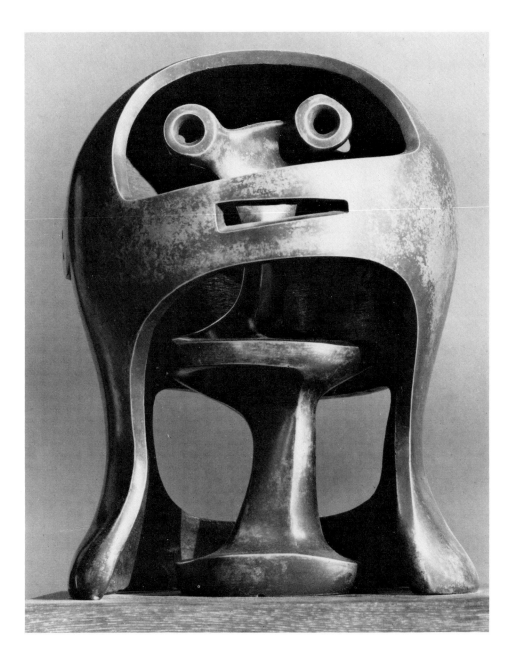

Animal Head, *1951*
Bronze
l. 12 in. (30.5 cm.)
Rita and Taft Schreiber

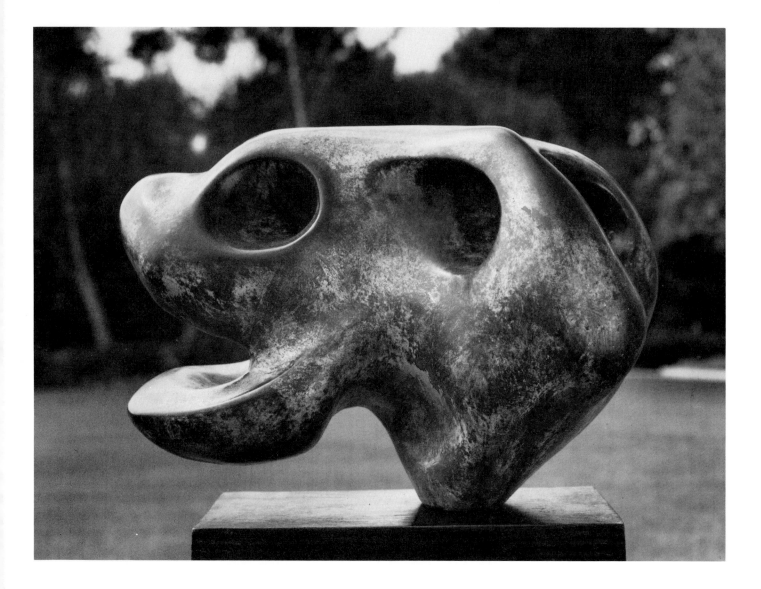

Leaf Figure No. 3, *1952*
Bronze
h. 19½ in. (49.5 cm.)
Mr. and Mrs. Stanley K. Sheinbaum

Leaf Figure No. 4, *1952*
Bronze
h. 19½ in. (49.5 cm.)
Mrs. Dolly Bright Carter

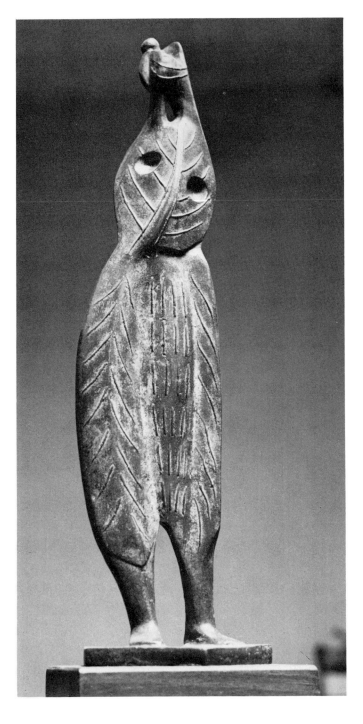

95

Maquette for Reclining Figure
No. 4, *1952*
Bronze
d. 21¾ in. (55.2 cm.)
Private Collection

Mother and Child on
Ladderback Chair, *1952*
Bronze
h. 8½ in. (21.0 cm.)
Mr. and Mrs. Hal Wallis

Time-Life Screen: Maquette No. 4, *1952*
Bronze
l. 13 in. (33.0 cm.)
Mr. and Mrs. Ira Kaufman

Maquette for Warrior—Without Shield
1952-53
Bronze
h. 7¾ in. (19.7 cm.)
Mr. and Mrs. Stanley K. Sheinbaum

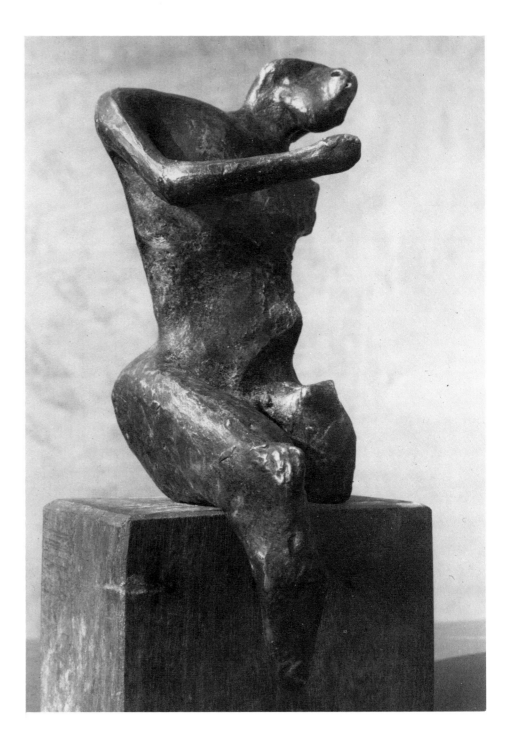

« . . . For the first great British sculptor in 500 years since the anonymous Perpendicular Gothic genius who originally carved the corbel-portraits inside the Chapter House of Salisbury Cathderal, the native tradition, however unconscious, seems a stronger natural motivation than any other. For Henry Moore, it continues through the soundly abstracted funeral brasses of the English cathedrals right up to the metaphysics of Blake's watercolors mystically wed to poetry. No closer parent than the latter exists for those magnificent form drawings of Moore's which are also imaginative visions—from the notebooks with which the sculptor has always continuously recharged and reinforced his plastic vision while he was long at work on a big commission.

«Last summer, I visited Henry Moore at his studio on a farm in Hertfordshire . . . and saw most of the sculptures which are, at this writing, still on their way over here. . . It was for me, as this exhibition will be for most Americans, an inverted experience . . . having known the drawings first along with a few of the early abstract sculptures. It became, however, an unforgettable occasion, apart from the deep pleasure of knowing the man himself—kind, sincere to a rare degree in a veiled society. Alive with ideas and strength, undidactic, in short with all the seldom encountered marks of greatness. The other wonder was the range and breadth of forms and materials which has come from his hand. . . . »

Less in tune with the contemporary art developments of the moment and often critical of Museum of Modern Art exhibitions and acquisitions, *Art Digest* associate editor Josephine Gibbs wrote on January 1, 1947:

« . . . There is no question that James Johnson Sweeney's selection and arrangement of Moore's work, now on view at The Museum of Modern Art, and the most comprehensive exhibition (of his work) ever to be held even in England, displays the artist to the best advan-

tage, but Mr. Sweeney had some of the most exciting material with which to work that has been seen here in a long, long time.

«Moore himself freely admits his 'influences'—African Primitive, Pre-Columbian, Medieval, Sumerian and an admiration for Picasso. Most are recognizable, singly or in combination, at some time during the 24-year survey of his career. The eerie part of it all is how little this electicism matters. It is a sprinkle of salt and pepper on a dish indigenous to Britain long before roast beef and suet pudding. Beneath the surface, creatively expressed most often in semi-abstract figures, is a force elemental and universal on one hand, and frighteningly a part of the primeval history of that tight little island at the same time. Nature, the elements and man get all mixed up. Do the rocks and trees whence these sculptures sprang resemble man or vice versa?

«Another remarkable feature of Moore's work—or perhaps a natural outgrowth from the base on which it stands—is the fact that the tiniest sculpture, 5 ½ inches tall, has a quality that makes one wish the word 'monumental' hadn't been so loosely used in the past. The small 'Madonna and Child,' a study for Saint Matthew in Northhampton, England, and three family groups, one seven and another six inches high, are as large in conception as the huge elm wood figures. For sheer size and elemental power, the crescendo builds up to the over six-foot elm wood *Reclining Figure* completed in 1940, subsides during the war years, then reaches another climax in another enormous elm wood figure completed just this year which amply demonstrates the artist's contention that 'a hole can itself have as much shape meaning as solid mass.' »

Among friends and admirers whom Moore sought out during his first American visit were Andrew Ritchie and his wife Jane. At the time Ritchie was the director of Buffalo's Albright museum, the institution which has shown the most consistent interest in Moore's work

since the tenure of his predecessor, Gordon Washburn, who was the first to purchase a Moore sculpture for an American museum. In 1946, Ritchie had included a number of Moore's shelter drawings in the Albright's «British Contemporary Artists» exhibition. More than twenty years later, in his position as director of the Yale University Art Galleries, he was instrumental in obtaining Moore's monumental *Seated Woman* (1958) to be placed prominently in the yard near the galleries. Although Ritchie did not personally become acquainted with Moore until the immediate post-war period, the Scottish-born museum director became aware of Moore when the artist's reputation was limited even in his native England.

«I happened to be in England during the years 1933-1935 when the group called Unit One, which included Moore, Barbara Hepworth and Ben Nicholson, sort of verbally led by Herbert Read, was making some impression on London. In one of their shows I saw one of Moore's first semi-abstract pieces deriving from a fraternal feeling for constructivism which Unit One really represented in England—a sort of carry-over from the Russian and Dutch Constructivist movements. Somehow Moore's work is never without deep feeling for the human figure. That was true from the very beginning, but at that moment in the early thirties, he had reduced that feeling very seriously in these very abstracted forms. The war years appear to me to have furthered his enormous empathy for the human struggle. It re-awakened his feeling for the direct formal and emotional treatment of the human figure, or more particularly the female figure. It may well be that his recurring emphasis on the woman, the earth mother, forms related to the woman in the round and his ability to work within and through the woman, the implication of the womb—that all these basic concerns of his sculpture, so prominent in the period right after the war, represented his response to the war and his strong feeling for the everlasting quality of mankind.

«Moore's sculpture of the early forties also impressed me with the fact that his father had been a miner, that he'd come from Yorkshire and from a mining community. I myself came from a very tough mining community near Glasgow, so I had a particular sympathy for his approach to the cutting of coal and stone, the digging into the figure, as it were, as you would dig into the earth, the pantheistic feeling of the permanence of rocks, the memory of the druidical quality of many standing stones in and about England and Scotland —all of these things seem to me to come to a head in his work.

«The slag heaps near his native Castleford that Moore recalls having been much impressed by when he was little do seem enormous on that fairly flat landscape. You have to remember that these mountains of debris from the mines have been growing ever since the 19th century—the oldest almost since the very beginning of the Industrial Revolution, well over 100 years. So they appear almost like pyramids because they have a planned, pointed character.

«When I first became aware of Moore's work, I was studying British medieval art. It was perhaps because of this strong feeling I had for it that I felt very sympathetic to Moore at once. My eyes hadn't been sullied by academic British sculpture which on the whole, say from the 14th century right to the 20th, is pretty feeble stuff compared to continental sculpture. So he was an excitement to me as a medievalist even forty years ago. From then on I never ceased to watch his progress.

«I do feel that one of the touch stones for a critic in measuring potential greatness in painting and sculpture is the increasing adventure-ousness of the artist. A potentially great artist does not establish himself in a pattern and keep to that, instead he's kept moving, sometimes in one direction, sometimes in another, sometimes being more naturalistic, at other times more abstract, but always growing.

«Now the most important thing to me is that his very latest shows have revealed Moore at his greatest potential. If you're greater in your

seventies than you were in your thirties and forties, then you really have something. It seems to me in his very recent pieces—like the marble *Stone Memorial* bought by Paul Mellon for the National Gallery—there is a great deal more tension, really almost a brutal force. I have been trying to think; within these last seven or eight years Moore has produced work that seems more dramatic than what he had been doing for a good long time before that.

«My own feeling is that for a long time he was reworking ideas and some of them had become overly familiar to him. In a sense, I think, he had become sort of isolated, too, because there is really no direct relation between his work and that of the younger sculptors. As happens with any great figure, the younger generation feels that they're under a cloud, that they have to somehow find their own direction. It might not be as strong a direction as the master's might be, but, nevertheless, they have to find their own identity. In the process, the master gets isolated, too. There is, for instance, the tremendous influence of González and Picasso, with their metal drawing and space sculpture, as it's called, which really took over after the war. Moore didn't feel particularly sympathetic to these new approaches and materials. He's strictly a carver from the beginning. Even though he's done so many bronzes, he is still a carver. I think that's essential to understanding his work.

«In my mind there is certainly no question that Moore is the greatest sculptor that has appeared in Britain for 600 years and one of the truly great 20th century masters.»

Ritchie attributes the long hiatus in British sculpture to the reluctance of the Elizabethan court to accept the dynamic Renaissance conceptions of sculpture, preferring to linger with a rather weakened taste for less and less forceful Gothic art—a taste that carried right into the eighteenth century in England. He points out that Westminster Abbey's tombs and other important British public sculptural

monuments were executed by second-rate foreign sculptors for many centuries.

«You just have to look at the Albert Memorial in Hyde Park to see just how low sculpture can fall. The surprising thing is that it took so long for a first-rate sculptor to appear on the English scene. Someone had to come. Perhaps it's because England's long refusal to accept all but its most academic artists, and that strange attitude that long treated art as something un-English. You could only import it. So we find centuries during which England maintained a very strong literary condition. But the visual arts were kept in pretty poor shape by the British mind, except during that rather vulgarly expressive phase of the 19th century when the Pre-Raphaelites managed to get some patronage from the industrialists of Birmingham and Manchester— but that school wasn't strong enough to sustain itself for very long. It was Moore who somehow realized that it was time for Britain to catch up with what had been happening on the continent and to fashion his own very personal language out of sources like Mayan and Cycladic art that had earlier attracted innovators like Picasso.»

Ritchie, recalling the amazement and opposition he found to his purchase of Moore's work during a luncheon at King's College, Cambridge, even twenty years ago, attributes Moore's slow rise to recognition to an almost total blindness of the most authoritative British public when it came to modern art. Despite the early and constant support given Moore by such influential art leaders as Herbert Read and Kenneth Clark, there were few purchases and fewer commissions for Moore in England until the advent of his international fame triggered by The Museum of Modern Art retrospective and the 1948 Venice Biennale Sculpture Award.

It was some time before Moore's rise to fame that Ritchie went to see him in Much Hadham in connection with the exhibition of

works by English artists that he was organizing for the Albright museum. At that time Ritchie received the impression of Moore as a man of enormous creative energy but fairly limited success.

«He and his family were living in a relatively small house with a simple English garden background up in Hertfordshire in Much Hadham. Over the years, having gone to see him nearly every year, we have become good friends. I've not only seen the progress of his sculpture but the progress of his property, acre by acre, until he has now the equivalent of a large public park much of which he has generously willed to the National Trust to provide the Tate Gallery with a place where his large outdoor sculptures can best be shown and where future generations will be able to see where he carried out such an enormously productive life.

«Having known Henry for a good many years now, I think he is the most deceptive person one could possibly meet. As a great sculptor, and one without any false modesty, he has an extraordinary humility which is very disarming. He has a very definite mind of his own. He knows exactly what he is doing. He will always know what direction he is going in and turns out to be self-analytical to an extraordinary degree. The clarity and simplicity of his language regarding his art is quite extraordinary. And it is amazing the feeling of discovery and the continuing living innocence he maintains even at his age—another quality of greatness.»

Ritchie recalls that physical vigor into advanced age has been a characteristic of many great sculptors from Michelangelo to Rodin and Maillol. Sculpture, particularly carving, takes physical strength, yet the continued physical activity is a health-giving factor.

«In considering his enormous energy and vigor, I'd almost go back to my original feeling about his father being a miner, having seen so

many miners myself. Having to crouch in seams of coal and live underground so much of their lives, they tend to be broad and husky but not particularly tall—an extraordinarily strong and tough breed of men.»

In 1952 Ritchie went back up to his native Scotland to see the way collector W. J. Keswick had placed Moore's magnificent *King and Queen* on a hilltop overlooking heath and moors.

«To see that extraordinary work in such a matchless site gave me the best impression of what really monumental sculpture could do outdoors. It led me to think that Moore was clearly coming to be the leading outdoor sculptor of our time, and he has grown in stature ever since. His work seemed more at home outdoors than indoors. When I assumed the directorship of the Yale University Galleries in 1957, one of the first things I wanted to do with our own court was to buy a major outdoor Moore. By 1959, I had secured a donor who was willing to help us back the outright purchase of a piece. We first looked at the large bronze which derived from the UNESCO piece which was being shown at the Carnegie Institute but that turned out to be unavailable. One day the donor, Alex Hillman, and I made a very sudden decision to fly over to England and to go right to Henry's studio. There we saw and bought the fine piece called *Draped Seated Woman,* 1958, which you can now see outdoors here at Yale.»

Dealers
and
Collectors

It was Curt Valentin who convinced such major collectors as R. Sturgis Ingersoll, G. David Thompson, Nelson Rockefeller, and Joseph H. Hirshhorn of Moore's greatness. This he accomplished in the years just preceding and during the months following The Museum of Modern Art exhibition—which later traveled to the Art Institute of Chicago and the San Francisco Museum of Art.

In his privately printed *Recollections of a Philadelphian at Eighty,* the patrician attorney and collector Ingersoll writes:

«I have no recollection when I first heard Henry Moore's name. In any event, in the depths of the Depression—I believe in 1934—I was in London. I wrote him a note asking him if I might call. He answered courteously, and I found my way to his house in the suburbs of London. In those years he was but a little known artist. I enjoyed high tea with him and Mrs. Moore. His house and garden were filled with his work, mostly in wood and stone. At that depressed time there was no market for his sculpture, and I was financially strapped. I admired, but no thought of a purchase was in my mind, and if there were a hope in his, the hope was not disclosed.
«Through the years we kept somewhat in touch with each other. I always felt guilty about our first meeting, thinking that when I contacted him, he and his wife probably felt that here comes an American millionaire collector who will lift us out of our difficulties.»

Yet Moore regards Ingersoll with affection and admiration. Despite his failure to buy any work from him during their first encounter, the Philadelphian remains in Moore's mind «the first American collector who ever paid attention to my work. His visit greatly pleased Irina and me.»

In the late forties Ingersoll bought a major *Reclining Figure* from Valentin which he gave to the Philadelphia Museum of Art in 1968. His influence was also felt in the acquisition of *Three Way*

Piece No. 1 by the Fairmont Park Art Association. This monumental work is now installed in Philadelphia's Kennedy Plaza.

Recalling the close collaboration between himself and his late wife Marion in their widespread art collecting activities, Ingersoll writes in his memoirs:

«We had luck in falling into a close friendship with Curt Valentin, a dealer of such enthusiasm, honesty and taste . . . he specialized in sculpture. We had a large lawn. Why not furnish it with sculpture. This we did! With immense pleasure to ourselves, Curt would frequently spend weekends at Forest Hills Lodge, and I often saw him in New York. Little by little our lawn had many guests—Rodin, Picasso, Epstein, Flannagan, Moore, Duchamp-Villon, Lipchitz, Lachaise, Marcks, and others. They found themselves at home with a resultant beautiful area of art.»

Shortly after Valentin's death, Ingersoll wrote to Moore:

«We have suffered a deep loss here in the death of Curt. I do not know whether you, 3000 miles away, can imagine the immense part he played in our lives here as between artists and non-artists like myself. You well know he had the most profound admiration for you as an artist, and a deep, deep affection for you as a man.
«Yesterday afternoon I went over to New York just for the purpose of visiting the gallery. Curt had planned an opening of painting and sculpture just covering his favorites. He planned to arrange it on his return. Miss Wade, however, bravely took over and has on view a charming exhibition. For two hours in the gallery I pondered on the pleasure and inspiration he had given us, and the immensity of the loss. There is a plan afoot to give a memorial exhibition in the gallery itself, to consist only of loans from American museums of objects acquired through him. I think it a delightful idea.»

It was in answer to Ingersoll's letter that Moore wrote on September 14 describing his brief journey to Italy. There he was among a handful of close friends who on August 24 paid their last respects to Curt Valentin:

«I was able to get out to Italy to attend the funeral. Altogether there were sixteen or seventeen of his close friends there. Most of us arrived in Forte dei Marmi the day before the funeral, and we gathered together the next morning at Pietrasanta, where Curt had died the previous Thursday in a hospital. The coffin was in the hospital mortuary and was entirely covered and surrounded by baskets and bunches of flowers. Henry Kahnweiler spoke for five or ten minutes about Curt and then Alfred Hentzen spoke for the same length of time. Both very beautifully, and although this could not be called a religious ceremony, it was most moving.

«We then followed the coffin to the little cemetery at Pietrasanta, which is wonderfully situated underneath the mountains, and in the warm sunshine the coffin was put in the vault and the temporary plaque, with Curt's name and dates, put up. Then most of us went back to Marino Marini's house and gradually, throughout the day, dispersed back to our various parts of Europe.

«Curt and I were almost in daily correspondence, just before he died, over my exhibition which had been planned for this October. After he died I took it for granted that the exhibition would not take place, but I hear now that his secretary, Jane Wade, and his executor, Ralph Colin, intend to keep the gallery going and so I shall have my exhibition with them in October. The gallery can't and won't be the same but I think it is better for everybody that they should attempt to keep it going than it should end suddenly.»

Following his wife's death in 1968, Ingersoll saw to it that the extraordinary sculpture collection they had acquired should never be

dispersed. He promptly donated eight of the most distinguished works to the Philadelphia Museum of Art, recording in his memoirs:

«I do not like to write in terms of money, but as reflective of the new enthusiasm for art in America, it is perhaps important to note that those eight pieces cost me about $50,000; on giving them to the museum, they were appraised for tax purposes at $990,000.
«Shortly after Marion's death I went to London. My spirits were at low ebb. On entering the Ritz, I ran across Moore; Jim Sweeney, the museum man; Hirshhorn, the American collector; and Sir Philip Hendy, the director of the National Gallery. They had been celebrating Henry's 70th birthday. They insisted upon my joining them in reestablishing the party. We drank plenty of burgundy, and I felt like a new man. Henry, the son of a Welsh miner, is as charming, cultivated and courteous a gentleman as I have ever known.»

Quite in contrast to Ingersoll's courtliness is the dynamic brashness of Joseph H. Hirshhorn, a tireless and unjustly maligned collector, whose enthusiasm for Moore is second to none. As a result of his giving his extensive collection to the nation, the soon-to-be completed Joseph H. Hirshhorn Museum and Sculpture Garden will constitute the single most important holding of Moore's work in the United States. Having acquired more than seventy Moore sculptures and drawings during the past twenty-five years, Hirshhorn recalls:

«The Modern's show came, I think, about a year after I bought my first Moore sculpture from Curt Valentin. When I first met Henry not long after that, he left me with a wonderful impression because of his simplicity and his sincerity. I have been a constant admirer of Henry Moore ever since, and we have become good friends. On several visits he has stayed with us in my home at Greenwich, Connecticut where a cast of the *King and Queen* stood in the garden. Every

In his Much Hadham living room Moore converses with American collector Joseph H. Hirshhorn.

time I think back, it always makes me wonder that he was, at the time we met, one of the greatest but not yet widely recognized artists. «He has often told me how American museum people and even the general public over here have been of tremendous help in establishing his international reputation. With a few notable exceptions, there was no large English following for Moore from the start. But once Valentin introduced his work over here, and especially during his remaining years as Moore's dealer after The Museum of Modern Art show, his American following grew enormously and very fast.»

During the time that Hirshhorn controlled a large segment of Canadian uranium mining and commuted from his native New York to Toronto, his loans to Canadian museums were creating enthusiasm for Moore there. This eventually helped to inspire the establishment of the Henry Moore Centre for twentieth-century art, a project to be discussed in the concluding chapter of this book.

In 1952 Hirshhorn helped form the Rio Tinto Mining Company of Canada, Ltd., a branch of an eminent and staid British firm. In her revealing book *The Proud Possessors,* the late Aline B. Saarinen—whom Moore and Hirshhorn alike admired both as an extraordinary person and as a fine critic and writer—sheds light on Hirshhorn's personality:

« . . . in the process of trading his vast mining empire for a controlling share (55%) of its stock and chairmanship of its board, Hirshhorn, a brash, self-made business tycoon born on New York's poverty stricken East Side, came in intimate contact with such aristocratic Britishers as the late Earl of Bessborough.»

When the Rio Tinto meetings were held in London, Hirshhorn invited Moore to join him for lunch at the executives' large round table. Spending a whole hour discussing Moore's new work with his English business associates—although some had never, or had hardly ever, heard of their great compatriot—he assured them that «this is a great man here, a very talented man.» Looking back he reflects:

«They simply knew very little about living artists and their work, whether they were British or not. On the other hand, Henry Moore was terribly interested in business but he doesn't understand it. Of course, he knew that he had met some very nice people at that luncheon. A number of those business executives became very interested in what Moore had to say and, some time later, I gave eight out of the twelve directors a small little Moore sculpture, each as a present.»

With encouragement from friends, curators, and old customers, Jane Wade went ahead with a large Moore exhibition several months after Curt Valentin's death. It was the last show that this remarkable dealer had planned, and it included the *King and Queen.* This piece

had been purchased by the Uris real estate firm and had been returned when several of the major tenants in the building where it had been placed threatened to leave. Hirshhorn recalls his response upon seeing it in the gallery:

«When I first saw it, the piece had been sold. But some time later, here it was, back in the gallery, and I bought it on the spot. A lady who has now become a very important collector never got over the fact that I bought it the day after she had seen it. She was there the day before me, and she had gone home to ask her husband if she could buy it. But she didn't reserve it. I came in and bought it in 15 minutes. Later I lent it to the Toronto Art Gallery, along with a large *Reclining Woman* and the *Glenkiln Cross,* and other top Moores from my collection.»

Aline Saarinen reported that one day the customs officer called Hirshhorn at his Toronto office to inform the collector «he would have to pay heavy duty on the Moore sculptures he was importing to show at the gallery.» With characteristic impatience, Hirshhorn turned brusquely from the phone to an aide, said «hey—they want me to pay duty on the Moores. Do something. Get that law changed,» and went on with his conversation on the other telephone. Within nine months Canada had managed to repeal its tariff on contemporary art, a step which it had taken the United States Congress several years to achieve.

Hirshhorn believes that Moore finally gained the world-wide recognition he had long deserved in the middle-fifties. He is proud of the fact that his own avid support for Moore goes back a good many years before that time.

«I think that the war, of course, delayed a wider knowledge and greater acceptance of Moore's work. But I also think that the English

were slow to give him the recognition he deserved. It took the Americans, a handful of museum people, and collectors particularly, to stimulate the great interest that now exists for his work everywhere. That came way back in the early forties and grew in the early fifties. I know it, because I was one of them. Whether or not younger English artists followed him does not matter. It was Moore who revived the great interest in contemporary painting and sculpture in England. In that way he has had a tremendous influence. He will go down in history as one of the most important artists of our time—a man of great stature for the whole world, and especially for England. I feel that even now Henry is searching constantly. All you have to do is to look at one of his sketchbooks. When he is at ease, relaxed, not working on sculpture, he is sketching, reaching for new ideas. I think his art becomes more powerful all the time.»

Abram (Al) Lerner, director of the Hirshhorn Museum, has been curator of the Hirshhorn Collection since 1951. He points out that the museum's Moores date back as far as 1928 although Hirshhorn's personal purchases of Moore works began in the forties. According to Lerner, the collector bought a few pieces from the artist directly, others from the Curt Valentin Gallery, and still other Moore sculptures and graphics from such diverse sources as Leicester, Martha Jackson, Harold Diamond, Marlborough, Hanover, and Gimpel Fils galleries. Discussing exhibition plans, Lerner says:

«We will have more than 40 Moores in our inaugural exhibition. But I look forward to the time when it might be possible for me to organize a fairly definitive Moore exhibition, adding loans from other sources to our own holdings.»

As soon as Moore's fame had spread internationally, and especially after the closing of the Curt Valentin Gallery within a year of

the dealer's death, there was a scramble among important dealers on both sides of the Atlantic to control the market on his work. Undoubtedly Knoedler's, Marlborough, and more recently Harry Fischer, Ltd. in London have negotiated most of the major sales and nearly all the commissions for Moore's sculpture during the past twenty years. Yet Moore, even now, steadfastly refuses to bind himself exclusively to any one dealer.

He continues to have a very generous attitude to those galleries which first helped him achieve domestic fame in England and to other London dealers who have long admired and befriended him. And, he is careful not to have more than one dealer handling his work in any one particular geographical area—with the exception of London. Moore has consistently thought that his works should be divided up among the people who really were interested in them so that as many people as possible could have access to him and to his creative expression. Although his later associations have been with other, larger English and international dealers, Moore has always remembered the Leicester Gallery with gratitude for having given him his first important London exhibition, and, there is a small consignment of his works usually to be found both at the Gimpel Fils and Hanover Galleries while other London dealers are apt to obtain Moores from private sources or through auctions which have no direct connection to the artist himself.

After Curt Valentin's death, Harry Brooks—for many years at Knoedler's and more recently at Wildenstein—became Moore's foremost American advocate. A close friendship has developed between the two men who are constantly in touch with each other, and Brooks himself has a considerable collection of Moores. Nearly twenty years have passed since the beginning of their association. Although Brooks left Knoedler several years ago for Wildenstein, Moore did not follow him there until the Knoedler Gallery was sold to Dr. Armand Hammer and associates in 1972.

Together with the late Coe Kerr, then president of Knoedler's New York gallery, Harry Brooks examined the eighty-four Moore works in the Curt Valentin estate. Knoedler's chairman Roland Balay then initiated the gallery's personal contacts with Moore. Before Knoedler's purchase of these items from the estate, the two men traveled to Much Hadham to persuade Moore of the validity of Colins' suggestion. The complication was that Moore had not previously thought of Knoedler's in terms of contemporary art.

Although the dapper Brooks did not meet the artist whom he was to promote so effectively until that October 1955 visit, he had developed a keen interest in the work from the time it was first shown at the Buchholz—later the Curt Valentin—Gallery.

«By 1955, Henry didn't really need a close association with any one dealer, because by that time his reputation had been completely established. Besides, he had so many friends, really close personal friends and admirers in the group at The Museum of Modern Art, that he would have been able to do very well by himself. Although The Museum of Modern Art had previously always conducted their own negotiations with Henry, after Knoedler's came into the picture, they were extremely thoughtful and kind, in that they generally conducted negotiations for any Moore piece through me. For instance, we sold them one of the two *Reclining Figures* and the big *Arch* both generally to be seen in The Museum of Modern Art garden. The relationship with Henry Moore became for me a very warm and personal one because he is such an incredible human being.

«It is interesting to recall that for the fifty-eight drawings and twenty-six sculptures Knoedler's bought from the Curt Valentin estate there was no immediate market. They sold slowly, and actually, from a dealer's point-of-view, it was better for us because, as the demand for Moore works became greater and greater, we were always pleased to have these pieces in our stock to fall back on.

«My usual way of operating was to make at least two visits to Much Hadham a year, often together with Coe Kerr. With Moore's suggestions we chose pieces which I thought would be most interesting for the American collectors. Then these pieces would be sent on consignment to New York where Knoedler's would exhibit them.»

Coe Kerr, who later headed his own gallery which handled Andrew Wyeth and other major American artists along with European paintings, shortly before his death recalled that although Moore's reputation had been steadily growing, «it wasn't huge in 1954. The drawings were still relatively inexpensive at that time.» He stated:

«His reputation really ballooned three or four years later when people began to realize widely that he was the best sculptor on the scene at the moment and also a magnificent draftsman. Major books began to appear about him in different parts of the world and Knoedler's cooperative arrangement with the Marlborough worked out to everyone's advantage.
«Except for his visit during The Museum of Modern Art exhibition, his visits to New York have usually been very brief. He is always in a rush to get back home, back to work.
«Every time I went to London, I went out to visit him in Much Hadham which is a wonderful, very peaceful place. It had been great to see his property grow. I first saw it when it didn't have those magnificent back acres. And by now there he is, on the very top. He is, undoubtedly, one of the great artists of the century. Certainly I consider him to be the greatest sculptor of our time.»

This is an opinion enthusiastically shared by his former associate, Harry Brooks, who remembers that not all Moore sculptures were equally salable at first:

«I think at the beginning there was a reticence on the part of American collectors to accept some of the harsher forms in Moore's work. Every artist worth his salt is always way ahead of his collecting public. I find, myself, that sometimes the more brutal Moores are very hard for me to grasp at the very first. Then, after I have seen them for a year or two, they become very easy for me.

«Henry himself talks about the tough and the tender in his work. Initially, the tender was easier for the American collector although the museum people were willing to accept some of his more brutal conceptions at once. When Joe Hirshhorn entered the picture as a Moore collector—and eventually became the most enthusiastic of them—the situation was changing. We had a large piece of a pregnant woman seated on a bench. That large bulbous stomach had made the work hard to sell to any American collector. But when Hirshhorn saw it in the small garden outside Knoedler's in Paris, he was immediately taken with it and bought it without hesitation. It stood in his private sculpture garden at Greenwich, Connecticut for years and now is one of more than seventy pieces he gave to the Hirshhorn Museum now being built in Washington.

«In the main, when I was choosing Moores in the first years, I picked them for private collectors, knowing that they were unable to accommodate truly monumental pieces and that many of them had a certain reticence about those tough pieces of his. Eventually it became easier to place the more difficult, truly huge pieces in Germany because there the buyers were nearly always museums of municipalities. In the late 1950s and in the 1960s Germany was economically very prosperous. Many of the cities where there had been great bomb damage were looking for new monuments, and they were certainly much more adventurous in picking their public pieces than their opposite numbers in the United States would be. But even with two very important large Moores now installed in the vicinity of the Houses of Parliament in London, the English have probably been least adventurous

when it comes to the truly large and challenging pieces with which Henry has amazed us in recent years.»

Brooks recalls that initially it had been difficult for him to know exactly how to price a Moore piece, especially a small one, of which there were six or nine casts. While Knoedler's might have two of these casts available, there were always others on the market—frequently in the hands of small English dealers to whom Moore had consigned them, dealers often content with a minimal mark-up since they had the pieces on consignment so neither risked investment nor had to account for any substantial overhead. These dealers would circularize their American clientele. By 1960 Brooks took steps to try to regulate the Moore market to some extent. He approached Harry Fischer, then a partner of the Marlborough Gallery, London, who had become Moore's prime representatives there. Fischer suggested that Brooks assist him in convincing the artist to set up some sort of uniform price scale for his works. And, during the past ten years, this scheme has become effective, at least as far as large pieces, architectural purchases, and commissions are concerned. Brooks remembers:

«I spoke to Henry about Harry Fischer and working something out with him about a more viable price structure. I had known that Fischer is a very intelligent man with a great interest and understanding of modern art. Eventually a great friendship developed between the two men. I think this also marked the beginning of Moore's ever-growing fame in continental Europe because Fischer and his wife had reestablished ties with art circles in Germany which had been severed when he had fled to London during the Nazi regime. Another reason that Harry Fischer became so important to Henry Moore's artistic life is that, although he is an Austrian, his wife Elfrieda is a Berliner and she and her family were very much a part of the intellectual and artistic world of Berlin before the Second World War. It is through

Fischer that Moore was introduced to the famous Berlin foundry Noack. He had been increasingly discouraged with the work done for him by various English foundries. He felt, that at least for the monumental pieces, they were inadequate.

«At Fischer's suggestion—and with his acting as an interpreter between Hermann Noack and Moore—Henry started doing some work with them and their association was an instant success. He always tells me that when they promised a piece by a certain date, it was ready and that the workmanship is always top grade.

«Henry never allowed a piece to go out of Noack without being checked out and worked over by him. During their work on a large piece he would make a trip to Berlin at least once a month to check on the work in progress. I really don't think these big monumental pieces, like the Lincoln Center piece, or those that began to dot various Germany city plazas, could have been executed, if Henry had not found Noack.»

Insisting that no matter how technically good a cast is, it cannot be considered a top or even a genuine work unless the artist works on the cast and supervises its patina, Brooks vehemently denies the accusations of those who claim Moore never sees the recent bronzes once they have been cast by Noack.

«That's absolutely untrue. Not only does Henry supervise the work as it progresses by going to Berlin, but nearly all the pieces are returned to Much Hadham where he supervises finishing work on them. If it's a piece to be installed in a major public place in continental Europe, Henry and Hermann Noack are usually right there to supervise its installation.»

Like nearly everyone who has gotten to know Moore rather well, Brooks recalls numerous incidents that shed light on the artist's

personality and private life. He, too, perceives in Moore a genuine modesty that in no way interferes with his knowing his own worth.

«Once when I was with Henry in Much Hadham, we were talking in the sitting room when Irina came in to say that Julian Huxley—then UNESCO's secretary-general and a very old friend—was on the phone to invite the Moores to a lunch he would be giving at his home in a few weeks time for Indian Prime Minister Nehru. Huxley had told Irina that Nehru had let it be known that one of the greatest pleasures that could be arranged for him would be to meet Henry Moore.

«Henry said, 'Oh, I don't think we can really manage to do that, dear —I have an awful lot of work to get done. So tell Julian that it's most kind of him to ask but that I don't think we can accept.' Fifteen minutes later Irina came back to remind Henry that on the day of the invitation they would have to pick up their daughter Mary from school which was quite near Huxley's house. So then Henry said 'Oh, then it might be fun to go to lunch because I know Mary would love to meet Nehru.'

«Henry has never been the sort of man that because he himself is famous seeks out the company of other famous people. He is first of all a deeply committed and exceedingly hard-working artist, and not far behind that he's a family man. His work and his family are his entire life and the idea that Mary as a school girl would like to meet Nehru dictated his change of plans that day.»

Joseph Hirshhorn, Ted Weiner, Leigh Block, and Ingersoll were just a few of the individuals who bought major Moore pieces through Knoedler's while Brooks looked after the artist's sales there. Major museums, including the Minneapolis Institute of Art and the Virginia Art Museum, were among important institutions to obtain top Moore sculptures through him.

Weiner (who is about to recreate his famed Fort Worth sculp-
ture garden in Palm Springs) successfully urged the trustees of the
Amon Carter Museum of Western Art to purchase Moore's *Glenkiln
Cross* and two *Upright Motives*. These are now beautifully installed
on the grounds of that museum, which was designed by Philip C.
Johnson. Together with Stanley Marcus, Weiner underwrote a major
Jacques Lipchitz exhibition in Fort Worth in 1963. Lipchitz and his
wife, Yulla, were Weiner's house guests for the opening of the
exhibition. The collector wrote to Moore on October 31, 1963:

«I was amazed one morning to see Jacques Lipchitz with a can of wax
and some rags polishing the large Henry Moore *Reclining Figure
Number Three.* When I asked him what he was doing, he said he
thought it would look better if it were waxed and shined. Incident-
ally, he is a man who speaks his mind in no uncertain terms and you
are one of his favorite sculptors.»

Twenty years after Moore had learned from Curt Valentin that
it was Lipchitz who made the pedestal for the one sculpture in his
1943 drawing show, he wrote to Weiner:

«I am very touched by what you tell me—Jacques Lipchitz polishing
the Henry Moore *Reclining Figure* because he thought it would look
better waxed. I like him very much indeed, and always have. We met
again about a year ago in Forte dei Marmi and spent a very nice eve-
ning together. If you are seeing him or writing to him, please give
him my warmest best wishes.»

Since 1958 Harry Brooks and Harry Fischer have certainly be-
come most important among Moore's dealers, as he continues to shy
away from any exclusive contract with a particular gallery. It is un-
likely that Fischer's recent split from the Marlborough Galleries will

alter this picture although Marlborough in New York, under the direction of Frank Lloyd, probably will continue to be as important to the Moore market as it has been since its opening in 1963.

For nearly twenty years now a great many Moore pieces have been sold by the Marlborough Galleries in London, and later in New York and through their international branches. Lunching in 1970 with Frank Lloyd, I was told that it would be his partner, Harry Fischer, who could tell me a great deal about Moore. This was because each of the gallery's famous artists was more or less assigned to one of the partners, and it was Fischer who had accompanied Moore on many important trips. Recently Fischer separated from the Marlborough Galleries and established a gallery in London under his own name. This, at the moment, has become the artist's main British outlet.

«One day, about twenty years ago, I was sitting in our London sales room when two beautiful pieces of lead sculptures by Moore were brought to me for sale. As you might know, in the thirties and even later, Henry did not have enough money to have things cast. But he spoiled many of Irina's pots, making lead sculpture in the kitchen. When these two lead pieces were brought to me, I rang him up and asked him to come to see me the next time he came into London.

«At that time we knew each other only casually and when he came I said to him 'Mr. Moore, here are two lead sculptures I would like to buy but I would also like to cast a limited number of bronzes from them and I cannot do this without your permission. Let's do one together.' He found this to be a most welcome idea and that was the beginning of our business relationship. It was just before his worldwide reputation was really taking hold.

«Much of his reputation abroad came through the efforts of Curt Valentin, whom I first met in Berlin because he started, as I did, as a bookseller. Although we were never really close friends, we knew each other well. It was Valentin—some years before my own art deal-

ing times—who made sculpture his main interest in his New York gallery and got collectors in America to buy very large modern pieces by Lipchitz, Calder, and Moore, as well as paintings and drawings. His great contribution as a dealer was to modern art.

«The great breakthrough for Henry came in 1946 with The Museum of Modern Art show. By that time his reputation in England was already high, and he was established as among the top twenty British intellectuals of great importance. But his market was very limited, and even today, when everybody in England is very proud of him, there are very few people still who collect him in a big way. Over the past ten, fifteen years there has been a great upsurge of interest, but on a wide scale his large pieces and his drawings have only been bought lately here, much later than the massive interest displayed by American collectors and curators.»

As friend and dealer, Fischer accompanied Moore on five of his trips to America and Canada and on many recent trips to Germany where, he recalls, «a museum director bought an important Moore as early as 1933.» It was through Fischer's connections that the Noack Foundry in Berlin has served for more than ten years now as the source for most major Moore casts.

«My wife is the daughter of a publisher, who fortunately, or unfortunately, published a good many books about modern German artists. His was not a very big publishing house, but he was a great friend of Barlach, Dix, and Kollwitz, and he devoted many of his publications to those artists whom the Nazis eventually branded as 'degenerate.' It was a great blow to the family when the Gestapo carted off every copy of thirty-six of his publications which he dared publish as late as 1939. Many of the sculptors whose work my father-in-law advanced, like Ernst Barlach, had their work cast at the old Noack Foundry in Berlin which was badly bombed during the war.

«Some years after Henry and I became close friends, I found him desperately unhappy with the work a French foundry he was using had been doing of late. One day one of his most beautiful seated figures arrived from France with its head turned the wrong way. It might have had to do with that foundry owner's illness, because he died very soon after this incident. When my wife suggested to Henry that he might want to try working with Noack in Berlin, he told her that he had also heard very affirmative things about that foundry from Valentin before his death. So he and I went to Berlin, and we found old Noack still alive and working in his restored foundry. But after only his first cast of a Moore piece was completed, the poor man died of cancer, and his son who was only twenty-four then took over. Since then the production possibilities for Noack have completely changed —because young Noack who, of course, also does a great deal of other casting, has built a new factory and now employs forty-three people. Henry likes Hermann, his family, and his workers, and has an enormous amount of work cast there which is delivered nearly always on time. Berlin today is a fairly isolated place, but it still works fairly well and there is no problem getting things out by air—or by waterway when a piece is exceptionally large. Everyone seems very happy with the arrangement.»

Close cooperation between Harry Fischer and Harry Brooks continued and led to Fischer's accompanying Moore to New York in 1962 on the occasion of a major show of his sculpture at Knoedler's.

«Henry said he wanted me to come along while he told them exactly how to place his work. It was a very easy-going atmosphere at Knoedler's then. Henry spent most of the few days he was there in helping place and light his pieces. Then he went and spent a relaxed weekend with his architect friend Gordon Bunshaft and his wife out in the country. As you know, eight years later Marlborough and Knoedler's

cooperated on a large showing at both galleries which was a huge critical and popular success.»

In recent years, monumentally-scaled marble carvings have played an increasingly important part in Moore's oeuvre. Some of the best of these were shown at Knoedler's in the 1970 exhibition. Fischer recalls with affectionate amusement how Moore often wiles their air-flight time away by quizzing him:

«Once there was a card he showed me in flight, and he asked 'Who did that?' I immediately answered 'Dürer.' It was the right answer. From then on, having been trained as a schoolmaster, Henry questioned me throughout the trip like a schoolboy about all kinds of art. I only slipped once when he asked me who invented oil painting, and I said it was one of Giotto's pupils. I was wrong. Oil painting was invented by the brothers Van Eyck, you know. It's all very relaxing. He adores to discuss all aspects of art. He always wants to know all the dates out of his enormous sense of history.

«I asked him once 'What do you want to be remembered as in the year 2000?' He immediately replied 'As an artist who made a significant contribution to European art.' For him the past is as great as the present, and both must relate to the future.

«You are always surprised by his enormous powers of invention, in spite of the fact that everything he touches is clearly a Henry Moore work. I'll never forget when he took us down in Much Hadham and said, 'I'll show you something new.' We were suddenly confronted with that *Reclining Figure No. 1.* It was a completely revolutionary idea for him to cut something in two and still create a sculptural unit. And then when we visited Carrara and saw the three big rose rings and the enormous *Memorial Piece,* we saw him turn still another corner. Every year it's a new surprise. Just like that time Julian Huxley gave him an elephant skull and he sat down and made over thirty direct etchings from it. At once he emerged as a master etcher.

«The peculiar thing with Henry is that if he is concentrating on one medium—etching, lithography, drawing, or sculpture—he must put everything away and concentrate on that thing. He was practically incommunicado during the weeks he worked on the Elephant Skull etchings. He will never stop surprising even those who know him and his best.

«There have been great sculptors in this century like Giacometti and Maillol. But there is nobody who has incorporated in his own work reflections of the complexities of the intellectual upheavals of our time the way Henry Moore has done. To my mind, he was never an abstract sculptor and never will be. But he reflects in a grand way the most fundamental aspects of our time.

«With the exception of Giacometti, no twentieth-century sculptor has been a draftsman of Moore's importance. He is a much greater draftsman than Rodin was. Even if he would not have done one sculpture in his whole lifetime, Henry would go down in history as one of the great draftsmen in the past five hundred years.

«To work closely with him and to have come to know him, his wife, and daughter so very well has been the most rewarding aspect of my often very difficult professional activities. And having played a part in placing many top Moore works in major public and private collections in America is a great satisfaction to me.»

Moore's infrequent American visits have usually been connected with exhibitions of his work in the United States and Canada or with his being offered honorary doctorate degrees from such distinguished universities as Harvard, Yale, and Toronto. And, one of his most significant journeys to this continent came with the unveiling of his *Nuclear Energy* sculpture at the University of Chicago on December 2, 1967.

An exhibition of one hundred works, titled «Chicago's Homage to Henry Moore,» was staged on campus under the direction of Joseph Randall Shapiro. Along with Leigh Block and Joel Starrells,

he is among the most avid Moore collectors in America. To see a whole wall full of top Moore drawings in Starrells' apartment, in addition to many major sculptures, is an extraordinary experience.

The *Nuclear Energy* sculpture bears a close relationship to Moore's earlier Helmet Head series and to other sculptures based on the configuration of the human skull. It is related to his Interior exterior forms as well. It is, therefore, important to realize that the work, often referred to as *Atom Piece,* did not originate in the artist's mind as an interpretation of atomic power. It was simply that the maquette, already in existence, was deemed suitable—by him and a University of Chicago Committee—to serve as a model for the large piece then being sought by the University. The piece was intended to mark the twenty-fifth anniversary of the first controlled generation of nuclear power which had been accomplished on that campus by scientist Enrico Fermi and his colleagues.

University of Chicago History Professor William H. McNeill first broached the idea of this commemorative sculpture to the artist in a letter written November 14, 1963. He expressed the hope that the proposed sculpture would be «a monument to man's triumphs, charged with high hope and profound fear just as every triumphant breakthrough has always been.» McNeill also proposed that a committee consisting of University architect I. R. Colburn and art professor Harold Haydon visit Moore if he were interested in their proposal.

Answering the initial letter, Moore wrote McNeill on December 22, 1963 that he was interested in the idea but that he would be fully occupied through the early summer with readying the Lincoln Center piece for the foundry:

«I appreciate very much that you would like to talk to me about the erection of a sculptural monument on the site of the first controlled release of atomic energy. I realize what a tremendous happening that was, and that a monument for such a triumphant breakthrough may

be called for. It seems an enormous event in man's history, and a worthy memorial for it would be a great responsibility and not easy to do. However, it would be a great challenge and something I might like to consider.»

Later that month the University committee visited Moore at Much Hadham. It was during that initial visit that Moore remembered a maquette he had made when he had in mind the possibility of a war memorial in Holland. It occurred to him that it might be suitable to the Chicago purpose if it were greatly enlarged in scale. Having tentatively agreed to consider the idea further, he proceeded to make a forty-inch model which he showed the committee on its second visit. When an agreement was finally reached with the University of Chicago, two twelve-foot pieces were cast—one to be installed on that campus, the other to be included in the artist's gift to the Tate Gallery.

Writing in the March 1965 *Art News* in his regular London column, Moore's biographer London critic John Russell reported:

«When Henry Moore was asked to make a sculpture to commemorate the work done at Chicago University on the preliminaries of the atomic bomb, he was understandably stunned by the implications of the theme and the difficulty of rendering it in other than illustrative or rhetorical form. The piece which finally resulted was shown, in a smaller size, in the Moore-Bacon exhibit at Marlborough, and it turned out to be amazingly apt and ingenious. Basically it consists of a dome-like structure, half-lookout tower, half-skull, half-mushroom cloud, which stands on a rugged semi-architectural support that is big enough, in the full-scale piece, for a man to walk through. The challenge of the subject could have been avoided by making what would have been, in effect, primarily a new sculpture by Moore and only coincidentally as a memorial; and it could have been met by a com-

plex of melodramatic allusions. What Moore has done is to produce something that works as a three-dimensional form and has just that nuance of allusion which will remind the visitor of where he is.»

Moore arrived in Chicago four days before the December 2, 1967 unveiling accompanied by his friend and dealer Harry Fischer. He busied himself with supervising the final installation of the piece and attended a number of social functions. These had been arranged for him in connection with the dedication and with the exhibition, which was dominated by extensive Joel Starrells loans now destined to become part of the University's collection. For Moore one of the highlights of his Chicago stay was a visit to architect Mies van der Rohe's apartment and drafting rooms the day before the dedication. Fischer recalls not only the solemn nature of the dedication but the extreme cold that prevailed during that Chicago December:

University of Chicago president Beadle and Mme. Enrico Fermi join artist in unveiling Nuclear Energy *on December 2, 1967.*

«Fortunately I had a little fur vest for Henry to put on because I was afraid he would catch pneumonia. And it was not easy to persuade him to put on a hat whenever he went outdoors in that terribly cold wind. But in the excitement of the dedication day, Henry forgot both these precautions, and as I sat relatively sheltered under a tent while Henry was seated next to Fermi's fur-clad widow at the base of his sculpture, I really feared for his health. But, luckily, all went well and we got home in fine shape.»

A photograph on the cover of the Winter 1968 issue of the University periodical *Chicago Today* shows a number of dignitaries, including Mme. Fermi and Moore. They all look very cold indeed although everyone is shown wearing heavy winter apparel. The magazine reported:

«On December 2, 1942, Enrico Fermi and his colleagues achieved the first self-sustaining nuclear chain reaction in a laboratory under the West stands of Stagg field. The moment, the minute of the advent of the nuclear age, was 3:36 p.m.
«Twenty-five years later, the time was again 3:36 p.m. Many of Fermi's former colleagues and other distinguished scientists from all over the world waited. This time they sat outdoors above the site of the now razed laboratory . . . on the roof of the Enrico Fermi Institute across the street, students, technicians and photographers watched.
«The weather was bitterly cold, wet, uncomfortable, even under the green and white tent erected for the occasion. Dominating that scene, a huge tarpaulin, encasing a 12-foot high monument, pulsed and buckled noisily in the wind. . . . At 3:36 p.m., Laura Fermi, widow of the Nobel laureate, and Henry Moore, the sculptor, pulled the tarpaulin free, unveiling Moore's massive bronze, *Nuclear Energy.* The unveiling climaxed two days of symposia and other activities marking the twenty-fifth anniversary of the experiment. It gave Chi-

cago a memorial of one of the world's great events and left a monument to the new age.»

The day after the unveiling, Moore left for Toronto. There he held the initial conversations with collectors and civic leaders regarding the prospect of a Moore Centre at the Art Gallery of Ontario, which is just now nearing completion. On December 14, 1967, the artist wrote to Professor McNeill:

«I got back from Toronto four or five days ago, and since getting home I have been fully occupied with work and affairs that have accumulated because of my American visit.
«I want to thank you and your wife for the wonderfully warm welcome you gave me in your home. You were marvellous, and the organization of my visit to Chicago could not have been better arranged—nor could I have been better taken care of, and relieved of any worries and problems.»

Two months before the installation of *Nuclear Energy* on the University of Chicago campus, Moore's monumental bronze sculpture *Three Way Piece: Points* was unveiled at Columbia University. Set advantageously on the Revson Plaza of the Law School Garden, the sculpture is the gift of the Miriam and Ira D. Wallach Foundation. Through Andrew Ritchie's determination, Yale had obtained its *Seated Figure* in 1959. And, the latest major Moore sculpture to become a prominent part of an American university campus is the eleven-foot high *Oval with Points,* installed at Princeton University in 1971.

Other American campus sculptures by Moore can be found at Vassar College, the Rhode Island School of Design, the Fogg Art Museum at Harvard, Boston University, Smith College, UCLA, and Storm King.

Exhibitions
and
Reactions

For five years after The Museum of Modern Art established Moore's work firmly in America, Curt Valentin successfully persuaded an ever-growing number of curators to add the British sculptor's work to top private and public collections. In this enterprise he was aided by an art press overwhelmingly favorable to the artist. By 1951 Moore had provided Valentin with enough works to stage a formidable exhibition at his Buchholz Gallery.

Writing in the January 1951 *Art News,* veteran critic Henry McBride discussed the growing transatlantic reputations of Dubuffet, Moore, Marin, and Tchelitchew:

«Of this quartet, and judging entirely by their records to date, I incline to place Henry Moore farthest along on the international highway. He has two countries completely sewn up, for New Yorkers look upon his work with almost the unquestioning faith of the Londoners and love him personally as much, for he has been over here and captivated everybody with his sweetness, simplicity and decency. What Paris thinks of him I have not heard, but I imagine it still holds him off a bit. In Paris, essential decency is not too potent a factor in establishing reputations as it is in London and New York. The French are polite, of course, but they might hold that Moore is a refined version of Picasso, an opinion that would please neither Moore nor Picasso much . . . (Moore's) career has been singularly lucky, for almost at the start of it there was the war and the air raid shelters and the recognition in the rows of sleeping figures of something at once so primeval and so modern that any kind of cubism would be justified in recording it. The whole experience was such a nightmare for the English that they in turn instantly agreed that any nightmarish treatment of it in the arts would do for it, in fact the more nightmarish the better. So there you had Henry Moore fully enfranchised and given the keys to the city. Like the thoroughly fine person he is, he has never taken any undue advantage of this trust,

and his new pieces are as clean and honest as usual, though possibly more machine-age than heretofore.»

While McBride's comments read more like a personal endorsement than an actual review, a more precise piece of criticism appeared in the March 15, 1951 *Art Digest*. Its associate editor Margaret Breuning wrote:

«Henry Moore, in spite of the really great prestige attaching to his work, shows that he is not an *arriviste* in his current exhibition through this month at the Buchholz Gallery. He has proceeded further into experiment in his sculptural design. It will be a blow to his fervent imitators that giving their figures disproportionately small heads and wide apertures will not suggest Moore's recent work. *Family Group,* a bronze, now in The Modern Museum and represented here by a small replica, is a highpoint of his previous achievement. It is definitely organic in its powerful figures, formalized in design.
«The artist has now gone further in his formalization, reaching an effect of architectural construction in the bronze *Standing Figure,* its pillar shape scarcely suggesting human form in its absence of recognizable details. The upward thrusts of curving and straight supports that build up the figure, leaving large interstices, the diamond-shaped suggestion of breasts, the bipartite head are decidedly removed from humanity. Yet is only carries further the sculptor's interest in carrying out his conceptions in a complex of solid forms, volute curves and open spaces. In this work Moore has expressed his absorption in the relation of formal elements with a vigorous freedom.
«*Reclining Figure,* in bronze, is more characteristic of his former designs. It seems to combine a rhythmic interplay of curving forms, an acuity of angles and scooped-out solids in a remarkable sculptural invention. Its suggestion of a latency of movement and organic existence are felt through its abstract design. The three versions of *Rock-*

ing Chair resemble three different phrasings of a musical motive in their sweeping, varied rhythms. A striking piece is *Head,* resembling a bronze mask, yet endowed with an inescapable sense of inner vitality.
«The large group of drawings in pen, watercolor and pastel, with their striations of accenting, are mainly studies for later sculptures. Their power and originality give a clue to Moore's wide influence.»

Except from strictly academic quarters Moore was spared adverse criticism of his first American exhibitions. But when the Curt Valentin Gallery staged a show of his work in the Fall of 1954, shortly after its founder's death, such noted critics as Clement Greenberg and Thomas Hess attacked Moore's work in highly emotional terms. Hess wrote in the December 1954 *Art News:*

«Henry Moore is considered, wrongly in the opinion of his reviewer, in the U.S. and Great Britain to be one of the world's great sculptors. The inflation of his reputation is mainly the achievement of British intellectuals, who, at the end of the last war, needed *chefs-d'école* who would be: native, yet Continental in style; metaphysical for metaphors, yet natural (i.e. connected with a country garden of the soul); verbally Socialist in human sympathies, yet aristocratic in stance. Britten in music, Sutherland in painting, and Moore had the luck to fit the bill perfectly. Official Arts Council exhibitions, essays by everyone from geologists and lay-analysts to post-Keynesian economists and new-Scottish poets eloquently presented them as the flowers and fortune of the Kingdom's new Empire-Everest climbers on the private range of scientific but ever holy Albion.
«Like the painter and the composer, Moore has been chivvied with honor and flattery into attempting architectural commissions far beyond the capacities of his dainty, eclectic style and his neat but limiting concepts of the work of art. Even when he models on a small

135

scale, his need to appear more sensitive and complex than he can be spoils most of the results.

«In this exhibition of sculptures of 1951-53, bits and tags from pre-historic China, Etruria, Alexandria, the Gold Coast, the Cyclades widen the reference of his figures only for those who look at them with an open history book in their mind—a book whose pages block the glance from eye to object.

«A few little bronzes and sketches escape the cul-de-sac of Official Modernity and offer carefully observed human gestures translated into variations on Picasso. In them are hints to the possibilities of a lost Henry Moore. For the rest the exhibition is an object lesson for the next generation of British artists—the Thomas Scotts and Francis Bacons. The enemies of promise will knight you, if you don't watch out.»

In his «Art Chronicle» in the *Partisan Review,* Greenberg twice referred peripherally to Moore in a distinctly negative sense:

«The irreplaceability of art that is permeated by obvious feeling turns out to be an issue on which I can agree in principle with the opponents of modernism now that I have had my fill of Henry Moore and artists like him.»

In the January-February issue, reviewing an exhibition by another sculptor introduced to America by Curt Valentin, he took occasion to attack Moore:

«Recent works by the German sculptor, Gerhard Marcks, also at Curt Valentin's, offered another lesson in the reward of probity. Marck's thorough craft matters less than his tenacity in insisting on the truth of his feeling—a wonderful and profound tenacity. In stylistic terms he follows where Rodin, Maillol, Lehmbruck, and Kolbe have led,

Reclining Figure: External Forms
1953-54
Bronze
l. 84 in. (213.3 cm.)
The Toledo Museum of Art, Toledo, Ohio,
Gift of Edward Drummond Libbey

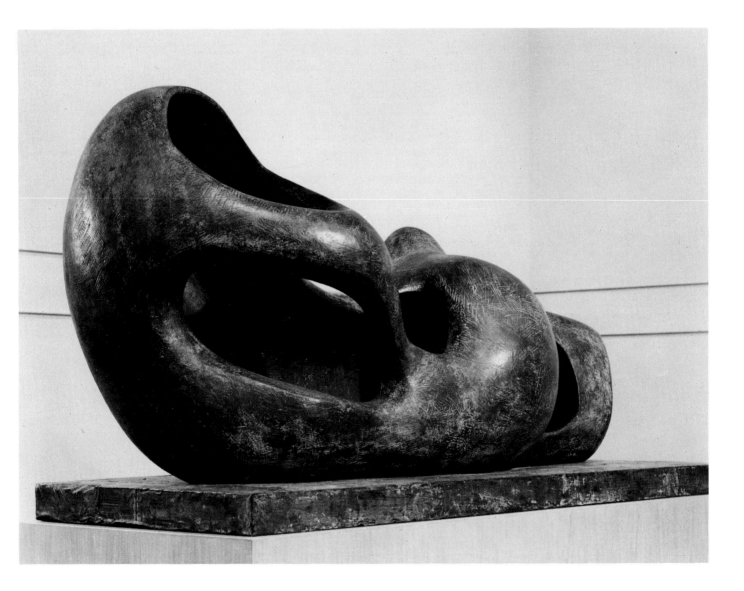

Upright Internal and External Forms
1953-54
Elm wood
l. 103 in. (261.6 cm.)
Albright-Knox Art Gallery,
Buffalo, New York

Three Standing Figures, *1953*
Bronze
h. 28 in. (71.1 cm.)
Norton Simon, Inc. Museum of Art

Warrior With Shield, *1953-54*
Bronze
60 in. (152.4 cm.)
The Minneapolis Institute of Arts,
Gift of the John Cowles Foundation

Mother and Child: Petal Skirt, *1955*
Bronze
h. 6 in. (15.2 cm.)
Mr. and Mrs. Bernard Greenberg

Reclining Figure No. 6, *1954*
Bronze
l. 9 in. (22.9 cm.)
Rita and Taft Schreiber

Wall Relief, Maquette No. 2, *1955*
Bronze
w. 18 in. (45.7 cm.)
Mr. and Mrs. Henry C. Rogers

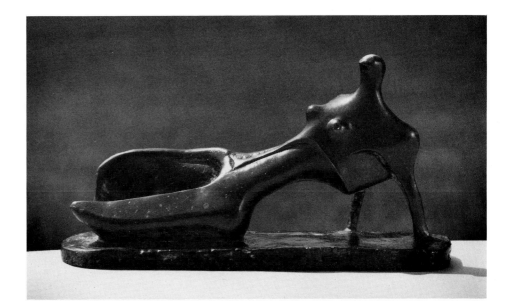

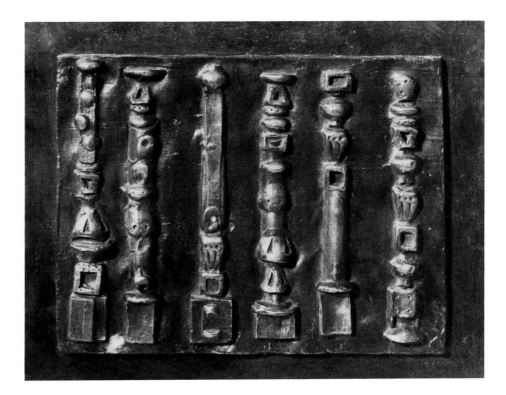

141

Upright Motive: Maquette No. 8, *1955*
Bronze
h. 12 in. (30.5 cm.)
Mr. and Mrs. Norton S. Walbridge

Maquette for Seated Figure
Against Curved Wall, *1956*
Bronze
w. 11 in. (27.9 cm.)
Bette and Marvin Freilich

Maquette for Seated Woman, *1956*
Bronze
l. 6¾ in. (17.1 cm.)
Mr. and Mrs. Mark Robson

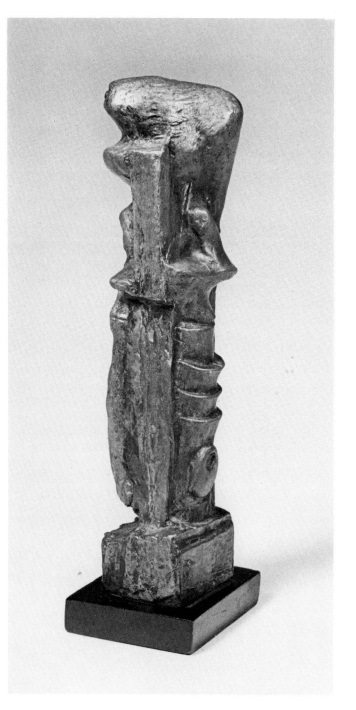

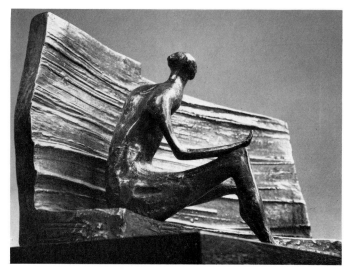

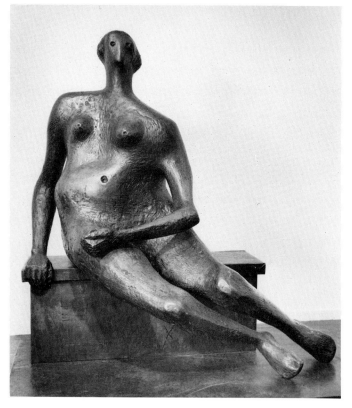

Reclining Figure, *1956*
Bronze
l. 96 in. (243.8 cm.)
Norton Simon, Inc. Museum of Art

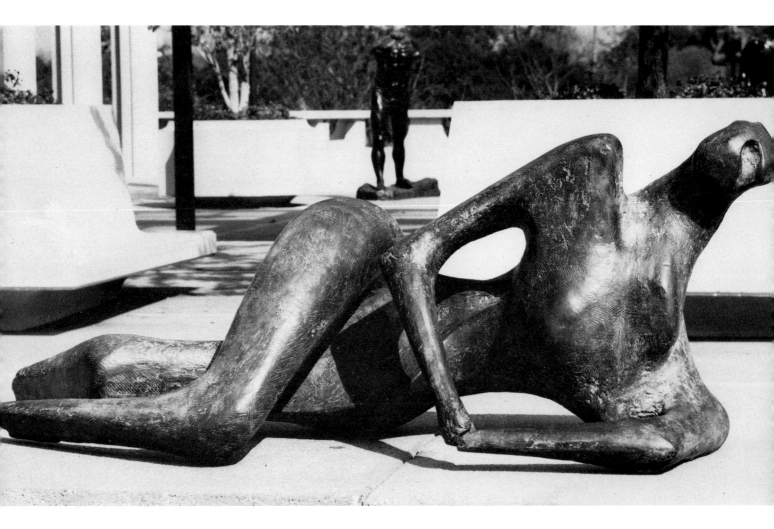

Mother and Child Against
Open Wall, *1956*
Bronze
h. 8 in. (20.3 cm.)
Norton Simon, Inc. Museum of Art

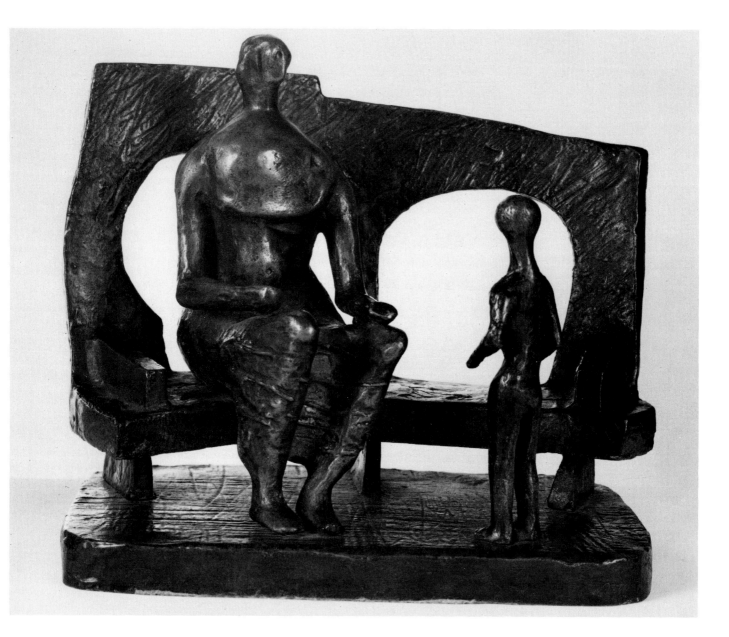

Upright Figure, *1956-60*
Elm wood
h. 108 in. (274.3 cm.)
The Solomon R. Guggenheim Museum,
New York

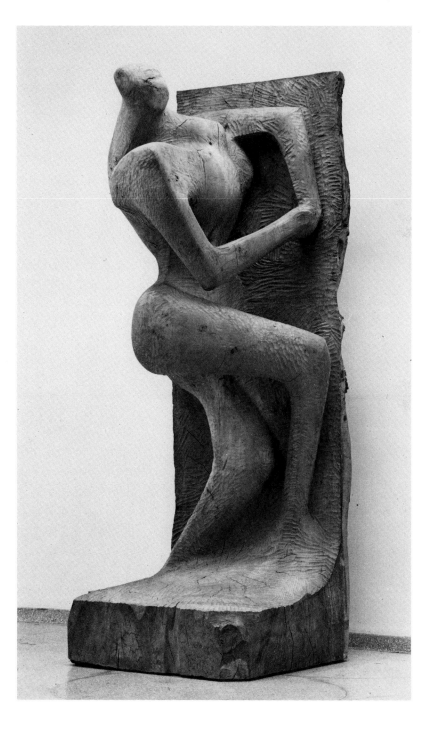

Seated Figure on Circular Steps, *1957*
Bronze
w. 13 in. (23.0 cm.)
Private Collection

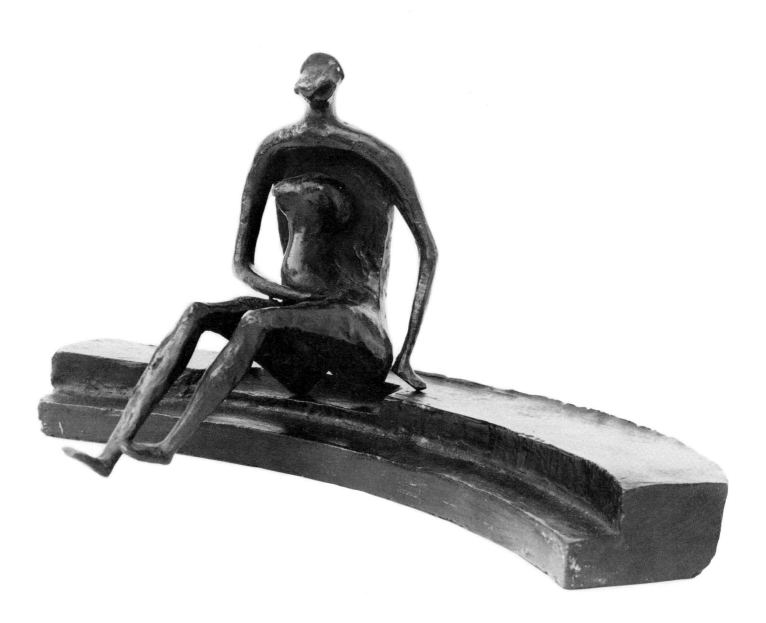

and archaicizes a little, as countless sculptors do nowadays, the in-
spiration in his case being late medieval German carving (though
himself mostly a modeler). Thus he is not a revolutionary phenome-
non like Brancusi. But the value of art that is explicit and authentic
in feeling, even if backward in style, becomes increasingly evident of
late, in face of the modernistic trickiness of someone like Henry
Moore. Plastic novelty has to be felt all the way through, or not
attempted at all.»

Taking quite a different view of the same exhibition was the
Arts critic who initialed his review L. G.:

«Although there are 32 new and interesting creations of Moore here,
it is the slender, ribbon supple *King and Queen* which dominates the
exhibition. It could almost be said that they preside over the gallery,
with an air of tranquil possession, their crown-heads and regal pos-
ture balanced by the firm adherence of their bodies to bench and
ground. They were conceived as figures for a park setting but so great
is their poise, they create their own spaciousness and it would be hard
to quarrel with the claim that they are definitely Moore's finest work
since the war.
«Their only competitor in scale and importance is the massive, muti-
lated, bronze *Warrior*. In the small study for this figure the shield is
slanted away from his chest to a degree which underlines the taut
force that Moore achieved in the finished work. He, like the slim,
angular *Standing Figures* in the show, demands a setting as uncon-
fined as the *Standing Figure* of 1951 which stands on a lone rock
surveying miles of lovely land in Dumfriesshire. In all these upright
figures one can see Moore's fascination with the thought of sculp-
ture in non-ceremonious settings, where they might be come upon
'unexpectedly.'
«The *Reclining Figures* also show a deepening interest on Moore's

part in the aspect they command. During the period when his concern was with weight and mass, you have the feeling that the figures are placidly receptive. Now, especially in *Thin Reclining Figure* and *Reclining Figure No. 4* their weight is displaced on a lateral plane and they have a watchful attitude which implies a cliff edge beneath them. This may be Moore's solution to a period which has not yet solved the problem of where to put its sculpture. Moore seems to be incorporating the ideal site within the figures themselves so that each object varies its own particular sense of 'place' within it.»

A 1958 visit to England by the late Jules Langsner, a distinguished Los Angeles critic, produced one of the most revealing comments on Moore's work ever to appear in an American publication. In the lead article of the August 1958 *Arts and Architecture,* Langsner wrote:

«The history of art consisted, until this generation, almost wholly of the accomplishments of painters. Where were the sculptors endowed with gifts equal of those of William Blake, Turner, Constable? If, by chance, a sculptor of creative sculpture appeared on the English scene —a Gaudier-Brzeska or a Jacob Epstein—he turned out to be a settler with roots in other traditions. Some obscure peculiarity of temperament evidently excluded the English from expressing themselves with the tangible substance of sculpture.
«The answer to the question of why England failed to produce sculptors of the first magnitude ran something to the effect that the English were essentially a 'word people.' That is to say, the imaginative cast of the English mind was most congenial with verbal imagery. Verbal metaphors, this explanation held, have a closer affinity with pictures than with sculpture, and therefore one found, from time to time, the works of pictorial poets of genius cropping out of the distinctive soil of English culture.

«Sculpture was another matter. It entailed a different kind of sensibility—that of susceptibility to the sensuousness of touch and shape inherent in sculpture but not, by any means, a requirement of painting.

«This explanation seemed to hold water until our time, when to the astonishment of many observers, including the English themselves, sculptors of the caliber of Henry Moore, Barbara Hepworth, and more recently, Armitage, Butler, Chadwick, Paolozzi, Turnbull, advanced England to the front ranks of the modern movement in sculpture. Either the 'word mentality' of the English is changing into something other than it has been, or else another explanation for the former paucity and present abundance of creative vigor of sculpture in England will have to be found.

«This may appear to be a roundabout way to approach the impressive, often monumental, organic forms of Henry Moore's recent work. Close examination of the *Upright Motives,* as the artist designates these gargantuan skeletal articulations, however, reveal the ineradicable Englishness of Henry Moore. That Englishness resides in his free and easy intimacy with the visible manifestations of nature. Moore is, indeed, a latter-day English romantic, a spiritual descendent of Wordsworth and Constable, taking into account, of course, that he responds to nature as a sculptor of the twentieth century.

«Moore's deep sympathy with the natural world is seen in the way the extrusions and hollows of the recent *Upright Motives,* as in many of the earlier works as well, suggest the shapes of water born pebbles, bones, rolling hills and valleys. A curious elusiveness pervades these works. The viewer is not quite sure whether they are formed by the human hand or they are, perhaps, some expression of nature seeking a state of sculptural consciousness.

«It is spiritual kinship with nature that distinguishes the organic forms of Henry Moore from the smooth bulbous concretions of Hans Arp or the pure condensation of shapes into archetypes found

One of Moore's key works
Upright Motive No. 8, 1956.
A cast of this piece is in
Norton Simon Museum Collection.

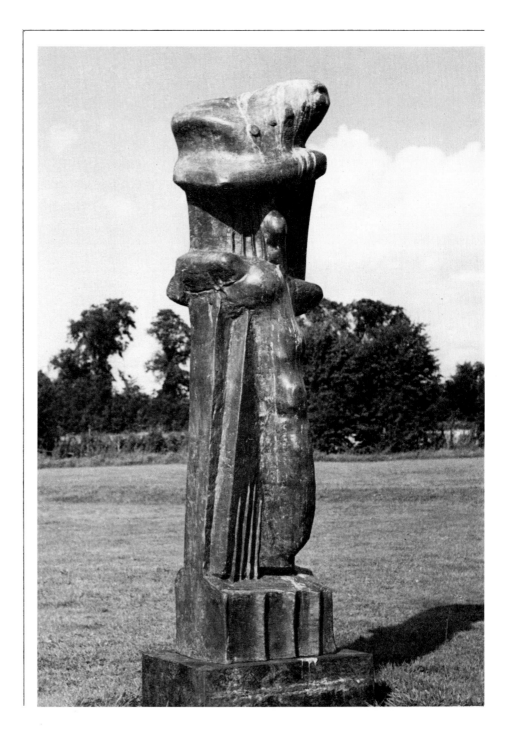

in the sculpture of Brancusi. The sculptures of Arp and Brancusi are most at home in a man-made environment, those of Moore in a natural setting. It is the difference, I suppose, between the artist whose perceptions repose within nature and the artist who observes nature from the outside. The distinction is not intended to be invidious. Both kinds of artists—the one who creates extensions of nature, as does Moore, and the artist who extracts from nature an essence hidden from view, as do Arp and Brancusi, enlarge the range of our aesthetic experience.

«This augmentation of organic nature is due, in some measure, to Moore's adherence to what might be called 'the principle of irregularity' of biological forms. The biological side of nature may appear, in certain instances, bilateral, perfectly symmetrical. Closer scrutiny, however, invariably discloses irregularities of detail, one half of the body slightly different from the other, the veining of a leaf varying from side to side, and so forth. These irregularities result from the processes of cellular growth, and from the pressures and internal tensions to which biological forms are subject.

«The Moore *Upright Motives* demonstrate this principle of irregularity. They suggest organic forms undergoing transformation, and one half expects, on subsequent viewing, to find that they have changed a swelling here, an indentation there, so imbued are they with the sap of organic life. It is this profound imaginative sympathy with nature that places Moore in the tradition of Wordsworth and Turner, and I might add, his keen penetrations of the workings of nature place him in the tradition of English naturalists, of the Gilbert White who wrote *The Natural History of Selborne* and the Charles Darwin who wrote *A Naturalist's Voyage Around the World.*»

By the time Knoedler's held its second Moore exhibition in 1962, the artist had begun the amazing process of self-renewal, transcending his earlier indisputable achievements—a process that was to

evolve into the creation of the monumental bronzes and marbles of more recent years. While still clinging to the device of belittling Moore by calling his art «official,» *Art News,* which had so strenuously attacked Moore on the occasion of his 1954 Valentin Gallery exhibition, seems to have changed its view. A review written by Nathalie Edgar in its May 1962 issue, said:

«Henry Moore, England's official modern sculptor, brilliantly innovates in this show. A markedly different trio is found among reclining mountain-scale giantesses and inventions in bones that we already know. Rising in bronze to an enormous 14-foot height are three totems, extraordinary in that absolute freedom and self-inventiveness are contained without being confined in a monolithic shaft. Their surfaces are at play and carefree—going up or round, being smooth or rough, pushing out or being in a valley—conceiving themselves, and without a thought they rise into a dominating shape. Likewise in the experience of seeing them there is a sharing between evanescent individuality and an impersonal aloofness that a slab of Stonehenge has while staring out fixedly at a point where one day the sun will rise again. Accomplished before our eyes, is the combination that is for all sculptors the consummate task of their labor. Only geometry may be missed. The continuous sculptural skin which Moore favors sometimes imparts a found-object look of a fossilized Brontosaurus leg, because it does not include an internal structuring. Such a geometric core, somehow, conveys a feeling of particularity and consciousness of gesture. Outside these considerations about art, there is something else demonstrated about artists: that great ones do not tire in their maturity and start repeating themselves, but produce their most avant-garde work and open doors to the future.»

Now it was *Arts'* turn to castigate Moore for some recalcitrant traditionalism with Sidney Tillim writing:

«Moore is now sixty-four. Originally his perforated sculpture, opening the form, served both to decompose the figure radically and yet retain its classic, monolithic density. But now Moore has degraded this concept to mere distortion which has none of the economy, none of the mutually justifying end and means that make for simplicity in art, and simplicity is the sense of a proper distribution of energy regardless of any physical complexities involved.

«Moore's perforations have gone so far as to break the figurative form into two and even three pieces resembling giant vertebrae or antediluvian boulders, each a sculptural entity in itself. The result deprives the work of its interesting circular operation between the *logos* of the hole and the *eros* of the form, both of which were capable of exchanging functions as they strung space between them, filling and displacing with no loss of sculptural presence. Actually, as we see now from the perspective of more than twenty years, this was a limited idea, an impulsive expedient on which Moore has staked his entire development since, by trying to develop the idea traditionally. It was as if he became a conservative after a single radical moment, and sure enough he had drawn kudos precisely for having reconciled 'freedom' (there's that word again) with tradition.

«But these two- and three-part figures, all variations on his favorite theme of a reclining woman, are virtually shorn of their sensuality as a result. Moore's adjustment has been to increase both the incidence of archaism in his style and to enlarge his style to monumental proportions virtually as the rule rather than the exception. But no basic enlargement of concept has accompanied works such as the *Glenkiln Cross,* a bulbous totemic form that soars eleven feet, and *Reclining Figure No. 3,* which takes its mountainous ease in almost eight horizontal feet of space. Here Moore has sought refuge in monumentality, almost for its own sake.

«The *Glenkiln Cross,* the largest of nine upright motives, offers final proof of Moore's strangulation by academic modernism. It uses the

primitive, the archaic—and therefore 'time'—in the same way that the academicians used history after David and Delacroix. It corresponds to the 'important subject'; it exalts the psyche of the bureaucratic mind just as battle scenes flattered respectable society more than a century ago. Moore's art speaks for a strain in our society which has accepted primitivism in modern art only after its Romantic principle has been deadened by a self-conscious application of cultural ideas.»

It was the same exhibition, however, which was to upgrade Moore's work in the eyes of one of America's most astute critics, Dore Ashton, who wrote in the June 1962 *Art in America:*

«I first saw Henry Moore's sculpture at the Museum of Modern Art in the 1940s and reacted with sharp distaste. I found his bulbous wood carvings, strung up like mandolins, arbitrary and graceless; his reclining figures with their naturalistic cavities banal; his studies of strewn bones and pebbles pedantic, and his eclectic adaptations of primitive motives affected. I could see no justification for his stylization of the human figure and disliked above all his awkward approach to the human head.

«I knew of course that Moore was the only significant sculptor in Britain at the time and that his intelligent ruminations had fertilized the imaginations of his younger compatriots. But that didn't seem just cause for the singular reputation he enjoyed. That Moore inherited a most uncomfortable dilemma—what to do about the encroachment of abstraction on humanistic conceptions of the figure—didn't move me. Nor did the obviously heroic labor to reconcile radical continental developments with his own nostalgia for the Renaissance and ancient figurative grandeur. Open linear forms developed by the Russians, pure forms by Brancusi, discrete forms by the Cubists seemed to have been clumsily milled in Moore's mind rather than by his sculptor's intuition. For all his painstaking study of natural forms I was never

convinced that Moore's solutions were anything more than willed intellectual schemes.

«Given such unqualified resistance it was for me an agreeable shock to see Moore's exhibition at Knoedler's and to find myself impressed by the triumph of an idea. After these many years of patient reiteration, Moore has finally resolved his dilemma. The idea of the reclining figure has become second nature, freeing Moore to concentrate on bringing to fulfillment a dream of sculptural analogy.

«The bones and seaworn stones, the reminiscences of water curling into the hollow of a shell, the similes for hillocks in the English countryside, have become Moore's own forms, abstracted and far removed from the moment of observation. He has reached a point of natural abstraction and is for the first time comfortable with it.

«Not all the pieces exhibited here were triumphs, but two monumental bronzes seem to me to gather up the sculptural reflections of Moore's entire career in masterful terms.

«The first, *Reclining Mother and Child,* is about eight feet long and four feet high. It lies as naturally, and with as much majesty, as a weathered stone on a plateau. The essential shape is based on the plevic cavity with two oval divisions and an arabesque profile. Housed within it is an abstract shape faintly resembling a joint bone.

«Moore has shaped the great curving walls with sculptural abandon. They billow into space unreservedly. He has rounded the contours to provide an illusion of deep foreshortening, catching the light as it slides smoothly over the sides like a thin sheet of water clinging with silken intimacy to the surface of steppingstones. By the time the eye has traveled over the sensitively fashioned walls and into the smooth cavity, the association of bone and pelvis dims and something grander, more imaginatively viable, replaces it.

«Even the way Moore has installed the secondary shape is different. I no longer have the idea that it is an intellectual idea of the conjoining of rhyming parts in nature. He is not studying the problem of a

shape within a shape but is presenting a deeply felt emotion concerning the archetypal nature of shelter. The small figure nestles to one side, close to the wall but not touching it. From the back view, the slim distance between the curve of the form's back and the curve of the pelvic hollow is minute, excitingly ellided by the invisible extension of both curves. The figure becomes a tender and specific abstraction of the notions of protection, contingency and human relationship. «The same is true of Moore's group of two large sculptures called *Figure.* At last the problem of the head is dealt with sculpturally. Head is no longer the sacrosanct seat of existence but a basic shape to animal, human and landscape realms. The two massive volumes with many bosses and recessions, echoing curves and formal retorts—arms, torso, thigh seemingly interchangeable—roughly treated surfaces become the organic unity Moore has dreamed of many years. His intelligence has ceded to an instinctive drive. Moore's massing of two parts in order to deal with a single figure is in itself an intelligent move.»

As Moore's work spread to many corners of America, not only collectors, curators, and critics flocked to Much Hadham but also a number of art historians. Among them Professor Albert Elsen at Stanford University has been a most qualified and erudite observer, whose comments were not limited to scholarly publications. In the September 20, 1967 issue of *Art International,* Dr. Elsen discussed «The New Freedom of Henry Moore» in a revealing article excerpted here:

«In the last five years Henry Moore has created some of his best sculptures, and they include works not drawn from his signature themes of the reclining figure or the mother and child. *Locking Piece, Archer, Three Point Piece, Large Torso Piece, Sliding Piece* and *Atom Piece* have put Moore's art into areas of thought, feeling and focus on the physical aspects of his form that he has not as constantly invaded before. These sculptures resist thematic interpretation and lack obvi-

ous formal rapport with the human body. Late in his career Moore seems to have become more boldly and consistently inventive rather than interpretive, without withholding his natural generosity of spirit or the fullness of intellect and feeling with which his figural work has always been endowed. *Locking Piece,* for example, was not conceived as a metaphor or paraphrase of an existing object or situation. It is the unique encounter of two analogous but dissimilar shapes whose perfection or imperfection of joining, openness and closure, stability and instability depend on our changing angles of vision. Almost half a century of Moore's patient study and shaping form with its texture, color, space, surface and proportion is visibly brought to bear on each new piece, such that we feel that a work like *Large Torso, Arch* was endlessly considered and refashioned into a dense concentration of nuances. What helps set Moore apart from younger British sculptors is an undiminished passion for the manually shaped and reworked surface of a continuously inflected solid mass.

«The possibilities of large scale for his work, first opened up to him in the late fifties, because they afford 'a stretching of my vision.' Moore knows the difference between large size and a form perfectly attuned to its final scale, and [many of his recent works] experienced important adjustment in proportion as well as shape as they were enlarged from small maquettes. Coupled with a new liberality of scale, there persists the impression of frugality of means and composition. Moore's single-shape works have an astonishing complexity and imaginative physiology when surveyed from all sides. No series of works from the preceding decades by Moore seemed to have as persistently attacked the challenge of achieving so much with so little on such an heroic scale. Yet, for those who have followed Moore's evolution, these newer, more abstract pieces seem partially invested with formal ideas from his previous figural art; the hard conical smoothness of the Helmet series, the stance of the legs and the hollows of the reclining figures, the curving parental shoulders of the

maternal themes, the tapered edges of the knife-edge figures, the rounded breast-bones of the early stone half length women. . . . Nothing has been forgotten, but everything has been transformed. . . . new demands have been made upon the viewer because these sculptures, compared to the artist's work before 1962, possess greater mystery and surprise. As an example, they cannot be absorbed or understood from one or two points of view. Individually and as a group these sculptures have a greater unpredictability as to their total appearance in the round. . . .

«Although the figure in fact is absent from these sculptures, Moore looks upon them in anatomical and physiological terms. When talking about his new pieces he often points to parts of his own body to indicate where he 'feels' a certain stress in the sculpture. In discussing *Large Torso, Arch* he bent forward and with arms extended downward in a pincer gesture indicated how he identified the stretching and arching of his shoulders with the sculpture's movement. In describing *Locking Piece,* he made twisting motions with his hands as if screwing a bolt into a nut or fitting two dissimilar bones in a common joint. The *Archer* evoked from him a thrusting arm holding a bow, an association he recalled that came to him midway during the making of the piece. *Atom Piece* (officially known as *Nuclear Energy*) was first developed as a maquette and two weeks later it was selected by a University of Chicago committee for the memorial now on their campus. Working on his own, Moore did not start out by interpreting atomic power or have any idea of its final purpose. For him it now has a morbid skull-like quality.

«Like Michelangelo and Rodin, with whom Moore constantly compares his own work and ideas, the sculptor's premise is that the human body provides certain models for the artist to follow. Comparable to the skeletal and muscular systems, Moore wants his work to have parts that interact with other parts in a credible way and seem to belong to a unified system. Machinery and man-made objects lack

these possibilities for his empathy and emulation, and geometric forms lack the drama he finds in every form of bodily stress or tension. The continuing assumption upon which Moore builds his new art is that to be effective, which for him means to have character and vigor, sculpture must reflect the energy and structural logic of organic life.»

Not since The Museum of Modern Art exhibition twenty-two years earlier had New York seen as extensive a display of Moore's work as during the simultaneous exhibitions of ten years of his work mounted by Knoedler's and Marlborough in April 1970.

During a week in which The Metropolitan Museum began its centennial celebration with a frankly nostalgic look back, some of us watched in amazement while Moore gave one of his extraordinary displays of energy, helping install and light his two extensive exhibitions while meeting a hectic social and professional schedule.

Monumental bronzes dominate installation of major Moore sculptures at Marlborough Galleries in New York in April 1970.

On my arrival at the Stanhope Hotel, opposite The Metropolitan, where I had expected to meet Moore the Sunday before his Tuesday, April 14, opening, I found a note from him telling me that he had gone to spend the weekend on Long Island at Gordon and Nina Bunshaft's home, but that I would find him at one of his two galleries early Monday morning.

Having stopped at Knoedler's and enjoyed my first look at his amazing and unfamiliar recent marbles (only one of which I had seen in the process of being carved at the Henraux works at Querceta) without finding the artist, I proceeded a block east on 57th Street to Marlborough's emporium. Penetrating a wall of rather officious young functionaries, I entered the main gallery to find Moore hard at work polishing one of the bronzes which had been tarnished a bit in transit:

«Well I am glad to see you here at last. It's almost like someone coming right from Much Hadham. It's been a hectic few days so far, but I think it will all work out well in the end. Look around here a while. Later we'll go over to Knoedler's. There are some problems with the lights to be settled still. Meanwhile I want to see whether I can't show these fellows here how to get this patina back the way I meant it to be.»

Not the least of Moore's achievements was the unprecedented staging of a joint exhibition by these two giant, rival galleries. Beneath the courteous exchanges between Marlborough's Harry Fischer and Knoedler's Xavier Fourcade there were a few moments of open irritation which Moore bridged quickly by injecting his own decisions. Nor was Harry Brooks, a former Knoedler man now at that gallery's arch rival Wildenstein, left out of a number of business meetings concerning future purchases and possible commissions which took place during that hectic week. As we walked around the new marbles

—large and small—at Knoedler's and I expressed my unreserved delight with his latest achievements, Moore said:

«There's not one piece here on which I have not actually worked myself. Carving is the activity that made me a sculptor in the first place. I could never leave any one piece entirely to even the most skilled assistant. Since I had worked all summer on the *Reclining Interior: Oval* piece, I could have just had it shipped here when I left Italy. But I felt that some work still needed to be done on the back, although I know that many people, unfortunately, never really walk all around a sculpture. It was sent to Much Hadham so that I could finish it there before it was finally shipped to Knoedler's. I think this is a very fine installation—as is that up at Marlborough. I'm sure by tomorrow we'll have the lights just as I want them.»

Still, he spent most of the following day supervising adjustments at both galleries. He had difficulty dodging Moore admirers, but he refused to attend the dual-exhibitions' invitational openings that Tuesday night. Instead, he told me over drinks in his room, while the openings were in progress:

«Harry (Fischer) will tell me all about it later on. I really came to see that the pieces are put up the way I want them to be. Basically, I hate exhibitions because of all the fuss and because by their very nature they always demand compromises, even in the best installation. We had our fill of crowds at The Metropolitan's ball last night, don't you think. That was quite an affair. I think you and I must have been among the last to leave. But I was feeling very happy because I think we have solved all our installation problems as best we could.»

Soon Fischer was back with glowing reports on the openings and on the excitement the new work was creating. And, then it was

time to repair to the 21 Club where Roland Balay and Jacques Lindon of Knoedler's were giving a dinner party attended by nearly all the people who had made America conscious of Moore's genius over the past thirty years. A great warmth and mutual affection could be felt here. Some of it was expressed in impromptu toasts. Here were distinguished members of the New York art world who had been fully justified in their steadfast belief in Moore's work. The next day he flew off to England, so that he could, as he told us that evening, «get on with it.»

Having spent a good deal of time with both exhibitions by the time they opened and having shared Moore's last inspection of the lighting and placement of these sculptures in the two galleries, I came away with the feeling that this cooperative enterprise added up to a dynamic reassertion of the sculptor's power.

To progress through the wide variety of bronzes at the Marlborough Gallery, finally arriving at the most recent and most triumphant reclining figures—so big that only the insistence of the artist and Harry Fischer persuaded the New York gallery personnel to hoist them into the gallery—was both a revelation and an inspiration. Britain's greatest living artist had proved once and for all that ideas germinal in a young genius' work can continue to nourish, broaden, and deepen his language. Now nearing seventy-two, Moore had never demonstrated a greater thrust of invention nor a more philosophical mastery of scale than could be found here.

Moore's varied and imposing marbles were beautifully displayed at Knoedler's. Evocations of primordial power attended the Roman travertine *Stone Memorial*. This work and others, including the red soraya *Reclining Figure,* the black marble *Square Form with Cut* and the complex directness of the roman travertine *Animal Form* projected a force found in many of the best of Moore's pieces here.

In each of these pieces Moore had found viable and convincing analogies for the rhythms and mysteries of nature, transforming them

into objects that majestically commanded the space they inhabited.

«Two New Shows Confirm Henry Moore's Greatness» read the New York Times headline of a review by critic Hilton Kramer.

«The English sculptor Henry Moore is one of the few great living artists—alas, one of the very few. As is always the case with artists whose careers have been long, productive, uneven and over publicized, we have sometimes taken his greatness for granted. Indeed, there have been times when even Mr. Moore seemed to be taking it for granted.

«Inevitably there have been lapses in inspiration, and these have often coincided with moments of extreme public adulation—such are the paradoxes of fame. Moreover, the middle and younger generations have turned to sculptural concerns far removed—in spirit as well as method—from those that continue to animate his work. For years now, Mr. Moore has found himself in the position of being ignored by the young and adored by the Establishment—always a severe test to an artist's capacity to sustain and enlarge his vision while avoiding a facile rehearsal of his own well practiced gestures.

«For anyone who has had doubts about Mr. Moore's ability to withstand the temptations of his hazardous position—and I must confess to having had a few myself—the two large handsome exhibitions that opened yesterday are good news indeed. At M. Knoedler & Co. there is an impressive survey of the artist's recent stone carvings; at the Marlborough Gallery there is an equally impressive selection of recent bronzes. Together these exhibitions constitute a review of Mr. Moore's principal accomplishments in the years 1961 to 1970. They are a triumphant confirmation of his greatness. For myself, they establish the nineteen-sixties as the finest period in Mr. Moore's long and copious oeuvre since the thirties.

«It was in the thirties that the artist first achieved an international renown as a carver. His style in that period combined a lean classical

austerity with a wonderfully inventive imagery. Deeply touched by the surrealist movement then in its hey day, he was able to assimilate his penchant for the erotic and the fantastic while maintaining a carver's loyalty to the sculptural monolith.

«His great distinction at this time was in the way he handled the monolith, penetrating and transforming the inert mass with the now legendary 'holes' which established an entirely new expressive relation between the sculpture's interior space and its external surface. This was the era of 'open-form' sculpture, but whereas others— Picasso, González and the Constructivists—approached the new mode by means of welding and joinery, Mr. Moore claimed the new sculptural space as the domain of the carver. From that period onward his position in art history was secure.

«The sculpture that Mr. Moore is now showing at Knoedler's and Marlborough still owes much to this pioneer work of the thirties, but a great deal has changed in the interim. The artist now works on a larger scale, and his forms have acquired a kind of public eloquence. Mr. Moore is one of the few living sculptors who can combine the lyric with the monumental in a large, complex image—an image that offers intimacy, mystery and grandeur in a single and metaphorical statement.

«There is a wide variety of imagery in the work of the last decade, but central to it is the theme of the reclining figure. The figure is at once a heroic conceptualization of the classical female nude and a metaphor for an intimate pastoral landscape. Often the figure is fragmented into two or three units; always it is conceived in terms of the interior-exterior dialectic of form that the artist perfected in his early surrealist phase.

«There are distinct recognizable echoes of the human scale. There is a celebration here of the anthropomorphic as well as the topography of the earth, and it is indeed the ease and authority the artist brings to this synthesis of nature and style that is so moving.

«Now in his seventies, an international celebrity and prizewinner, sought after by committees, commissions and collectors the world over, Mr. Moore has refused to settle down to a quiet old age. His new work is both a summary of past achievements and an extension of them. And his creative energies show no signs of diminution. This alone would make him a rare and valuable phenomenon in the art of our time.»

Not only many of his long-time American friends including Seymour Knox, Joseph Hirshhorn and Gordon Bunshaft, but critics from many parts of the world were drawn to Florence in 1972 for the record-breaking exhibition which surely will go down in history as the most extensive and exciting display of Moore's work mounted during his lifetime. Having spent several days and evenings at the exhibition site, I came away more firmly convinced than ever of the validity and force of Moore's idiom.

Singly and together the 289 works shown, including 168 sculptures, representing a half century of the artist's creative activity, made an unforgettable impact on the crowds who visited this unparalleled exhibition.

For some years now Henry Moore's prime preoccupation has been with the relationship of monumental sculpture to open air sites and to architecture. If that summer's unprecedented exhibition at the Forte di Belvedere succeeded brilliantly against the backdrop of the panoramic view of this most sculptural of all cities, it was because Moore's latest and largest pieces had themselves become tremendously impressive, through nonutilitarian, expressions of architecture.

Here, against the ancient stones of Tuscany this indomitable sculptor had set his bronzes and marbles. There were some one could walk through and others through which one could see the incredible surroundings in a new way. Still others reminded us of the monumentality not only in the end results of his recent creativity but in the

often seemingly miniscule sources of his visual inspiration—always found in nature.

It was the organic force and harmony of the largest and best of Moore's works that succeeded in asserting themselves against the competition of the sculptural grandeur of that city's Renaissance architecture. In choosing this matchless site for the most important exhibition of his illustrious career, Moore took his most challenging gamble and won it. Nothing could have better proved his assertion that «art is a universal activity with no separation between past and present.»

The relationship between Moore and Michelangelo is not one of style but of spirit. The fundamental difference in their work lies in Moore's twentieth-century awareness of the unity of nature—landscape, figure, animals, and all—as against Michelangelo's sixteenth-century conviction which held that man is the center of the universe. If strivings towards divinity are the essence of Michelangelo's lasting achievements, it is Moore's profound understanding of evolution and transformation that fully assures his place among the great sculptors of all time.

In Florence even the largest, most recent, and powerful abstractions never seemed non-objective. Rather, they reemphasized their derivation from the artist's lifelong observation of natural phenomena—by no means limited to his continual involvement with the human figure.

Even the seeming angularity of that imposing, built-up marble *Square Form with Cut*—set on a parapet overlooking the Duomo—appeared to become a rounded, flawless entity through which emptiness became a positive spatial factor (even while remaining innately negative). Here Moore created a marble so large that it could not be carved as one piece but had to be built up layer by layer like a wall—a technique that added yet another facet to Moore's conception of sculpture as architecture. This idea is really the other side of the coin

of his conviction that the Duomo itself—besides being one of the world's greatest cathedrals—is also a brilliant piece of sculpture.

In the back, large pieces like the huge cave-like polystyrene *Two Large Forms,* in which one could dwell for many contemplative moments, were set against the Tuscany landscape—as tranquil as the Florentine panorama is busy. Moore once again managed to demonstrate how important it is to see his large pieces against the sky as they themselves are always earthbound, spiritually and aesthetically rooted to the soil.

Everywhere in the Florentine show one found evidence of Moore's symbolic expression of the paradox of opposition and interdependence between male and female forms. Even in his syntheses of these forms, the sculptor never allows us to forget their essential opposition, thus relating physical reality to psychological truth. Perhaps no single piece better demonstrated Moore's inimitable creation of contrapuntal organic form than the massive, yet somehow choreographically light, bronze *Three Piece Vertebrae*—seen so differently in Florence than in Seattle or Jerusalem.

But the germinal part of Florence's thoroughly retrospective exhibition was contained in the interior galleries of the Forte's palace. Here, we were able to follow the artist's thought processes and at the same time to discover that Moore would have to be counted among the great artists of our time even if he had never executed a single sculpture. The incredible skill and emotive power of his drawings over the past fifty years—never before displayed in such abundance—revealed Moore to be one of the quintessential draftsmen in the history of art. It became evident that the cavernous character of much of his recent sculpture had been foreshadowed by many, much earlier graphic experimentations.

That Moore is spiritually at home in Italy was demonstrated by the most moving and consistent aspect of his wide-ranging work—its reaffirmation of man's dignity.

Everyone who looked carefully at the Florentine show came away convinced that Moore had been able to significantly broaden and deepen his vocabulary at an age when even the best of artists are usually content to repeat or refine their earlier statements. That his outdoor sculptures were not diminished in power by the magnificent panoramas against which they were shown was proof of the grandeur of their visual poetry.

Moore's most recent exhibitions in New York and Florence demonstrated unequivocally that this inspired artist has been able to give ever greater eloquence to his work in the face of a degree of fame and fortune that would have led most celebrities to rest on their laurels. Perhaps the scorn so many younger artists, critics, and curators display towards Moore is based on their callous insistence that a contemporary artist's relevance is limited to one decade at best. Perhaps it is this frantic novelty-seeking which has driven such top American artists as Mark Rothko to suicidal despair and often drains many young contemporary artists before they are half Moore's age. His recent monumental works are evocative of the very sense of timelessness so badly needed to relieve our bruised spirits in this strident, often murderous age.

In surrendering himself wholly to the work to be done, Moore has long known the truth of T. S. Eliot's assertion that the artist «is not likely to know what is to be done unless he lives in what is not merely the present, but the present moment of the past, unless he is conscious, not of what is dead, but of what is already living.»

Moore and Architecture

Moore rejects the notion that architecture is the mother of the arts as fiercely as he resists the idea of sculpture thought of merely as decoration for buildings. Only in the *Time-Life Screen* has Moore ever made a sculpture that is an integral part of a building. And, with the exception of the *Sun Dial* for The Times of London, he has never allowed himself to be commissioned directly in his maturity.

This Spring, on a brief but revealing visit I paid with him to the British Museum, Moore bridled as he explained the shortcomings of the vast Duveen Galleries which now house the Elgin Marbles.

«When I first saw these marvelous sculptures as a young man, they were in galleries far more suitable in scale, and they were lighted to much better advantage. It was not so many years ago that the Elgin Marbles were moved to and dwarfed by these galleries built by and named for Lord Duveen. Here is a prime example of the blindness of architects to the true meaning of sculpture. It's simply yet another instance of money thrown away to belittle great art while celebrating one donor. Anyone can see how inappropriate the column size of this room is to the scale of the sculptures and how the various pieces are installed too high up to be seen properly.
«It's time that the myth of architectural primacy be debunked. Sculpture was central when the early temples were built about the statuary of the Gods, not architecture.»

Yet, ever since Moore created the sixteen-foot, twenty-ton marble *Reclining Figure* for the UNESCO building in Paris in 1958, the artist has collaborated with architects, some of whom have become close friends. More and more monumental Moore pieces—both bronze and stone—can best be gauged in the relationships and tensions they create with the buildings that are near.

Even the highly successful *Lincoln Center Reclining Figure* (1963-1965) which gave Moore a chance to make an enormous

sculpture reflected by a pool, was not done on specific commission. Once he accepted the invitation of a Lincoln Center Committee, headed by broadcast executive Dr. Frank Stanton, the artist set out to make a number of models. He told the Committee that he would go to work at creating a piece he thought would be suitable to the space. If they liked it, they could put it up. If not, he would keep it.

Moore was particularly intrigued by the pool which would force him to create a sculpture that «would make you *think* that it goes down to a bottom, like rocks.» An added incentive was the scale of the plaza and the surrounding buildings which eventually led him to create a piece, twice the size of the UNESCO *Reclining Figure* (1957-58), which was then the biggest sculpture Moore had completed.

«I like the challenge of working to a really large size—much bigger than I would be able to do if the work were just for myself, or just for exhibition,» he wrote about the Lincoln Center piece. Since then, his work has evolved into even grander scale, so that some of his sculpture can in itself be regarded as architectonic—impenetrable as a fortress in his *Memorial Piece* (1969) now in Paul Mellon's collection or an invitation to walk through it like the large *Arch* (1969) in front of I. M. Pei's Columbus, Indiana library.

Some of the largest pieces now in public places in the United States got there through the efforts of architect Gordon Bunshaft, a partner of Skidmore, Owings and Merrill, who designed part of the Lincoln Center. Since he first met Moore in 1961, Bunshaft has become the artist's close friend and strong advocate. His own collection of Moores is a highly selective and substantial one.

«I first met Henry when I went to see him informally about the possibility of his accepting a commission for Lincoln Center. Later, Dr. Frank Stanton went to see him to officially invite him. Henry was excited by the possibilities. He has a phobia about doing anything for a specific place and about accepting a definite commission. It turned

out that for Lincoln Center, he did create a marvelous piece for a specific place. Without a contract or any formal arrangement, he went ahead and developed two large pieces, then he decided to offer us the one he liked best. He didn't ask anyone first. I personally liked the one he chose best, and I think so did Stanton and the Art Committee, which never saw any of the preliminary maquettes.

«At the first meeting of the Lincoln Center Art Committee, which included Alfred Barr and Andrew Ritchie as well as Stanton and John D. Rockefeller, III, Picasso and Calder as well as Moore were suggested. But with the agreement of the Albert A. Lists, who were the donors, it was decided to invite Moore.»

Harry Fischer, one of Moore's principal dealers, who was then a partner of Marlborough Galleries, recalls accompanying Moore to New York in 1962 to discuss the Lincoln Center proposal.

«I remember that the members of the Lincoln Center Committee came to the Stanhope Hotel where we stayed. Dr. Stanton and John Rockefeller, III, along with a number of noted architects connected with the project, took us to the Lincoln Center site which looked like a battlefield. Later we were brought to an architectural office to examine the plans for the Plaza.

«Following this meeting there was an elaborate luncheon at the St. Regis Hotel, presided over by Mr. Rockefeller. After dinner someone got up and said, 'Mr. Moore, we are very happy to have you here and we hope you will accept a commission for Lincoln Center.'

«I was sitting opposite Henry and he leaned over the table and said, 'Harry, what should I do?' It was a rhetorical question. Then he said, 'I'm so sorry, I would love to do a piece for that plaza, but I can't accept an actual commission. I will build a little pool in my garden and try some suitable maquettes. Then I will enlarge the piece. If what I finally produce suits you, put it up; if it doesn't, it's all right too.' »

Bunshaft also remembers that the luncheon was a lavish one, part of an effort to persuade Moore to do the Lincoln Center piece, while he was also being asked whether he would like to do a major work for the space in front of the Seagram Building—a proposition that interested Moore. He admired architect Mies van der Rohe who had collaborated on the actual design of this building with his most famous disciple Philip Johnson. Everyone realized that the situation was fluid—that Moore would only do one piece for a public New York site at a time. Bunshaft recalls:

«I remember saying to John Rockefeller, 'I'd like to live long enough to have some client plead with me to do a job.' With architects it's the other way around. Finally, when the whole thing was done and the finished piece came over, Henry came to supervise its installation and we would be over there together day and night. Everyone orig-

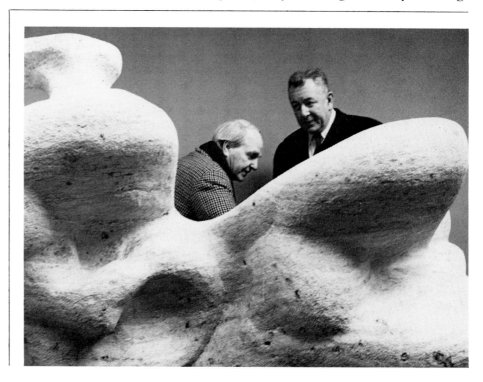

Moore shows friend Gordon Bunshaft major marble piece in his Much Hadham studio.

inally connected with the project liked the piece. We had floodlights on it and it was still all planked up when Albert and Vera List, who donated a generous art fund to Lincoln Center, came to look at it. I remember how very pleased they were.

«Since then I have seen a great deal of Henry and I have great affection and admiration for him. I don't remember the English ever having an artist who was sort of number one in the world at any one time. I don't think England has ever done a really great building. Nevertheless, London is wonderful because it's all bits and pieces yet it holds together because there's a nice human quality about it. I don't know much about the history of English sculpture, but I don't think it ever existed on Moore's level.

«Here's this man who has been aware of what has been going on throughout the entire history of art and has quietly created his own art world. I don't think he has been terribly much influenced by his contemporaries historically. I think he admires Michelangelo and that his dream is to be the Michelangelo of the twentieth century—without hiring any public relations men to create that atmosphere. I think he has no false modesty and is intelligent enough to feel that he is one of two or three great sculptors in the world today.

«I haven't known many artists closely. But I knew Giacometti, and I know Henry. Both were always concerned with their environment as it affects their work. Giacometti wouldn't move out of that terrible little dump he lived in for fear it would affect his work. He had the means to do anything he wanted, but he just wouldn't move out of there. Henry hasn't got that fear, and he makes himself comfortable out at Much Hadham, but he is in need of those familiar surroundings for most of the year. Of course, now he could live much more ostentatiously. Frankly, he doesn't want to do that. He knows that his work habits come from living where he lives.

«The Italian summers are a product of his desire to do big marble pieces. I think many artists today share his need to do things on a

173

monumental scale. I think the large paintings everybody's doing are sort of a substitute for painting a wall. And the artists don't want to have to ask an architect whether they can paint a wall. The sculptors, especially in America are coming around to working on a scale compatible to large urban complexes. In Italy Henry has the materials and the facilities to work on a truly monumental scale—facilities he does not have at home. This coincides with his love for Italy and his desire to get a certain amount of relaxation in his growing years. His first working trip came when he went to select a large marble piece for the UNESCO work.

«When you get to the largest of the latest big Moores, like the *Vertebrae* in Seattle and the great new marble ones, they get to be like architecture in themselves. You walk into them, through them, around them. That is as it should be.»

More recently Moore has collaborated with architect I. M. Pei. In *Architecture Plus,* Stanley Abercrombie writes « . . . of all architects practicing today, it is Pei who shows the greatest ability for making his buildings combine with art to form seemingly inseparable wholes. . . Perhaps this is because Pei knows when *not* to use art. 'One percent for the construction cost for art is no longer unusual,' he says, 'but I never use art as decoration. I use art only when nothing else will do.' » Abercrombie continues:

«One such place was the Bartholomew County Public Library Pei designed for Columbus, Indiana. Columbus was already rich in fine individual buildings, but it lacked a focus. The library alone was too small to provide such a focus, but Pei persuaded the city to close an adjacent street, and he placed the library so that it worked with two other buildings to frame a public square. The essential key to the plan's success, however, was the introduction of a significant rallying point.

«Pei sought out Henry Moore in his studio in England at Much Had-

174

ham, Hertfordshire, and presented the problem to him. Pei mentioned his admiration for a small Moore arch he had seen in New York City and which his daughter had delighted in running around and through. Could a similar piece be enlarged enough to allow adults to walk through? Moore thought it could.

«After looking over Pei's plans, Moore spoke briefly with one of his assistants. In two hours, while Pei and Moore were having tea on the terrace, the assistant put together a full-size polystyrene mock-up of the arch. Both the architect and artist were delighted with it. 'I. M. Pei came to me and wanted the arch,' Moore said recently, 'and we scaled it up from the one that I consider a working model at the Museum of Modern Art. . . . I wouldn't let an architect have something that I thought would be wrong with his building. . . . This one is right for Pei's library.' It is also right for Columbus, *Large Arch*—not only often walked through now, but, on fine days, even the location for children's classes—transforms an open space into a civic center. The arch, incidentally, was cast in bronze in Berlin, then shipped to New Orleans, and finally barged up the Mississippi.

«Another Moore, *Two-Piece Reclining Figure No. 3*, marks the entrance to Pei's Everson Museum in Syracuse, N.Y. (completed in 1968). Entering the museum would certainly be a lesser experience without it, and its forms seem a happy complement to the strongly sculptural—but very different—forms of the museum behind it. Such competition is intentional; Pei thinks, in fact, that a bland architecture is an unworthy background for art.»

One reason that recent Moore pieces have taken on an autonomous architectural character may well be the artist's innate preference of seeing his art set against nature. Anyone who has ever talked to Moore at length has heard him say, repeatedly how his works look best seen against the open sky or put into an expansive, even wild landscape:

«It's quite right that sculpture with architecture has more problems for me than putting a work of sculpture into a rural landscape. Trees and grass—all open spaces—have less difficulty for me. Such surroundings interfere less with sculpture than architecture because the forms of nature are much more assymetrical and haphazard. They don't have architecture's straight lines and geometric forms which catch your eye and insist on the site rather than on the sculpture.

«So, that sculpture, in relation to architecture, must have its own existence and its own three dimensional reality. I don't mean sculpture that's stuck on the architecture which I don't like anyhow—that kind of decoration in which sculpture is just surface, flat, stuck on or pinned on like costume jewelry on a woman's clothes.

«I have said many times that, on the whole, I'd prefer my sculpture to be in nature rather than in relationship to even the best piece of architecture I could ever think of. Still, today it is inevitable to make sculpture that relates to architecture. You can't just have your sculpture in wild nature like that *King and Queen* of mine up on that hill in Scotland. We do live in cities. And we do have paintings and sculptures in our homes. It's best if sculpture indoors be allowed to fight the natural disturbances around it rather than to light it especially and make it into a kind of decorative object for the room.

«I have never seen a person or a piece of sculpture against architecture that I would say can be seen perfectly from every point of view. I just don't know it. When dealing with an architectural situation, I attempt to consider certain things that can go wrong. There is a kind of right size for every such situation. I think that in the Lincoln Center piece its size in relation to the four buildings all around it and to the plaza is just about right. This is the thing I tried to think about. I don't work with architects except on these generalized problems like size. I don't like doing commissions in the sense that I go and look at a site and then think of something. Once I have been asked to consider a certain place where one of my sculptures might possibly be placed, I

try to choose something suitable from what I've done or from what I'm about to do. But I don't sit down and try to create something especially for it.

«On my first large architecturally related work, the UNESCO piece, I spent three or four months trying to think of something for the site. Eventually I gave that up and decided to do one of my Reclining Figures for it, only much larger than those I had made before. But the material was dictated by the site and the building. I first thought of doing a bronze. I changed from a bronze which grows darker, especially in a city, because the background behind the sculpture was going to be dark. I solved the factor of the sculpture disappearing into darkness by not doing a bronze, but a carving from the same kind of stone as was used on the top of the building but stayed away from the stone that would be immediately behind the sculpture. You don't want your sculpture to disappear into the architecture.

«There are other important decisions that have to be made if you are trying to create a sculpture for a certain architectural environment. It would be silly to try to compete with a tall, thin tower building by trying to put up a tall, thin sculpture near it. It just wouldn't work.

«Deciding not to do any sculpture for the Seagram building had nothing to do with my not liking the building itself. I admire the building enormously. People wondered why one was hesitant over doing a sculpture for the Seagram building when it was such good architecture. There were several reasons for my deciding against it. As you know, what Mies van der Rohe wanted, being a classical architect—or at least more or less classical rather than romantic—was a sense of symmetry that would have been created by my making two sculptures where the two fountains are. I don't like making things in pairs, I don't like their being ornaments too much. Besides, although people rightly think this is a good building, you would really have seen the sculptures mostly as you came out of the building. You would have seen them against some awful architecture. It would not have been

doing sculpture for the Seagram building but for the whole block. This is a primary reason why I wasn't so keen and excited about that invitation. Anyhow, at the same time I was being asked about that, I had already agreed to do the Lincoln Center piece. That was enough of a task for the time being.

«I have actually only made two works that are incorporated into architecture. There's the *Time-Life Screen* (1952-53) and a relief I did for the underground station at St. James in London as a young man. I didn't really want to do it, but the architect was such a nice fatherly figure and so persuasive that I did this relief. It's eighty feet up from the ground. Nobody ever sees it. Nobody ever looks eighty feet up. You can't see what it's like anyhow. It's like trying to tell whether a girl has a pretty face or not from 100 yards away. You might know a bit about her figure from that distance but you

Artist surveys monumental bronzes on loading dock outside his large Much Hadham studio.

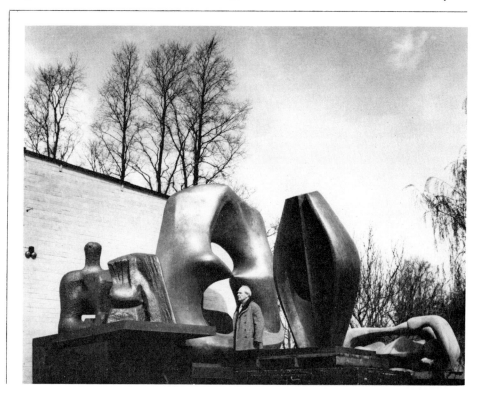

178

wouldn't know a lot about her face. From then on I decided that I didn't want to do any more relief sculpture.

«The *Time-Life* commission came about in a very accidental way. First the architect simply wanted to buy my *Draped Reclining Figure* to put on a terrace used by employees in the building. Then he told me that he had a problem with a screen he needed to put up to connect his building to the one next door on the Bond Street side. He wanted to protect the terrace that would link these buildings—the one for which my sculpture was meant—from the street. They had conducted a competition, and he asked me to look at the entries several sculptors had submitted and to tell him my thoughts about them. I looked at them, and to me they all seemed like very silly solutions to the problem. None of them showed that this was actually a screen with no solid building behind it. I thought such a sculptural screen should be pierced. Instead, all the suggestions were pictorial reliefs trying to represent the story of the magazines. It was just story telling and had no connection with the building at all. Having told this to the architect, he asked me to propose a solution to his problem, and over the weekend I began to have some real interest in designing a sculptural screen which would be appropriate to the building and its needs.

«When I had finally designed the carvings that are on the building now, I hoped that they could be turned so that you could see them from different angles, say the beginning of each month. In that sense they would have been sculptures in the round and not just reliefs. But when they were done and we tried to implement this idea, it turned out to be impossible because each of those four big blocks weigh I don't know how many tons. If each had been put on a turntable functioning on a pivot, and if in fifty years' time that pivot gave way, they would have created a danger, and that was unacceptable. Therefore they have stayed up there, unturnable. In that sense it was another instance of how when working with architecture you never get the

perfect solution. Even at Lincoln Center my piece is hardly ever seen properly because the reflecting pool rarely has the water at the level necessary to my design.

«Still, the Lincoln Center piece is right for its place. Aside from the satisfaction the making of it gave me, the project resulted in warm friendships with Gordon Bunshaft, the architect—with whom I have collaborated on other projects such as the *Lambert Locking Piece* (1963-64)—and with Dr. Frank Stanton who headed CBS and was a key figure in the whole Lincoln Center scheme. During the progress of the project he must have come to see me almost every two months. He'd come sometimes on a Saturday night plane arriving in London Sunday morning, drive out for lunch, and then we'd be looking at the models I was making and talking about the piece and its progress. So from then onward we became very warm friends with him and his wife, who always accompanied him. Later we had further contact over the CBS Special about me and my work done by Charles Collingwood. And although I have not known Gordon Bunshaft for all that long, we have become very close friends. He and I do have ideas about sculpture and architecture that are sympathetic and that is very nice.»

In the last few years, Moore has created sculptures that are architectonic in size. Among the most impressive are his *Stone Memorial Piece* (1969) made of travertine marble destined for display near the National Gallery in Washington; the large bronze *Arch* (1969) in Columbus, Indiana and that fantastic edifice of a marble sculpture titled *Square Form with Cut* (1970) which was one of the highlights of the most brilliant Moore exhibitions ever staged—the one at Forte di Belvedere in Florence in 1972. Moore made the model for this gigantic piece in polystyrene in Much Hadham and then began working on the marble version at the Henraux works at Querceta, near his summer home at Forte dei Marmi. No sound piece of marble of such size can be found, so Moore decided to put it together piece by piece

Woman, 1957-58
Bronze
h. 59 in. (149.9 cm.)
Mr. and Mrs. Ted Weiner

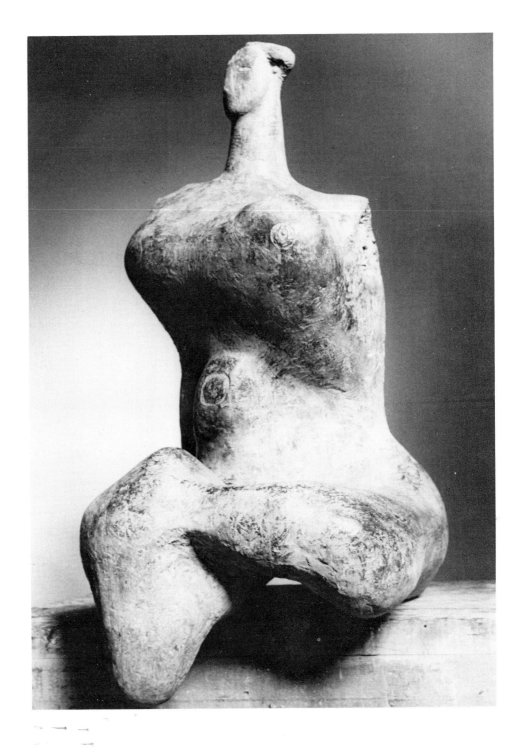

Bird, *1959*
Bronze
l. 15 in. (38.1 cm.)
Mr. and Mrs. Ted Weiner

Three Motives Against a Wall No. 1,
1958
Bronze
w. 42 in. (106.7 cm.)
Mr. and Mrs. Stanley K. Sheinbaum

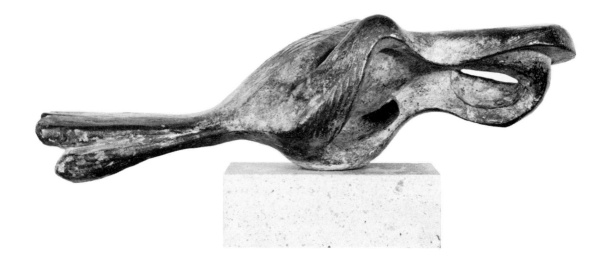

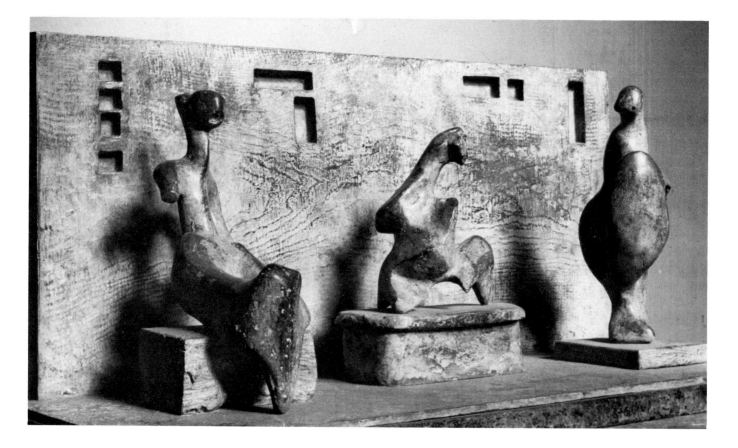

Mother and Child: Hollow, *1959*
Bronze
h. 15 in. (38.1 cm.)
Mr. and Mrs. Ted Weiner

Relief No. 1, *1959*
Bronze
h. 88 in. (223.5 cm.)
Norton Simon, Inc. Museum of Art

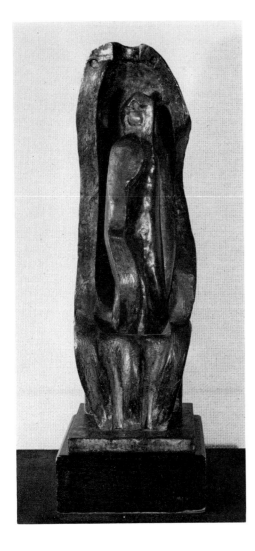

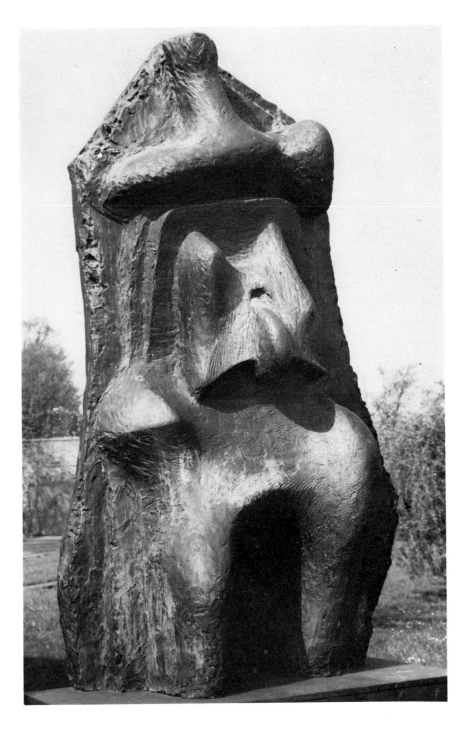

Two Piece Reclining Figure No. 1, *1959*
Bronze
l. 76 in. (193.0 cm.)
The St. Louis Art Museum
Gift of Mr. and Mrs. Howard Baer

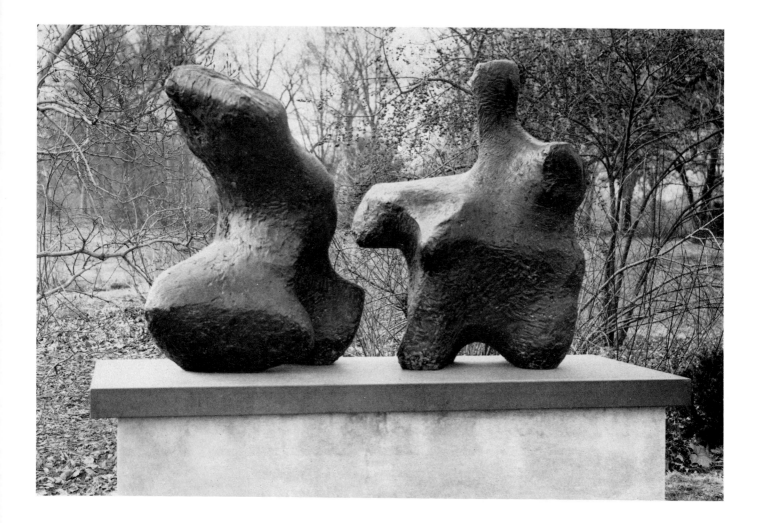

Headless Animal, *1960*
Bronze
l. 9½ in. (24.1 cm.)
Mr. and Mrs. Ray Stark

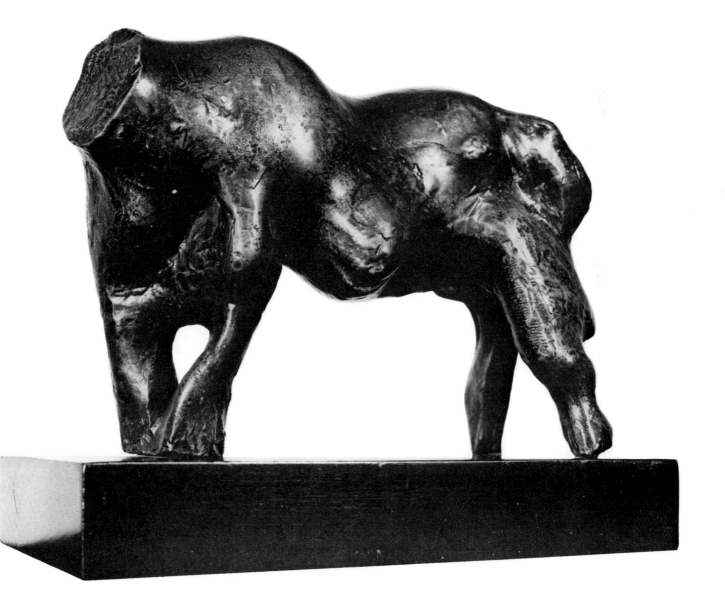

Two Piece Reclining Figure No. 2, *1960*
Bronze
l. 102 in. (259.0 cm.)
Mr. and Mrs. Stanley K. Sheinbaum

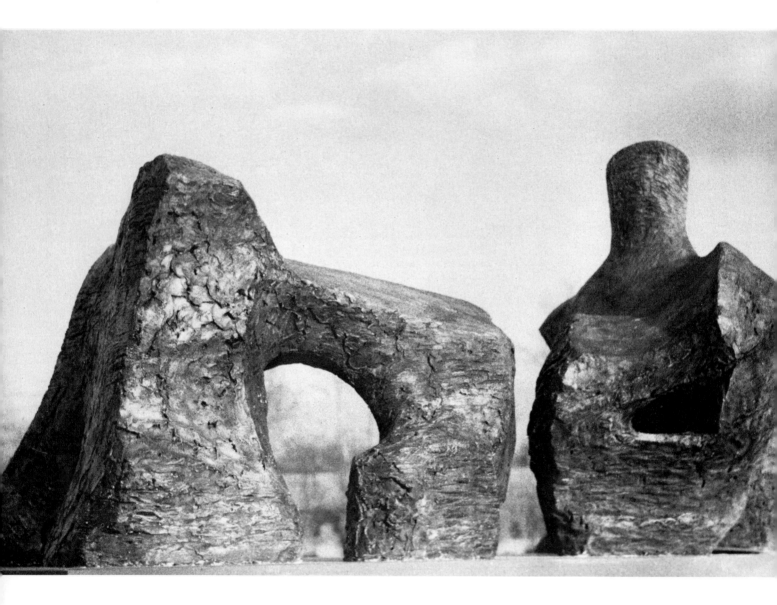

Two Piece Reclining Figure: Maquette
No. 1, *1960*
Bronze
l. 9½ in. (24.1 cm.)
Norton Simon

Three Piece Reclining Figure, Maquette
No. 1, *1961*
Bronze
l. 7¾ in. (19.7 cm.)
Mr. and Mrs. Ray Stark

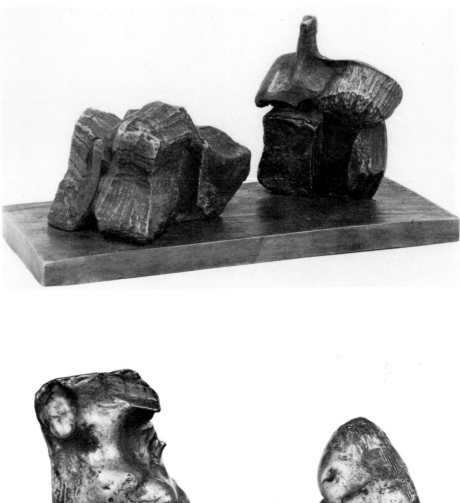

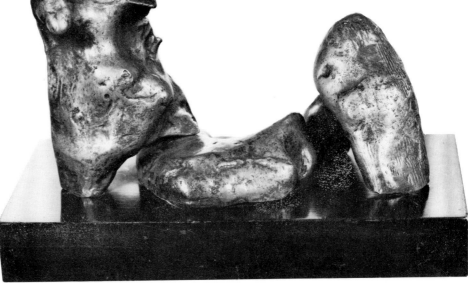

Two Piece Reclining Figure No. 3, *1961*
Bronze
l. 94 in. (238.8 cm.)
The Frederick S. Wight Art Galleries,
University of California, Los Angeles,
Gift of David E. Bright

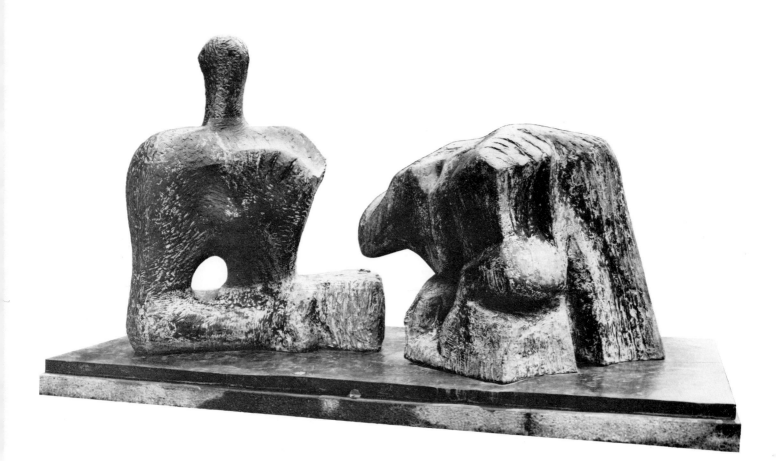

Reclining Figure, *1963-65*
Bronze
336 in. (853.4 cm.)
Lincoln Center for the Performing Arts,
New York

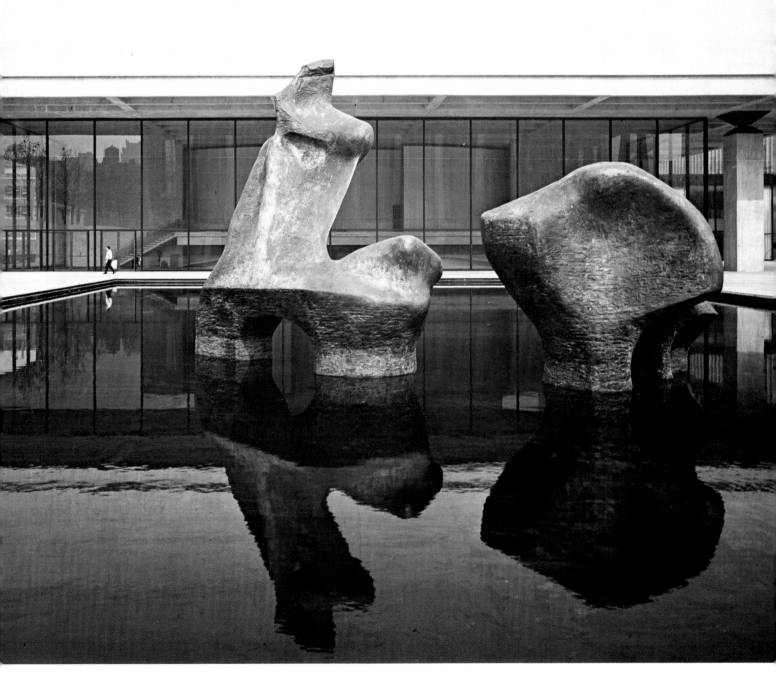

Three-Way Piece: Points, *1964-65*
Bronze
h. 76 in. (193.0 cm.)
Gift to Columbia University School of
Law by the Miriam and Ira D. Wallach
Foundation

Nuclear Energy, *1965-66*
Bronze
h. 144 in. (365.8 cm.)
University of Chicago

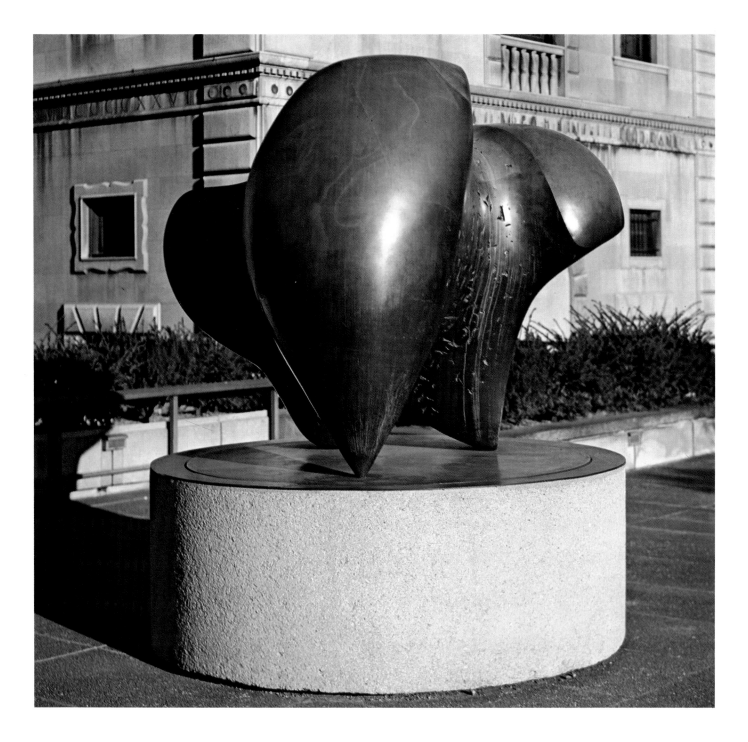

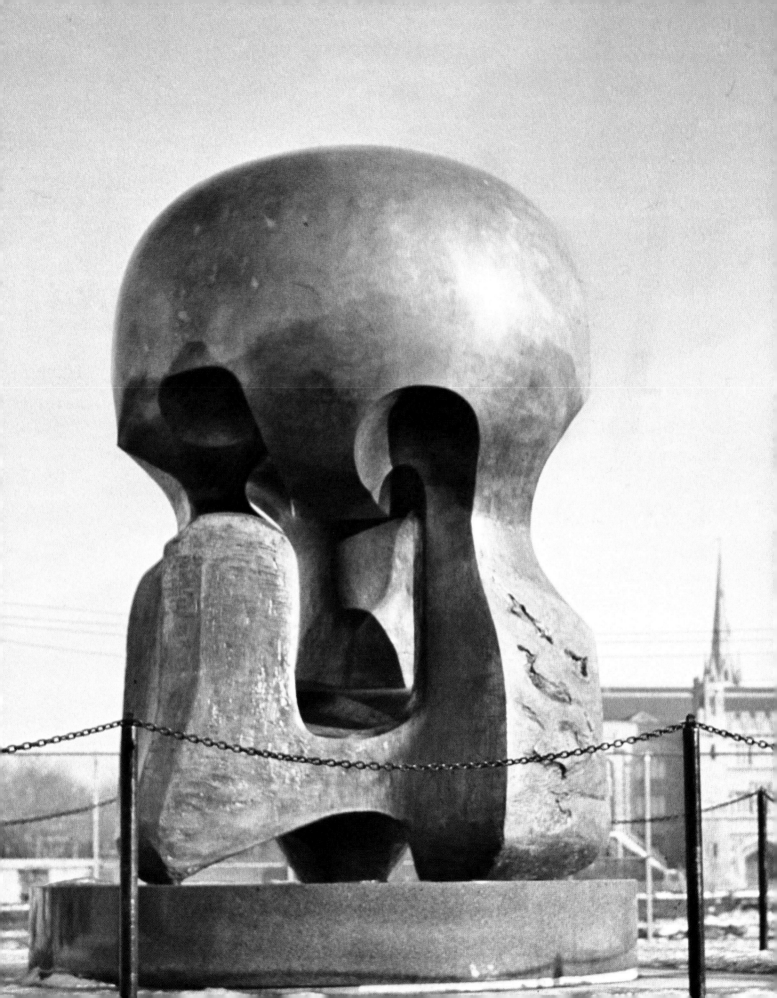

Two Piece Reclining Figure No. 9, 1968
Bronze
l. 98 in. (248.9 cm.)
Mr. and Mrs. Ray Stark
Los Angeles

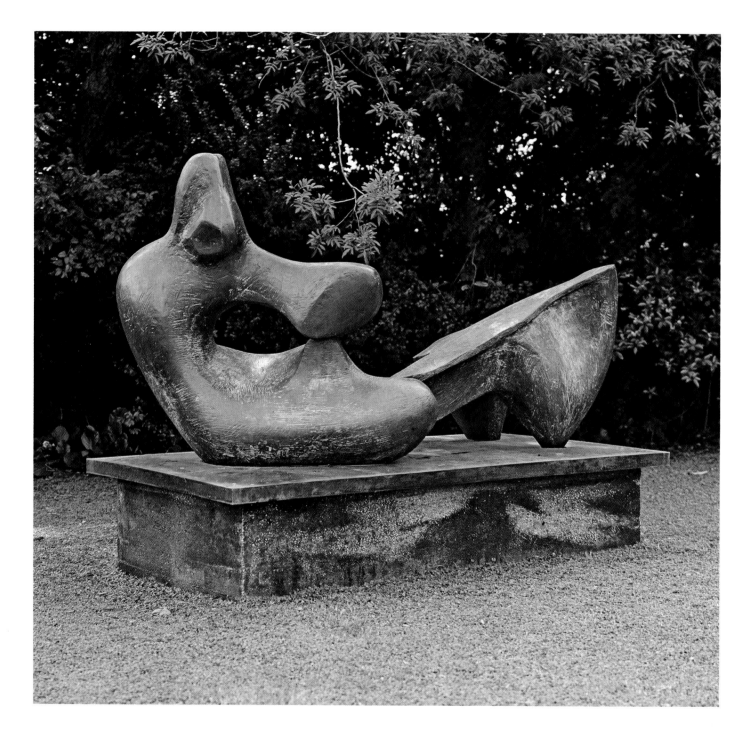

Seated Woman: Thin Neck, *1961*
Bronze
h. 64 in. (162.6 cm.)
Mrs. Anna Bing Arnold

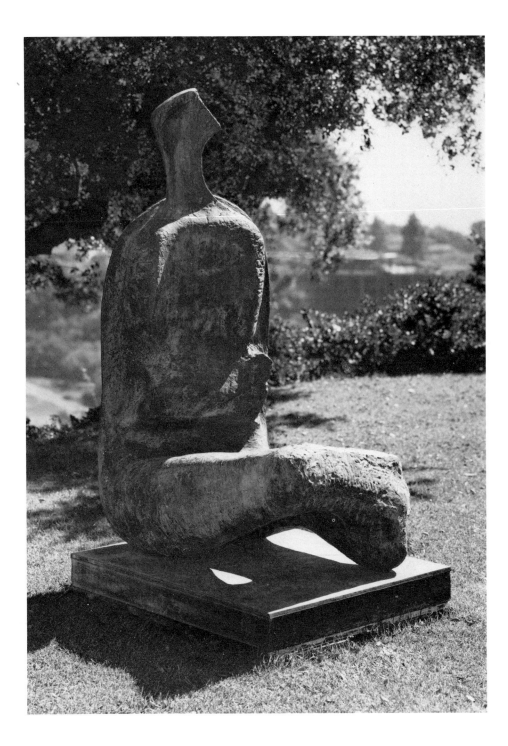

Two Piece Reclining Figure, No. 4, *1961*
Bronze
l. 42 in. (106.7 cm.)
Rita and Taft Schreiber

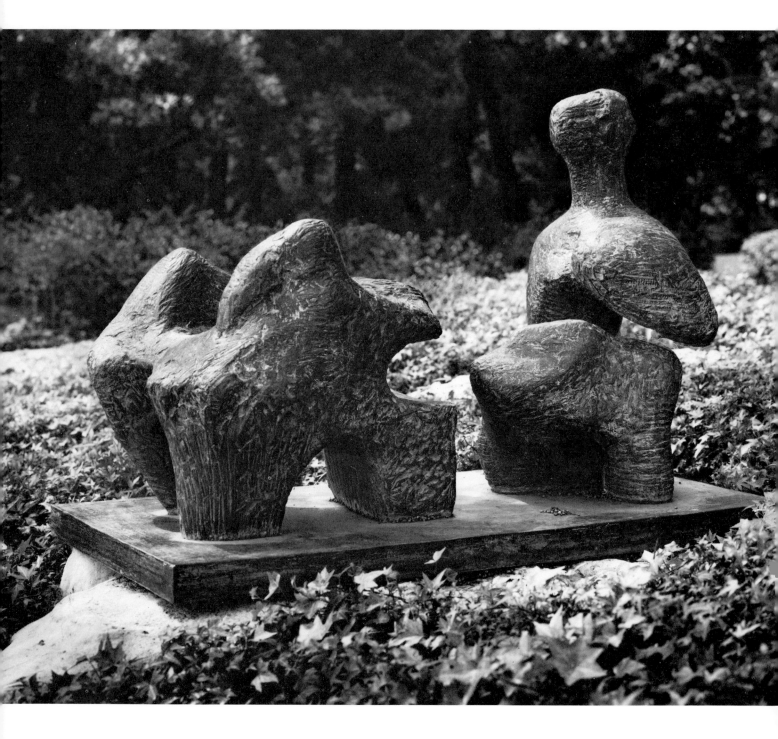

as if he were building a building. When the polystyrene parts were shipped to Italy, they were numbered according to the layer and position to which they belonged. The workers at Henraux copied each polystyrene piece exactly, avoiding the pitfalls that many modern sculptors risk by giving the marble workers a small version of what they want enlarged. In this instance, the marble workers were working from the actual size created in another material. Currently Moore says he is planning «a sculpture big enough so you can walk between the two pieces of it.»

«My desire to do sculpture of such large dimension may date to the time when I first came to London as a young provincial student. One of the first things I did was to make a trip to Stonehenge. I had seen photographs but never visited there. Stonehenge is really both sculpture and architecture. You do walk in amongst the stones, and I think their average height is something like sixteen feet. I was terribly impressed by this and ever since I have wanted to work on such a scale. But there is no chance for a young sculptor to do that. He lacks time, money, and space for such ventures. So it's only now that one can carry out some of the ideas about large sculpture that one's had for such a long time. The *Arch* at Columbus is large enough for people not only to see it but to walk through and around it. Although it is based on parts of the human torso—specifically the shoulders of a man—it does give the feeling of being a triumphal arch. With the smaller version, the one at The Museum of Modern Art, you've got to bend down to go through it.

«The rightness of the size of a sculpture depends on where it is. My fourteen-foot *Archer* is somewhat too small for its location in front of the Toronto Town Hall, because I let the architect convince me to make it the size he thought it should be. But the second cast of the same piece which stands in front of Mies van der Rohe's museum in Berlin is right in size. The sculpture looks much bigger there, because

it is not surrounded by tall buildings. You see it is not only set against a rather low building but against the verdant landscape of a park. Its size there is right, which demonstrates that the rightness of the size of a sculpture depends on where it is placed. Now that's a very different thing from the notion of scale of monumentality of sculpture. You can have a sculpture that is monumental in feeling although it is only three or four inches high. Some of Michelangelo's smallest wax models have the same monumentality of vision as his big David.»

One grey, drizzly morning in January 1971 I found myself in Seattle having gone there to report on the installation of one of Moore's most intriguing monumental bronzes—*Vertebrae* (1968)— in front of the Seattle First National Bank building. Having arrived the previous night, I at once walked to the building, only a few blocks from my hotel, to find to my amazement that the plaza on which the Moore piece was to be installed remained empty.

Now, only a few hours before its official dedication, the twenty-four by nine-foot piece which weighed more than fifteen tons was being ever so carefully put into place by a small army of workmen. Despite the puzzlement and outright skepticism voiced by a number of the workers about the sculpture they were installing, they moved with great precaution and precision until the three-piece sculpture rested on the nine touchdown points that had been marked for them in a shallow reflecting pool adjoining the new downtown high-rise building.

It wasn't the much advertised $165,000 price tag that elicited their repeated, often antagonistic questions as they made sure that the hydraulic crane swung the three sections accurately into place, but the difficulty of comprehending the sculptor's meaning at first glance. Unwittingly they demonstrated that Moore had fulfilled one of the conditions he has long set for the validity of sculpture:

«Sculpture should always at first sight have some obscurities and further meanings. People should want to go on looking and thinking; it should never tell all about it immediately.

«Initially, both sculpture and painting must need effort to be fully appreciated, or else it is just an empty immediacy like a poster which is designed to be read by the people on top of the bus in half a second.»

In Seattle Moore has achieved just that tension towards architecture that he feels to be essential for a major piece in an urban setting. The powerful horizontal work—with its very own peaks and valleys—complements and contrasts the sharp strong vertical lines of the building.

Seated Figure *shown through* Vertebrae *in back of Hoglands on rainy day.*

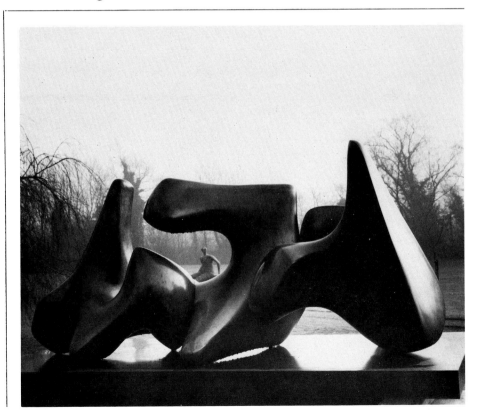

San Francisco art agent Paule Anglim, who had previously had an important part in negotiations that led to the installation of a cast of Moore's *Knife Edge-Two Piece* (1962) at Queen Elizabeth Park, Vancouver, B.C., recalls that she was involved in all phases of the Seattle project in cooperation with the bank, its architectural firm Naramore, Nain, Brady and Johanson, dealer Harry Brooks, and the artist himself:

«From the very beginning of the selection of the sculpture to its realization, I recall an active participation in the project of three years. I saw the small maquette for *Vertebrae* at Henry Moore's studio, later I saw it developed to two intermediary dimensions, and then finally I saw the full scale plasters of each segment before they left for the foundry. In working at a great distance, as on the Seattle project, Henry Moore showed an extraordinary capacity and patience in trying to understand all the particulars of the situation.»

Once Moore and his assistants had completed this very large and extraordinarily complex piece at Much Hadham, its plaster was sectioned for shipment to the Hermann Noack Foundry in Berlin where it was cast. Once the casting of the three segments was completed, they were reassembled under the artist's watchful eye. As usual, Moore minutely supervised the finishing of the piece.

Three years in the making, *Vertebrae* was then packed in three crates and shipped on the Johnson Line's S.S. San Francisco to Seattle where it arrived in November 1969 and was put into storage until the building's completion.

Vertebrae (1968) is one of the very best demonstrations in Moore's entire oeuvre of his assertion that sculpture's real uniqueness over painting is «that it can be seen from innumerable points of view.» It is for this reason that the latest and largest of Moore's sculptures have always evolved from little more than hand-sized maquettes

created in the quietude and familiarity of Much Hadham. His drawings now have become an independent enterprise, never used as a preliminary stage towards a sculpture.

«Once you draw a view, it tends to become dominant. And that won't do if you are thinking of inventing a sculpture that is to be seen from many vantage points whether it be in a rural or urban surrounding. «Ideally a good building in itself should really be a work of art architecturally. It should not need another object to make it good. But if you have a first-rate sculpture next to an excellent building—and some rapport or tension is created between them—this can well lead to an enhancement of the urban surrounding. Good sculpture should be used on city sites with the same discrimination with which sensitive people put paintings and sculptures in their homes.»

More than twenty years ago, Moore voiced some pertinent ideas about the renewed opportunity of collaboration between sculptors and architects—ideas he has tested and confirmed in the interim:

«During the 'functional period' of architecture, around twenty or thirty years ago, the modern architect had no use for sculpture in connection with his buildings. This was perhaps a good thing, both for sculptor and architect, for the architect was concentrating on his architecture and it freed the modern sculptor from being just a decorator for the architect and allowed him to concentrate on his own art in isolation.

«However, it has now become clear that architecture is the poorer for the absence of sculpture, and the sculptor, by not collaborating with the architects, misses the opportunities of his work being used socially and being seen by a wider public. I am sure the time has come for architects and sculptors to work together again.

«When sculpture passes into the public domain, the sculptor is then involved, not merely in a simple artist-patron relationship, but also in a cooperation with other artists and planners. The piece of sculpture is no longer a thing in itself, complete in its solution—it is a part of a larger unit, a public building, a school or a church, and the sculptor becomes one artist in a team collaborating in the design as a whole.

«Ideally that collaboration should begin from the moment the building is first conceived, and neither the planner of the town nor the architect of the particular building should formulate their plans without consulting the sculptor (or the painter if he too is involved). I mean that the placing of a piece of sculpture, in a public square, or on or in a building, may radically alter the design as a whole. Too often in modern building the work of art is an afterthought—a piece of decoration added to fill a space that is felt to be too empty.

«Ideally the work of art should be a focus around which the harmony of the whole building revolves—inseparable from the design, structurally coherent, and aesthetically essential. The fact that the town planner or the architect can begin without a thought of the artists he is going to employ to embellish his building shows how far away we are from that integral conception of the arts which has been characteristic of all the great epochs of art.

«Assuming that such cooperation is sought and given from the beginning of an architectural conception, then there are many considerations, which the sculptor must bring into play. He will want to consider both external proportions and internal spatial volumes in relation to the size and style of sculpture that might be required—not merely the decorative function of sculpture in relation to formal quantities, but also the possibility of utilitarian functions. . . . The sculptor will also want to consider his own materials in relation to those to be employed by the architect, so that he can secure the effective harmony or contrast of textures and colours, fantasy, and utility, of freedom and necessity as one might say.»

Moore's Art
in
Southern California

At twenty-two Henry Moore was a grammar school teacher in his native town of Castleford. At that time he wrote a play «Narayana and Bhataryan» to be performed by his pupils, and the linocut he designed for the program's cover is his first known graphic work.

During the past twenty-five years a number of films have been made about the artist and his work, and he has appeared, infrequently, on radio and television. There is nothing theatrical about Moore himself although he occasionally gives himself to a bit of clowning when on holiday with his family. But over the years Moore has remained an avid theater-goer, and he vividly recalls some of the great performances he has seen. His increasingly frequent visits to continental Europe have awakened in him a keen interest in opera, and his wife's Russian birth may account for their shared interest in the ballet.

Both the artist and his wife have long been particularly fascinated by the movies and its stars. Their daughter Mary spent a delightful few weeks in Scotland not too many years ago working as a script girl for Billy Wilder shooting scenes for his Sherlock Holmes film. Moore remembers being especially grateful to MCA-Universal executive Taft Schreiber for introducing a very young, excited Mary to Charlie Chaplin. The Moores have frequently accepted invitations to special film previews, including Royal Command Performances in London, and many an evening is spent watching films on television. However, the only time that the artist stays glued to his television set nearly all day long is during Wimbledon week. That is the one time of the year when Moore completely abandons his rigorous work routine, giving in to his life-long passion for tennis. Although he no longer plays the game himself, he does still play and often win a highly competitive game of ping-pong.

To judge by the number of collectors connected with the movie industry who have helped make Southern California an exceptional reservoir of Moore's work, Hollywood's appreciation of the artist

At London premiere of Funny Girl *Moore chats with Barbra Streisand as producer Ray Stark looks on.*

matches the enthusiasm Moore has for many of its movies. Actors, writers, directors, producers, agents, and executives who collect Moores include Vincent Price, Burt Lancaster, Hal Wallis, Phil Gersh, Mickey Gribin, Frank McCarthy, William Fadiman, Mark Robson, Ray Stark, Billy Wilder, Lew Wasserman, and Taft Schreiber. One of the largest collections of Moores in America is owned by Mrs. Stanley Sheinbaum, Jack Warner's daughter.

Yet Moore has never visited Southern California. He did pay a very brief visit to San Francisco to visit architect Henry Hope regarding the possibility of creating a sculpture for a new Longshoreman's Union headquarters building—a project that never materialized—but he has resisted the lure of Hollywood which brought his daughter Mary out for a whirlwind trip a few years ago. Nevertheless, the major exhibition of his work from Southern California collections—

being mounted by the Los Angeles County Museum of Art simultaneously with the publication of this book—is only the most recent chapter of that geographical area's appreciation of Moore which goes back thirty years.

But Moore's admirers in Southern California are hardly limited to the film industry, and other top Southern California art collectors whose appreciation of Moore is reflected in their holdings include Wright Ludington, Norton Simon, the Sidney Brodys, the Frederick Weismans, the Richard Sherwoods, Norton Walbridge, and Ted Weiner. UCLA, The Fine Arts Gallery of San Diego, and the Los Angeles County Museum of Art include major Moore sculptures in their permanent collections while the Santa Barbara Museum of Art owns three excellent Moore drawings, thanks to Ludington's generosity. One of the finest Moores in this area—the *Seated Woman: Thin Neck* 1961—belongs to Southern California's most philanthropic art patron, Anna Bing Arnold.

In the various Norton Simon collections there are seventeen Moore sculptures—shown together for the first time during the Fall 1973 LACMA exhibition for which I served as guest curator, with architect Craig Elwood designing the installation. But, unlike a good many other collectors, Simon himself has never met Moore:

«To me Moore and Brancusi are the greatest twentieth-century sculptors. By combining contemporary notions with a classical quality, Moore's art escapes the capriciousness I sense in so much contemporary art. One is always conscious of Moore's attempt to communicate with the viewer on many different levels. Ranging from near-sentimentality to a dynamic toughness, his work remains challenging even once you become well acquainted with it. I am convinced that his is an expression of lasting worth. His continuing growth as an artist is in itself sufficient to reject the judgement of those who claim his work to be anachronistic. It would not surprise me if his-

tory eventually would judge Moore to be one of the greatest sculptors of all times.»

In little more than ten years Taft and Rita Schreiber have built one of the most distinguished art collections in Southern California. Among their most important acquisitions are major monumental pieces, maquettes, and drawings by Henry Moore whom they have come to know quite well.

Even before they were introduced to Moore by his art-minded fellow Yorkshireman, actor Charles Laughton, they had acquired a fine Moore drawing. A top executive of MCA-Universal, Schreiber—who has become an astute and knowledgeable collector—disarmingly describes this early purchase:

«In June 1957 we were visiting a London gallery when Mrs. Schreiber spotted one little drawing she wanted to buy. I said that was fine since the price seemed to be reasonable. John Levee, the artist, happened to be with us. He turned to my wife and said: 'I think that is a very good choice. It's a fine Henry Moore drawing.' When Rita said: 'Who is Henry Moore?' Levee told us that he thought Moore to be the greatest sculptor in England today and probably one of the greatest artists in the world. That time we were just beginning to acquire art. I guess we just didn't know very much. So we bought this lovely little drawing and began our collecting of Moores without even knowing it.

«That's before we even talked to Laughton about art and two years before we actually met Henry Moore through him. It was in Summer 1959 that we had a marvelous visit at Much Hadham. We had tea with him, Irina, and Mary and had such a remarkably good and relaxed time that I had the gumption to ask him whether I could buy a couple of pieces I saw during our visit. Somehow I sensed that he felt quite friendly towards us and was delighted when he agreed

to let me have a cast of the *Seated Figure* and the *Animal Head* maquette. Once Henry agreed that he would make them available to us, I told him that I didn't want to buy them from him wholesale, so it was arranged that I would acquire these pieces through the Redfern Gallery.

«There is an interesting sidelight to our *Seated Figure.* Henry had intended to mount a wall behind the seated girl because that was his particular concept of this sculpture although he had made other seated female figures, similar to it, without the wall. I told him that we were planning to put our piece in front of our window, overlooking our garden, and that I thought the pieces would look nicer there without the wall. He readily agreed so that our cast is the only one in that series in this state. He was even nice enough to finish the seat so you wouldn't even know that there was a wall needed. After I had sent him a photograph of the piece the way it is set in our house, he said that he realized that I was right, that the sculpture looked better without the wall with our garden as a background.

«Charles Laughton had a tremendous respect for and interest in Moore. In 1958 he began sending me things about Moore and talking to me a great deal about art and collecting. At the time I was Laughton's agent, and we were close personal friends. I have a number of letters, booklets, and photographs that Laughton sent me in about 1958, and the little bronze maquette for the UNESCO *Reclining Figure* was actually given by Moore to Laughton who later gave to to me since we were building up our collection just as he was dispersing his. He wanted the piece to be part of a substantial collection.

«Laughton and Moore knew each other from the very beginnings of their taking a place in the world of fame; Laughton's fame came with his parts in 'Mutiny on the Bounty' and 'Ruggles of Red Gap' when Moore was still struggling for wider recognition. But ever since 1930, Laughton had been an avid collector. At first he could not

afford to spend too much, but when he started collecting, the prices were still fantastically low. I think Laughton knew of Moore very early, and he became the only sculptor he had in his collection which included Renoir and Seurat paintings and a great number of very lovely things which he sold many years later. During his engagement wtih the Royal Shakespeare Company at Stratford-on-Avon in 1959, Laughton had seen the Moores from time to time. He felt such a strong kinship that Moore became the only sculptor whose work he would praise. At the time the Hanover Gallery was showing some major works by Marino Marini and Alberto Giacometti along with some Moores. After we visited the show with Laughton, he said: 'Of course, Moore is the master. Marini is all right, and I think that Giacometti might make it some day.' »

Moore remembers the Schreibers' initial visit to Much Hadham was followed by their bringing Laughton to visit later the same year: «The visit that Taft Schreiber, his family, and Charles Laughton made at that time stands out very clearly in my mind because I had always admired that fellow Yorkshireman as a very fine actor. There is something glamorous about film stars that makes one treat them as something special. I remember meeting a few, including James Mason at The Museum of Modern Art opening in 1946. So when Taft brought Laughton here, I was very pleased, and I was glad that he wanted to buy a piece or two that he especially liked. We went off to lunch together near here, and I remember that Laughton was a bit edgy when someone came up to him for an autograph. He gave it all right, but he brushed them aside with some sort of a grumbling objection. Later Laughton invited all of us, because he'd met Mary, to his performance of *Lear* at Stratford which I thought was marvelous. He told us to bring Mary backstage after the performance. And we did go around to his dressing room where he was lying on a couch, absolutely exhausted. It may have been that his long, eventually fatal illness had already set in at that time. In my mind Laughton and

Schreiber are very much tied in together, and I always think of that fine actor when Taft visits or calls me.»

In 1962 the Schreibers acquired a cast of Moore's monumental *Reclining Mother and Child* sculpture which is installed at the edge of their park-like property silhouetted against the sky and the panorama of the city below. During that year, Schreiber, a trustee of the Los Angeles County Museum of Art, was also instrumental in arranging for the purchase of the *Three Piece Figure* by the late Bart Lytton, who intended to donate it to the museum, and of a large *Standing Figure* by his business associate Lew Wasserman. In 1964 Marlborough Galleries offered a cast of Moore's magnificent *Knife-Edge (Bone) Figure* to Schreiber who immediately saw it as a suitable sculpture to be placed in the lobby of the newly completed Universal headquarters building at Universal City. Schreiber recalls:

«I had no trouble at all convincing my associates to acquire this very large piece for the lobby of our building which needed an important

Reclining Mother and Child *1960-61 shown installed on the Bel Air estate of Mr. and Mrs. Taft Schreiber in Los Angeles.*

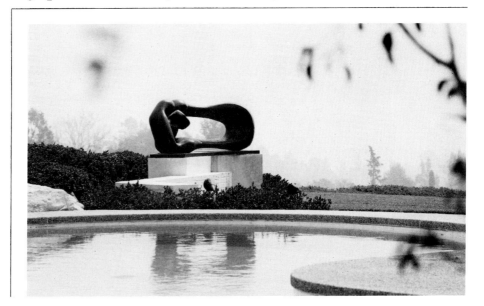

piece of sculpture. We did buy it and set it up on a specially-designed pedestal. But after a while something went wrong with the patination. When I talked to Henry about it, he explained that this cast has actually been patinated for outdoors but that his own cast—which he had set aside for his family collection—was patinated for indoors. Since he would prefer to have his own cast outdoors, he offered to trade. So we flew back the cast we originally acquired, and soon Moore's own cast was installed in our lobby.

«It is the most noticeable and conversation-provoking thing we have in our building. We have handed out thousands of copies of a special brochure we had printed about the sculpture under Henry's supervision. Some time ago we were planning to lend the sculpture to a Savings and Loan Association our corporation owns in Denver, but we had so many complaints from our employees in the headquarters building at Universal City that we decided to let well enough alone and not to disturb everybody.»

A small *Family Group* maquette, obtained directly from the artist, is the Schreibers' favorite small Moore in their possession. One of the most unusual of his works owned by them is a 1929 drawing which Moore declares to be the sketch in which «I started to play with the idea of having a figure within a figure for the first time.»

There is warmth and admiration in Schreiber's relationship to Moore. He discusses his friendship with the artist from the point of view of a man who has spent much of his life as a talent agent:

«People of talent certainly like to hear complimentary things said about them. In our industry having fans is very important to the talent. In a way, we in our family have become Henry Moore's fans. But there is far more than applause or momentary admiration in our feelings towards him. As I have come to know famous people, I have learned that there are always a limited few who seem to be able to

live gracefully with their fame without having it swell their heads. Henry's simplicity and the quality of his family life have made a deep impression on us and our children. Not only his art, but his kindness towards us, has been the most rewarding experience to me as we have become more and more involved with the collecting of art.»

Los Angeles was second only to New York in becoming acquainted with Henry Moore's work through an exhibition of twenty-four drawings at the Stendahl Galleries, then located at 3006 Wilshire Boulevard. Earl Stendahl had obtained the exhibition from Curt Valentin who had sold only about half the drawings in the exhibition that opened at his Buchholz Gallery in New York in March. Included in the Stendahl exhibition were six drawings not to be sold, among them two owned by James Johnson Sweeney. The first California collector to buy one of the drawings was Wright Ludington of Santa Barbara who acquired *Figures in a Setting* (now in the collection of the Santa Barbara Museum of Art). No record of the other purchases exists.

Stendahl, a pioneer Southern California dealer, managed to sell only three of the Moore drawings despite the fact that he had tacked to his wall a note about the drawings written by Sir Kenneth Clark, then director of the National Gallery, London. It read:

«A sculptor discovers and recreates form, and a sculptor's drawings are primarily records of his search in nature for rhythmically coherent and expressive shapes. With Henry Moore the transposition of things seen into harmonies of hump and hollow is freer than in the older sculptors, and his drawings are further from their point of departure. His sketch-books are filled with ideas for sculpture, an abundance of exciting shapes swimming over the pages, first one, then another leaping to the eye and then vanishing like salamanders into flame. From this amazing reservoir Henry Moore extracts such ideas as hold for

him a promise of development, and gives them, in larger drawings, a more independent and secure existence. A few of them may finally take solid shape in wood, stone or metal.

«Although the majority of Moore's drawings and all his recent sculpture bear no detailed resemblance to the human body, its general proportions underlie all his ideas and we have no difficulty in recognizing it, standing, seated or reclining. Indeed Moore's sense of the human organism is so strong that, like Picasso, he can hardly draw a shape in which we do not immediately discover morphological characteristics. The roots and branches of his hollowed-out forms do not exist solely for aesthetic reasons but because they seem to be necessary to the life of the figure, like heart, lung, and pelvis. This animism is at the furthest remove from the disembodied harmonies which are the usual aim of abstract art and often die of their own purity.

«There is nothing pure or exclusively cerebral about Moore's work. The color of his drawings, for example, is logically superfluous in studies for sculpture; but it is essential. It is not decorative, but emotive. It drenches each new form in a strong light of emotion and so helps to sustain for Moore himself the excitement of his first discovery. In his more elaborate drawings he uses an even stranger way of keeping his formal inventions alive: he groups them together and situates them in a definite ambience. He had begun this practice before the war but the drawings done in air raid shelters in 1940 suggested new possibilities in the composition of figures and their relation to their surroundings. His latest drawings show how this experience has been assimilated: his old, obsessive shapes re-emerge, but the draperies, and some of the terrors of shelter life still enfold them and give them the fateful air of antique tragedy.»

In his Sunday column on September 5, 1943 Los Angeles Times art critic Arthur Millier reviewed three one-man shows, finding Moore's the most puzzling:

«Moore, English sculptor, offers the strangest experience. He draws figures with precision of a passionate anatomist but the anatomy of his figures is not that of regular humans.

«In drawing after drawing he twists out weird, half-human forms like fossilized bones. Some sit carding wool. Others stand or lie in unearthly landscapes. They have small heads, vast shoulders and are apparently conceived as solid lumps from which Moore's fancy scoops hollows and holes.

«One may wonder why an artist of such evident gifts concerns himself for years with these morphological freaks, yet at the same time pays tribute to the great dignity of forms, the superb draftsmanship and the distinguished coloring.

«Moore is a leading English artist today. He got his real training in the British Museum. You may sense an influence from the Elgin Marbles in his drawings.»

A somewhat more thoughtful and revealing appraisal of California's first encounter with Moore was given by Grace Clements in her review appearing in the September 1943 issue of *Arts and Architecture:*

«Judging from reproductions which are available in this country, there appears to be a more vital abstract movement in Great Britain today than might be imagined, as well as a high level of accomplishment marked by a unity of direction which seems quite lacking in the United States. Henry Moore, British sculptor, with an exhibition of recent drawings at Stendahl's, is a subjective abstractionist who ably engages in an investigation of 'the ultimate nature, causes and reasons of things.' Because of the present difficulty of working in the materials of his medium, Moore has become a prolific draftsman. It is, of course, not surprising to find in his drawings a deep concern with

form. More unusual is the absence of eclecticism, of his adventures outside the realm of anthropometry. Though a major portion of his drawings evolve from the human form, there is ample evidence that his interest reaches beyond its physical limitations in a desire to understand and project a metaphysical understanding of the *function* of the human form. One is made to feel in his bone-like structures, not anatomy of the text book, but the architecture of man. And elsewhere when these forms have been sheathed in flesh, there is conveyed through the magnitude of his volumes as well as their penetrations, a remarkable strength, solidity, and with it all impending movement —beings highly integrated, capable of profound dignity.

«Through these abstractions of form Moore has also made felt the presence of war. From his awareness of imminent death, the destruction of life, emerges a persistence of the idea of birth, of the mother and child, the interdependence of the two. In fact, this idea of human interdependence finds constant stress in his many-peopled compositions—each figure an entity in itself, separate and alone, and yet existing in the knowledge that they are not altogether alone. In unison, their subjectively conceived bird-like heads look skyward in a common bond: death comes from above where once men turned their devotions.

«The art of Henry Moore is highly integrated, deeply sensitive, provocative of thought in a manner seldom reached by the multitude of contemporary artists who so glibly court the favor of popular taste, beguiled by the transitory acclaim of public favor, an easy prey to the passions engendered by small minds and cracker barrel philosophies. The existence and work of such men as Moore, infrequent as they may be found, are heartening rockets in the night assuring us that man is still capable of creating art.»

As curiosity value goes, the most intriguing published reaction to Stendahl's show of Moore drawings came from the painter Stanton

Macdonald-Wright, who won considerable international fame when he and Russell Morgan invented Synchromism during the turbulent teens in Paris. By 1943 Wright had temporarily abandoned this non-objective painting idiom and was producing canvases that were figurative abstractions, closely related stylistically to the work of Braque. Writing in Bob Wagner's *Script,* the «in» magazine of that moment, Wright delivered himself of the following ascerbic comments on September 11, 1943:

«At the Stendahl Galleries Henry Moore, well-known English sculptor, is exhibiting drawings done in pen and ink, pencil, and crayon. To flabbergast the great American proletariat, not to say bourgeoisie, a foreword of measured eulogy and daintily restrained praise by Sir Kenneth Clark is inserted in the catalog. I, too, have little difficulty in restraining my perfervid enthusiasm while, at the same time, recognizing Mr. Moore's undoubted talent for simple grouping and even simpler rhythmic sense.

«These drawings have an atmosphere of the post-Renaissance combined with the normal racial reactions to Modernist French influence found so often in the young English school beginning with Gaudier-Brzeska and the Vorticists. The public—that public made up of pseudo-intellectuals, loiterers, *flâneurs,* the hopeful and the art student—will doubtless be shocked or interested or irked by the so-called forms that appear with fairly boresome repetitiveness in Mr. Moore's gift to posterity. There are figures of men and women, made to look superficially like gnarled tree trunks and eroded boulders, and even like the bones of the arm and leg, placed in backgrounds of perfectly recognizable architectural details, landscapes and geometrical perspectives. There are delicate tints of green and red-orange, and even an apricot blush here and there. But let these things not mystify you—they are very simple and very intelligent.

«It is credited to Michelangelo that he once stipulated that any part

of a statue which breaks off when the statue rolls down a hill is an unimportant piece. Now apply this to modern sculpture in the mind of a man who seeks an even more compact expression. Arms and legs and head must be made larger and attached to the torso, the head must be made smaller, and less evident, and to achieve all this, the body itself must be made more massive. Often one must forego the pleasure of drawing feet or hands or features, and one must, by a mental process, closely akin to doodling, run all the semi-free appendages of the body together—as though the body were melting and thus losing its precise character. Well? You're right—there is Moore ... but Moore is not a phoney—he is a serious hard-working sculptor who attempts by too much intellectualization, to produce *original* forms, to supplant sensitive forms. . . . No, Mr. Moore, the day of doodling intelligently is gone—the day when strangeness and highly idiosyncratic abortions stirred the esthetic snobbery of a large audience is gone—the day when any foreigner could slap us down purely because he first saw the day beyond the seas, is gone—the day that established a different art criterion, based on *noli me tangere* is gone. The day when all art is submitted to the same judgment is come. You struck our shores too late. Not too little and too late, but too much and too late.»

Despite such xenophobic outpourings, a number of Southern California collectors—including director Billy Wilder, actor Vincent Price, and art patron Wright Ludington—began buying significant Moore sculptures and drawings from Curt Valentin in New York during the forties, although the bulk of Southern California Moore acquisitions were made in the fifties and sixties.

A good many art-minded Los Angeles people recall seeing the key Museum of Modern Art exhibition when it was shown at the San Francisco Museum of Art in the summer of 1947, having been invited by its director Dr. Grace McCann Morley.

On June 29, 1947 Spencer Barefoot, who later became an impresario, reviewed the large exhibition in the San Francisco Chronicle. Part of his critique read:

«Last week at the San Francisco Museum of Art, this city had the opportunity to view at first hand The Museum of Modern Art's large retrospective of the work of Henry Moore, the work of one of the most vitally creative artists of this period. Many persons who walk into the big south gallery of the museum during the next two and a half months will not become Moore enthusiasts; but many others will, and I think it is safe to predict that any one who spends a little time with the 60 pieces of sculpture and the 60 drawings on display there will be, in one way or another, deeply moved and stirred by what he has seen.

«For Henry Moore, like Rodin of an earlier time, and Picasso of the present, is one of those original and creative minds that put their stamp upon their generation. They accomplish this by their ability to assimilate and make their own influences they have had from previous eras and civilizations, and by the freshness and vigor, and the essential logic, with which they approach their own creative effort.

«The influences which have been most important in Moore's development are freely admitted by the artist in his own writings on art ethics, and they are readily distinguishable in the present show. Egyptian, Assyrian, archaic Greek, Chinese, Aztec, South Seas, African—Masaccio, Turner, Blake, Picasso—the list is a long one. But there is not a piece of sculpture or a drawing in the whole large exhibition that fails to bear the imprint of the originality, imagination and mentality of Henry Moore.

«You may not agree with all of Moore's theories in art, but I think you will have to agree that he has attained at least one of the objects of his long search to attain his own highly personal creative expression. 'For me a work must first have a vitality of its own,' he once

wrote, 'I do not mean a reflection of life, of movement, physical action, frisking, dancing figures and so on, but that a work can have in it a pent-up energy, an intense life of its own, independent of the object it may represent. When a work has this powerful vitality, we do not connect the word *beauty* with it. Beauty in the later Greek or Renaissance sense is not the aim of my sculpture. Between beauty of expression and power of expression there is a difference of function. The first aims at pleasing the senses, the second has a spiritual vitality which for me is more moving and goes deeper than the senses.' The sculptures at the San Francisco Museum of Art have that vitality, whether they are the more or less representational works of his earlier career, or the later, abstract stone carvings, or the compositions in wood and string. And they have also the 'power of expression' which Moore wanted them to have. It was Rodin who said 'a thing can only be beautiful if it be true.' To many of those who look at and think about the Moore sculpture, it will seem to have, to a high degree, the beauty of which Rodin was speaking.

«Because the Moore drawings are better known than the sculpture, less need be said about them . . . all of them reveal a brilliant technique, an original approach, and the same sense of mystery and wonder that permeates the sculpture.»

Most of the Moores in Southern California were acquired from dealers in New York and London—and a few from the artist himself. A good number of smaller pieces came from the Felix Landau Gallery on La Cienega Boulevard which closed in 1972 when its owner moved to Europe where he is active as a private dealer. Landau, who retains an office in Los Angeles, recalls:

«I began handling Henry Moore's work around 1955. On the tenth anniversary of the gallery in 1958, I had a small one-man show of small pieces and drawings by Moore. Some time in the early sixties, I

found a small terra cotta of Moore's in Los Angeles. It had never been cast. Through Harry Brooks, then at Knoedler's, I arranged for Moore to make an edition of bronzes from it. It was as a result of this transaction that I then went to see Henry Moore in England and became friendly with him. Most of the Moores we sold were small sculptures and drawings but one of producer Ray Stark's large pieces came through us.»

In the early sixties La Jolla Center museum director Donald Brewer (now the director of the University of Southern California Art Galleries) became acquainted with New York collector Charlotte Bergman. Together with her late husband Louis Bergman, she had assembled one of the largest collections of Moore pieces—mainly small ones—anywhere. The Bergmans had come to know Moore in England just before the war and had obtained a good many works from the artist himself. No fewer than twenty-three sculptures and twenty-eight drawings in Brewer's 1963 La Jolla exhibition came from this one collection while the largest piece in the show was the *Three Part Reclining Figure,* 1961-62, which the late Bart Lytton had just bought from Moore. Brewer recalls:

«I remember Lytton had the piece flown to Los Angeles so that we would have it in time for the show. Another important loan from his collection was the 1950 *Standing Figure.* As you remember, the exhibition which opened at La Jolla in August 1963 was also shown at the Santa Barbara Museum of Art and at the Los Angeles Municipal Art Gallery. It received wide attention, including photographic coverage in *Life* magazine. It was the first time a substantial number of Moore's sculpture was shown in California in 20 years.»

At the time the *Three Part Reclining Figure,* 1961, was the largest Moore sculpture in the country, and in the catalog, which also

included an account of my first visit to Much Hadham, John Russell discussed the implications of this work:

«. . . in his recent series of big scale reclining figures, of which the *Three Piece Figure* forms the climax of this exhibition, survival is the subject. These sculptures are manifestations of the ability of the human body to survive and dominate, no matter how catastrophic its surroundings. Fragmentary and ruinous the huge carcasses may be, but their condition is not one of collapse. Never are they merely inert. On the contrary: they take on the grandiose and enduring look of landscapes which have survived everything that nature, and everything that we ourselves can do to destroy them. . . . for this is the point of Henry Moore: that when so much around us is tending towards either hysteria or inanition, despair or inconstructive hatred, he has an alternative attitude to offer. He knows, as he knew in 1945, what people now need most, and what they can usefully bear.»

Although Moore was unable to accept an unofficial invitation by the City of Los Angeles to attend the Municipal Art Gallery opening of this exhibition in November 1963, its attendance was large and its impact great.

During the ten intervening years, a great many major sculptures, maquettes, and drawings by Henry Moore have found their way into Southern California public and private collections. Included among these is the important *Two Piece Reclining Figure No. 3*, 1961, that came to UCLA's Franklin D. Murphy Sculpture Garden from the estate of collector David Bright, through the generosity of his widow, Mrs. Dolly Bright Carter.

Tentative plans to stage a *Henry Moore in America* exhibition in Los Angeles on the occasion of the artist's seventieth birthday failed. However, if the Fall 1973 Los Angeles County Museum of Art exhibition of Moores from Southern California collections is

compared with the exhibition seen in Los Angeles ten years earlier, one is afforded an excellent opportunity to gauge the continuing growth of the artist's popularity among major collectors of the area.

But, not included in the 1973 exhibition is the largest of all Moore sculptures in Southern California, the 1969 *Reclining Figure: Arch Leg*—permanently and most advantageously installed at the Gallery of Fine Arts in San Diego's Balboa Park. Purchased by La Jolla art patron Norton Walbridge after seeing a photograph of the 174-inch long piece in the 1970 Marlborough-Knoedler catalog, it is represented in the Fall 1973 Los Angeles County Museum of Art exhibition by its maquette, lent by Mr. and Mrs. Walbridge.

During the past twelve years my own admiration for Moore's work and my affection for the artist himself have grown steadily. As the Art Critic of the Los Angeles Times, I have been in a position to watch and to comment upon his accomplishments over the past fifteen years. In the face of Moore's broadening and deepening of his by-now-familiar language, one cannot heed the small-and-fashion-minded hecklers who would relegate Moore to the role of an "Establishment anachronism" by claiming that his notions and methods have no contemporary relevance.

To me, the critical, scholarly, and popular acclaim Moore's work has received internationally during the past thirty years demonstrates conclusively that there is still room in our overcrowded, pluralistic contemporary art world for that rarity—a truly great artist. Moore will always follow his inner promptings and the dictates of his genius. From his long experience, unabated energy, and deep feeling will continue to come works both timeless and of the moment.

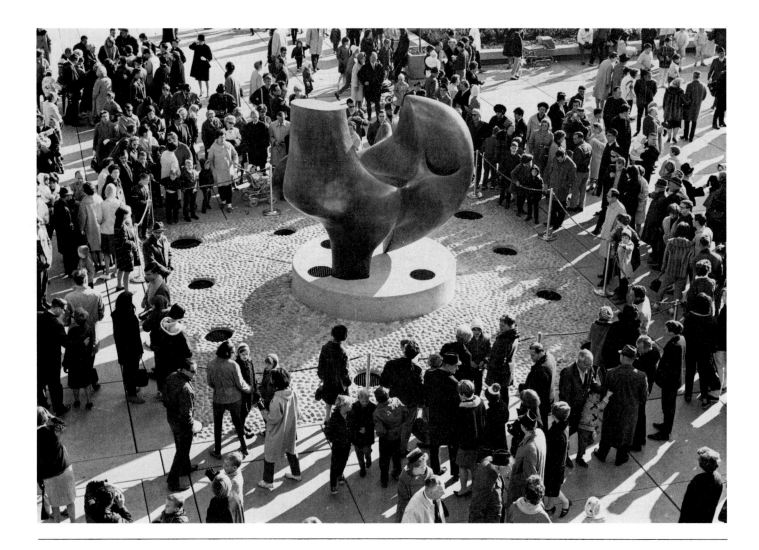

Crowds surround Henry Moore's
controversial Archer *in Toronto's*
Nathan Phillips Square shortly after
its dedication.

Toronto Moore Centre

On the North American continent Toronto will provide a permanent focus on Henry Moore's work through the Moore Centre of the Art Gallery of Ontario, now nearing completion. Paralleling his important gifts of original plasters and sculptures to London's Tate Gallery—which he long served as a trustee—the artist has agreed to donate forty major plasters and a dozen top sculptures to this Toronto museum, while also offering its trustees the opportunity to obtain casts, at cost, of about twelve completed plasters that have not yet exhausted their predetermined cast number. Moore may also allow them to purchase at casting cost one example of most of the bronzes he creates in the future.

According to William J. Withrow, the able director of the Art Gallery of Ontario, Toronto's Moore Centre will also own and exhibit an important selection of drawings. This is especially valuable in view of the fact that the Centre's appointed curator, Alan Wilkinson, now working on a doctoral thesis about Moore's work at London's Courtauld Institute, has already written authoritatively on Moore's drawings and has been, over the past few years, very much part of the artist's home establishment at Much Hadham.

Moore's gift to the Art Gallery of Toronto will insure its becoming a permanent center of Moore studies, second in importance only to the Tate Gallery in London to which Moore has not only given or bequeathed other plasters, but many sculptures as well. In 1967, with Harold Wilson Prime Minister, the British government announced that it would allot £200,000 if the Tate Gallery trustees would raise an equal amount so that a permanent Moore Gallery to house the artist's gift could be included in the planned expansion of the Tate. Plans are also afoot to preserve his Much Hadham acreage and the monumental sculptures on it, under a national trust so that future generations may see Moore's sculpture where it was conceived.

Any twenty-first century scholar wanting to seriously study Moore's oeuvre in its entirety will have to go to Canada as well as to

England, thus preserving long past his lifetime the close transatlantic ties Moore has forged. The arrangements made by the artist with the Tate Gallery and the Art Gallery of Ontario will also effectively eliminate the possibility of any unauthorized posthumous casts being made, thereby avoiding uncertainties and confusions like those which still surround Rodin pieces made after that master's death.

For a good many years Moore destroyed his plasters to make sure no casts were added to the number he had authorized. Although some of his very latest pieces were first rendered in polystyrene, a large number of monumental Moore pieces were cast from plasters he created in earlier years.

«To make a bronze sculpture you first have to make the piece in some other material. In my case it has been sometimes in clay, but mostly in plaster. These are not plaster casts; they are plaster originals. That is, they are built up in the plaster. Later I cut them down or add to them, continually altering them until I am satisfied they are ready to be cast. They are the actual works that one has done with one's own hands. At one time I used to destroy these because of what happened to someone like Rodin, who didn't destroy his originals nor leave clear instructions as to how many pieces should be in an edition of each bronze. I remember Curt Valentin telling me once that there were something like eighty casts for one particular Rodin sculpture, most of them made after Rodin died. To prevent this, just as an etcher will score the original plate, a sculptor will break the original terra cotta or plaster or whatever material he has made his original in. This was my practice until about ten years ago.

«Then someone—a friend who works at the Victoria and Albert Museum—came out one day just as we were breaking up some plasters and said, 'But why do that, because sometimes the original plaster is actually nicer to look at than the final bronze.' He was right because sometimes an idea you've had and that you've made in the original

material or plaster can suit it better than what the final bronze may do. Especially to begin with it was difficult for me sometimes in the early stages of making a bronze to visualize for sure just what the plaster I was doing would look like in bronze. But I've learned by now to know that I can change the patina of bronzes and I can visualize very easily what kind of final result there will be in the bronze as I make it in the plaster. So, this led to the idea of not destroying the plasters, leaving me with a great many of them that I would not sell but wanted to find proper homes for. The Tate's new extension will not be built for some years, nor would I want to give them all the plasters. It was this situation that made me receptive to giving them to Toronto when the idea of a possibility for a Moore Centre there was first broached to me the spring after the 1966 October unveiling of the *Archer* in front of the new city hall. There had been a lot of controversy over it there. The then-Mayor Philip Givens strongly defended it. With all the debates on it in the newspapers and everywhere it became the best-known piece of sculpture—easily—in Canada. People were saying 'what is it? What does it mean?' Since this all took place during the reelection campaign, the Mayor lost the election by a few votes. He was very nice and wrote to me during that time saying that if the controversy over my sculpture had any part in his losing the election, he was very proud of it. He met me when I went there in March 1967.

«It was at that time I also met the collector Sam Zacks, who unfortunately died recently. He had very fine modern and primitive things. Among others I met was Bill Withrow, the director of the Art Gallery, and a number of art patrons including Allan Ross and Mrs. J. D. Eaton. It was Sam Zacks who took the lead in making the necessary financial arrangements through public and private funds to provide housing for the plasters and other works I was willing to give them. I remember his coming here with Edmund Bovey, who succeeded him as chairman of the trustees, architect John C. Parkin, and

Withrow. We all went all around London together to see the different museums so that I could show them what was right or wrong with them as far as the display of sculpture is concerned. When I was eventually shown the model for the building, I could see that my ideas about that very important subject had been followed.

«This Moore sculpture Centre is only part of that museum's overall expansion, including space for the very fine collection that Sam and Ayala Zacks have donated. As far as I am concerned, it will display my plasters and some of the bronzes. But there will also be a theater where lectures on sculpture generally will be given and a library of all books on sculpture that are available. It will also house a very large slide collection of sculpture of all periods. We have signed a general agreement on the whole matter. I think that the people concerned in Toronto will do everything very well and seriously.»

The Moore Centre will not confine itself to being a permanent depository for some of Moore's most significant work. It has also been planned to function as an international study center for all twentieth-century sculpture, complete with research facilities including a comprehensive library, slide and photographic archives.

The gallery space itself will be the one exhibition facility in America that Moore himself participated in designing. Aside from the pieces to be installed in the 15,000 square-foot space, some of the monumental works will be displayed in the museum's outdoor spaces. During the artist's lifetime and for twenty-five years after his death, the Centre will focus its exhibition activities on Moore's work while also making space available to sculpture by other artists of international reputation. Under the conditions which established the Moore Centre, it will be obliged to show a representative sample of Moore's work in perpetuity and to carry out a lending policy that will allow as many people as possible an opportunity to see Moore's work.

John C. Parkin in discussion with
Moore in the offices of
Parkin Architects, Planners, Fall 1971.

Central to the realization of the Moore Centre was the controversy that arose over the installation of the *Archer* in front of Toronto's new city hall, designed by architect Viljo Revell who won an international competition for this commission. A more positive outcome was the close friendship that developed between collector Sam Zacks (who died in 1970), his wife, Ayala, and the artist. From its inception avid supporters of the Moore Centre concept included Edmund C. Bovey, now president of the Art Gallery of Ontario, Allan Ross, Mrs. J. D. Eaton, and M. F. Feheley.

Toronto architect John C. Parkin designed the new complex of the Art Gallery of Ontario, including the Moore Centre. His idea was to prevent its becoming enmeshed in a big structure and thereby losing its individual identity. Parkin told me:

«It seems to me that Toronto's involvement with Henry Moore really could be traced back to the holding of a world competition for the

design of the new City Hall and Public Square in downtown Toronto. Our then-Mayor, Nathan Phillips (after whom the square is named) fought a single-handed battle to make certain that the new city hall *was* built. The competition was won by a Finnish architect, Viljo Revell. Revell won over some 525 other competitors. This was the largest architectural competition ever held in world history. It exceeded the League of Nations competition in which Le Courbusier participated and was unfairly rejected in 1925.

«Shortly after Revell's arrival here he walked into our office and picked us as the co-architects to help execute the project with him. It was John C. Parkin who became partner-in-charge for this collaboration. Over the nearly six-year period we worked with Revell and the three design associates he brought with him—until his untimely death of a heart attack just before the project's completion—we developed a very warm and unusual business relationship.

«From the very outset Revell had the idea that there would be a major work of sculpture placed in a very conspicuous location in the Civic Square. Shortly after he began working on our plans Revell made it plain that he wanted Henry Moore, whom he considered the greatest artist in the world, to make a sculpture for the location he had chosen. As I was the design partner in our firm at the time, he told me repeatedly that, if anything were to happen to him, it would be his wish that we could carry on with his plans for a Moore sculpture.

«On his own initiative Revell paid several visits to Much Hadham and struck up a warm and very natural kind of relationship with the artist. He made photographs of the winning model available to Moore during one of his repeated visits.»

According to Moore, who vividly recalls the architect's visits, Revell understood his reluctance to accept a specific commission and his preference for having an architect choose a suitable work from among those he had already finished or was in the process of creating.

The eventual installation and dedication of the *Archer* (originally known as *Three Way Piece*) led to his first visit to Toronto which produced the initial conversations about the possibilities of creating a Moore Centre there.

«Over two years Revell visited at least three or four times out here in Much Hadham. When I was doing the working model for the *Archer,* he thought it would be absolutely the right configuration for the location on the square that he had in mind. As he was the architect of this building which was not yet completed, I let him tell me what size he thought it should be. Now I think he chose too small a size. I think that the building needed something larger. As yet, in my own experience, I have never put a piece of sculpture with architecture where the sculpture has been too big. If there has been a fault, it's always been that the size has been too small. Nothing dwarfs sculpture more than architecture. The only one piece of mine that is absolutely right in relationship to the buildings around it is that at Lincoln Center in New York. I wouldn't want it bigger, nor would I want it smaller.»

No matter what reservations Moore might now have about the size of the *Archer* in Toronto's Nathan Phillips Square, its presence there and the artist's subsequent visits to that Canadian city set into motion the efforts and negotiations that led to the Moore gift and to the now imminent opening of the Moore Centre of the expanded Art Gallery of Ontario. Parkin does not share the artist's reservation about the sculpture's size:

«I think it is difficult to judge the question of the scale of *Archer* to the Square and to City Hall because for the greater part of the day the Square is filled with people, and the *Archer* is not 'lost.' But it is separated from its relationship to the building by the people surrounding it. If you visit the Square on that rare occasion when it is virtually

empty—then it might appear well in scale. I think what Moore and Revell surely had in mind was the Square as a 'living thing,' that they weren't developing a relationship between sculpture and architecture devoid of people.

«One of the ironies was that many of the same people who opposed the Moore sculpture were people who had opposed the design of City Hall itself. An intense dislike for the whole concept had developed within a very tight circle of people. They claimed that City Hall would be too expensive, impractical and anti-functional.

«Now we have some great art collections in this city. Since the *Archer* was first unveiled, the attitude has changed completely towards public art. I think it would be a very bold person who would stake his political career *against* public art in the future.

«Revell had included the expenditure for the *Archer* in the City Hall building budget. Due to cost paring—which subsequently proved unnecessary—the sculpture was dropped from the building budget by the City Council. The morning after this action was reported in the press I received a phone call from a very good friend who said that he would set about the task of rescuing the Moore for Toronto, irrespective of the City Council action, and that he and his family foundation would give $20,000. I immediately phoned the then-Mayor of Toronto, Philip Givins—now a member of our House of Commons—to tell him the good news. Mayor Givins called in a group of very influential civic leaders who formed a committee headed by Keiller Mackay, a former Lieutenant Governor of Ottawa. Much of Mayor Givins' own energies were spent in the campaign to raise these funds just as a mayorality election campaign was underway. Unfairly some politicians claimed that his spending so much time on art somehow signified a 'distortion of values.' Givins went down in defeat.

«On the other hand, what was controversy then has now become virtue. The people who objected most are noticeably quiet now. Some

who objected most vehemently have gone down to continuing defeat themselves. They're gone because Toronto is now a vastly different city from the kind of city it was a few years ago. Toronto is now a committed city, one concerned with problems of urban environment. The Moore controversy was really a turning point—and from that eventually also came the realization of the Moore Centre.

«At a March 14, 1967 official reception, City Council was on hand to honor Moore who came to Toronto for the first time on that occasion. I was present at this reception in the Aldermen's Lounge, adjoining the City Council chamber. I was standing only a few feet away when a prominent businessman, Allan Ross, raised the question of acquiring further works by Moore for our city. Present, of course, was Samuel Zacks, then President of the Art Gallery of Ontario.

«Once the sculpture was unveiled it became increasingly less of a subject of controversy. Newspapers were filled daily with photos of people touching it, being photographed in front of it. It became an integral part of the Square as it was intended to be.

«All successive events stemmed from Moore's first Toronto visit. Henry found in this city a great new group of friends, some of whom became very close to him. First among these was Samuel Zacks. It was through his continuing persistence, right up to his untimely death, that we found it possible to secure this great Moore collection.»

I was present in mid-April 1970 at New York's Marlborough Gallery when Moore called Ayala Zacks to make plans to fly to Toronto to pay a bedside visit to her ailing husband who had become a very close friend of Moore's in a relatively short time. I saw Moore blanch as he was told that Sam Zacks was too ill to receive *any* visitors and heard him express deep anxiety after this phone call was completed. Harry Fischer immediately altered their travel plans. Only about a week after his return to Much Hadham, Moore sent a hand-written note to Mrs. Zacks:

«Dear Ayala: I am back home and have re-adjusted myself after the abnormal activities and time I spent in New York.

«Besides problems arising out of my visit to New York there were accumulated matters here at home to deal with (some of which I had to go to London to see to) or I would have written before now.

«I wanted to send our love to you both—and I wanted you to know how deeply concerned I feel about Sam. I was very upset after speaking with you, from New York, on the telephone—and I am very sad whenever I think about it. I send my love to you both and my wishes for courage and hope.»

A few months after her husband's death, I visited Mrs. Zacks in her beautiful penthouse apartment in Toronto. A strikingly handsome and energetic woman, she was born in Israel, schooled in

Art patron Sam Zacks (right) and Art Gallery of Toronto director William Withrow discuss Warrior *piece with Moore.*

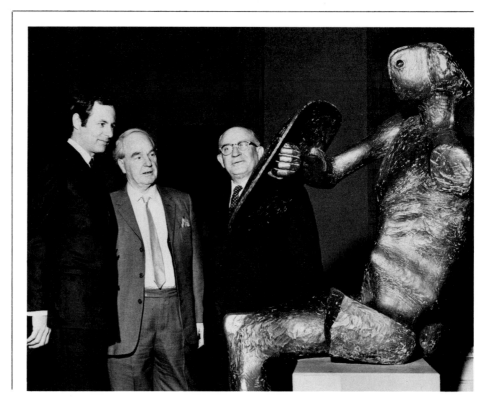

Europe, and came to Toronto in 1947. I remembered seeing selections of the wide-ranging Zacks Collection in 1957. It had been shown in the Santa Barbara Museum of Art, then under the direction of Ala Story who was one of the first to show Henry Moore's work in New York where she managed the British-American Art Center during the war. Later, together with Margaret Mallory and Erica Anderson, she was involved in the production of a film on Moore, narrated by James Johnson Sweeney and released shortly after The Museum of Modern Art Moore show of 1946-47. Mrs. Zacks told me:

«We started collecting as soon as I arrived in Toronto in 1947. Coming from France, I found Toronto quite different, artistically speaking. I also found it very difficult to get used to the hard winters of Canada. The next Spring we went to Switzerland, and every morning Sam would disappear for a while. Finally he showed me these Renoirs he had arranged to buy and said that they would be the start of bringing France right into our home. We felt a need to bring the beauties of the world around us and to create our own environment.

«Henry Moore was one of the first sculptors whose work we acquired. First we bought a few drawings and gouaches including a watercolor of the *Family Group,* and later we acquired one of his *Mother and Child* pieces, his very large *Maternity* sculpture and the beautiful *Bird* that you can almost hold in your hand and play with. We had been very much taken by his work long before we owned any of it. I knew his sculpture during the years of the war I spent in England.

«I first met Henry through some English friends about 1950. It was a wonderful meeting. They took me out to Much Hadham one day and we had tea with him and Irina and their daughter, Mary, who was a little girl then. It was a very, very beautiful afternoon. He showed us the grounds. We walked through the fields. A marvelous day.

«What I admire is that the place has hardly changed, other than the adding of the large living room. There is still the same simplicity, the

same modesty, just the bare essentials to make life pleasant without being overburdened, and they kept this trait in the house, and that is what I admire so much, both in Henry and Irina. You sometimes or even often, see artists growing into an easy material life, changing everything. The only things I have seen changed at Hoglands over the years is the addition of that beautiful living room, the magnificent pieces of art they have acquired, and, of course, the very important studios that grew on the grounds and allow his work to be so monumental now. Every time I come, there is another one. Then, he has really grown with the times, finding new media for his work and preserving the large pieces he is working on by a very transparent material, so that the outside is still part of the environment, giving it the influence of his creativeness, and this is one of the very touching and endearing things about Henry. His success hasn't changed anything in his present life.

«With the *Archer* coming to Toronto, a new involvement with Henry Moore began for us. We were not involved in its commission at all, but when he came to the Inaugural, Sam was the President of the Art Gallery, and we attended the dedication. A natural link was established again and as Sam and others began to develop their ideas about the possibilities of a Moore Centre in Toronto, he began to come more often. When he came to the unveiling of his *Atom Piece* in Chicago, he stopped here on his way home and talked at great length about the proposals Sam had been making for a Henry Moore Centre that would be an integral part of the expanded Art Gallery of Ontario. It was not just a selfish desire to have as many of his works of art as possible here but the hope that in his case the fate of the Rodin Museum, which is in itself almost a dead body now, would not be repeated.

«From the beginning it was our purpose to create a center which would attract young artists, new artists. Aside from showing the Moores we will have, we hope this will be a place to allow young sculptors to show their art within a proper space and under the best

Mrs. S. J. Zacks and Mrs. E. C. Bovey joined Moore at Empire Club Lunch in Toronto in October 1971.

possible conditions of lighting. I am sure the Henry Moore Centre will attract people from all parts of North and South America to Toronto as well as European art lovers and students, and this to us is very important.

«I think the most wonderful thing is Henry's approach to the Centre here because he shares our conviction that it has to be a place where young artists are encouraged to come, work, and exhibit.

«I remember how much Henry enjoyed the Eskimo art that my husband collected so avidly. It is the one field in our collection which I did not share so much with him. It was really all Sam's doing. He adored these early ivory carvings of birds and harpoons. There were always cigar boxes of these small pieces in his desk drawers, and he would take them out to handle them and look at them all the time. I remember how he and Henry had some wonderful times sitting on the floor playing with them, watching them, and discussing them. I stayed somewhat in the background as Sam developed his close friendship with Henry. But I enjoyed watching both of them get on to know and like each other more and more.

233

«When we were in London in the winter of 1968 to discuss the whole project, Mrs. Eaton came along, and the Boveys, I believe. It so happened that Ontario's Premier was in London at the same time. We arranged a dinner at the White Horse Inn in Soho where Henry met with them in a beautiful little room. Our architect John Parkin was also with us, and we had invited the architect who is designing the expansion of the Tate, including the space allotted to Henry's gift. «The party was extremely gay. My husband, of course, was very happy to have brought all these people together. Each one said a few words. I remember Henry was very happy on the occasion and expressed his delight at being associated with Toronto and with this venture, and that he thanked Sam. It was a wonderfully happy evening. A final decision to go ahead was made at that time so that only technical matters remained to be arranged. The following day we went with Henry to the Tate, and he explained how they were going to enlarge it. At that moment our own project became such a real thing to me, something that was beginning from the grass roots to build itself up. When Sam threw himself into something, he always carried through to the very end. Unfortunately, he did not live to see this to the end. That's why I feel that it's now upon me to carry on.»

After Moore's initial visit to Toronto in March 1967, key trustees of the Art Gallery of Ontario wasted little time in formalizing the casual ideas for the possible creation of a Moore Centre. These ideas had their origin in conversations held during the events surrounding the dedication of the *Archer*. In his capacity as chairman of that museum's board, Zacks wrote on May 30, 1967:

«Your recent visit to our city has stirred considerable interest in the idea of a Henry Moore Gallery in Toronto. Mr. Allan Ross has informed me of his talks with you at the time and subsequent correspondence. With his concurrence I am now writing to you.

Three Piece Reclining Figure No. 1
1961-62
Bronze
l. 113 in. (287 cm.)
Private Collection

Ear Piece, *1962*
Bronze
h. 7 in. (17.8 cm.)
Mr. and Mrs. Norton S. Walbridge

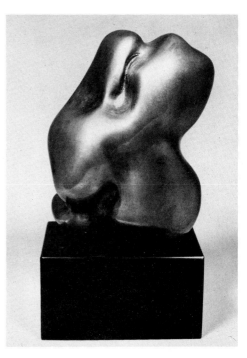

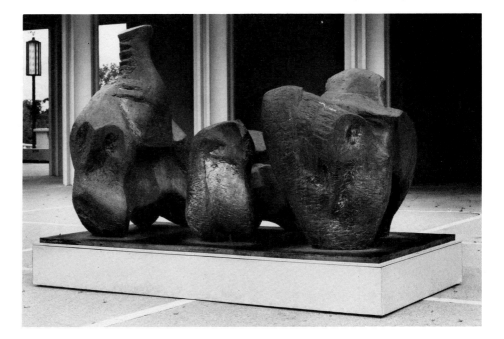

Maquette for Head and Hand, *1962*
Bronze
h. 7 in. (17.8 cm.)
Mr. and Mrs. Billy Wilder

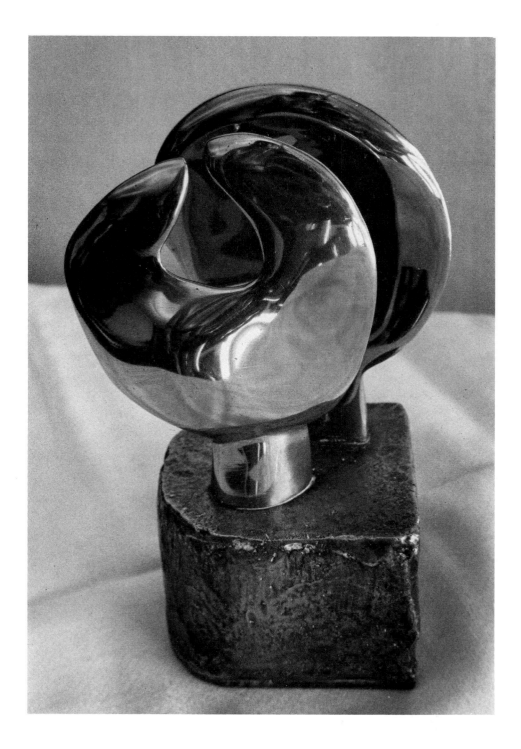

Helmet Head No. 4: Interior-Exterior,
1963
Bronze
h. 18¾ in. (47.6 cm.)
Mr. and Mrs. Stanley K. Sheinbaum

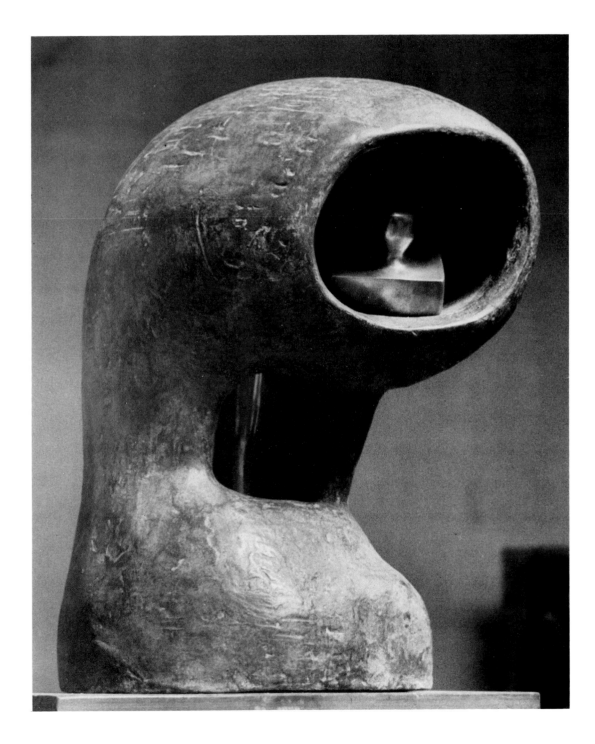

Two Piece Reclining Figure: Maquette
No. 6, *1964*
Bronze
l. 9½ in. (24.1 cm.)
Mr. and Mrs. Norton S. Walbridge

Working Model for Three Way Piece
No. 1: Points, *1964*
Bronze
h. 25 in. (63.5 cm.)
Norton Simon Foundation

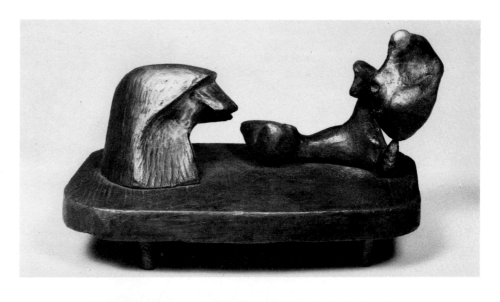

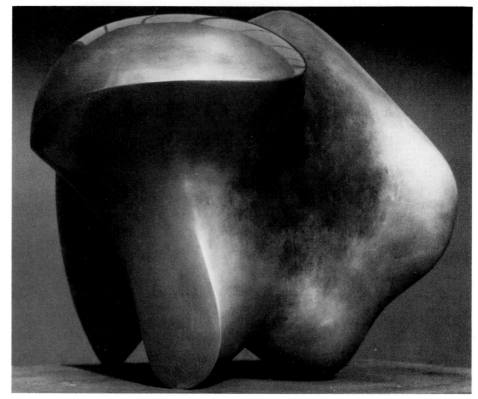

238

Two Piece Sculpture No. 7: Pipe, *1966*
Bronze
l. 37 in. (94.0 cm.)
Mickey Gribin

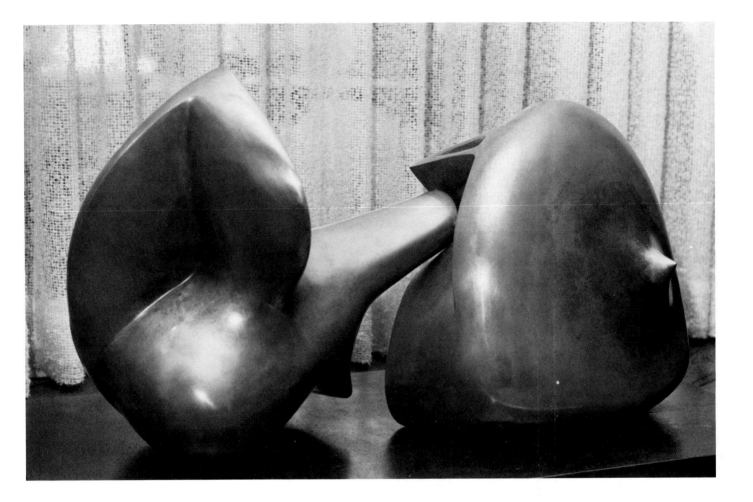

Maquette for Oval with Points, *1968*
Bronze
h. 6 in. (15.2 cm.)
Mr. and Mrs. Billy Wilder

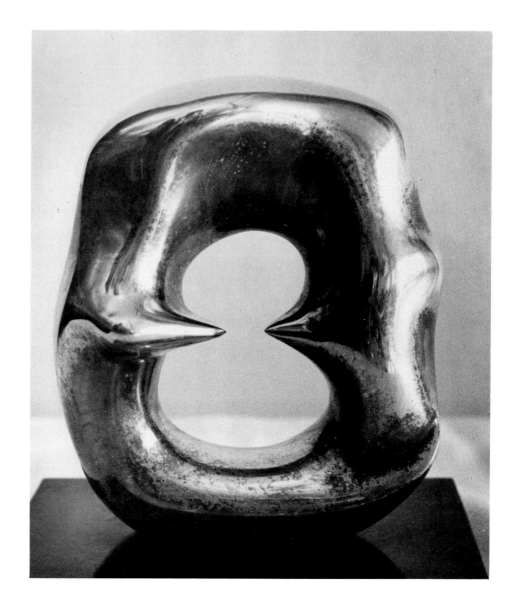

Three Piece Sculpture No. 3: Vertebrae
1968
Bronze
l. 90 in. (228.6 cm.)
Seattle First National Bank

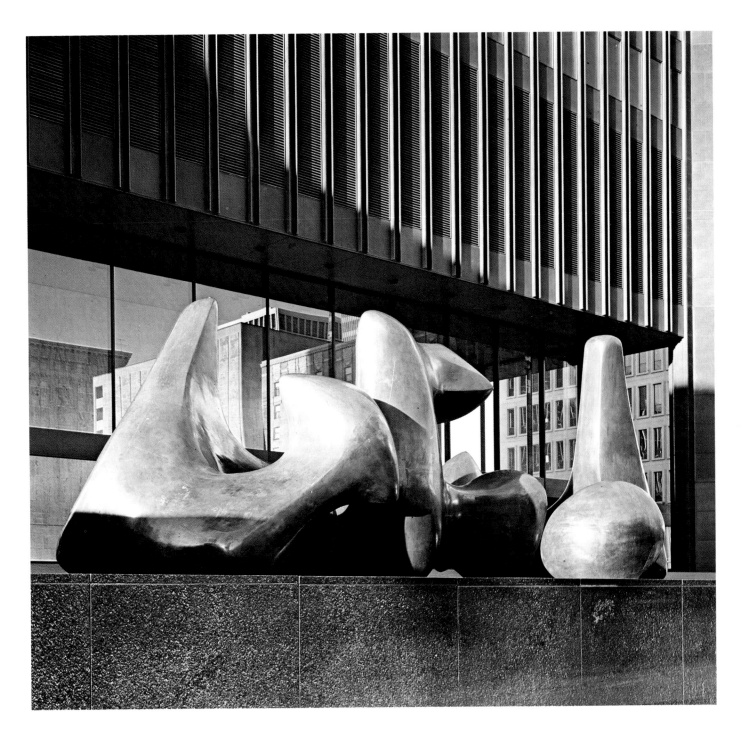

The Arch, *1963-69*
Bronze
h. 240 in. (609.6 cm.)
Bartholemew County Public Library,
Columbus, Indiana

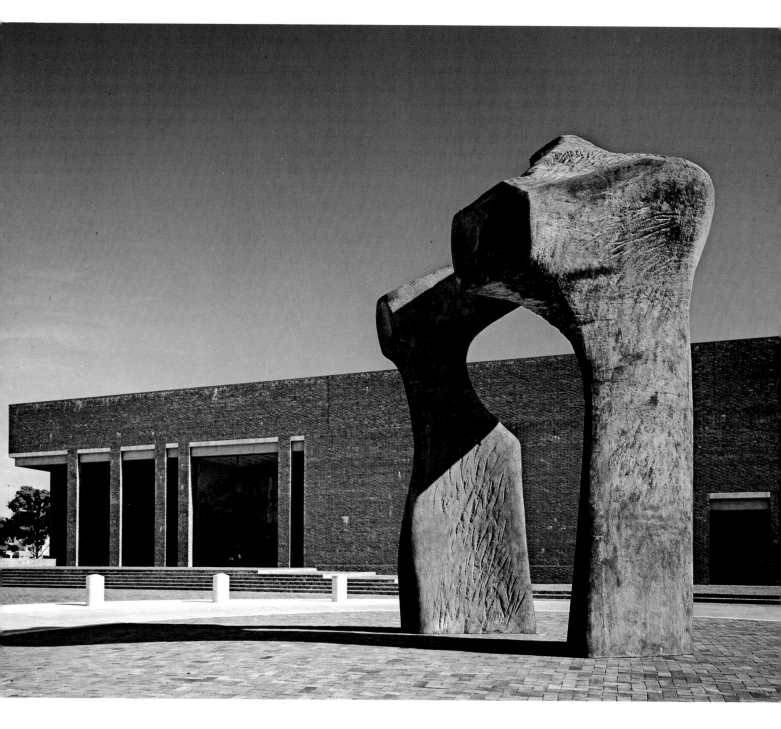

Reclining Figure: Arch, Leg, *1969-70*
Bronze
h. 172 in. (436.9 cm.)
The Fine Arts Gallery of San Diego

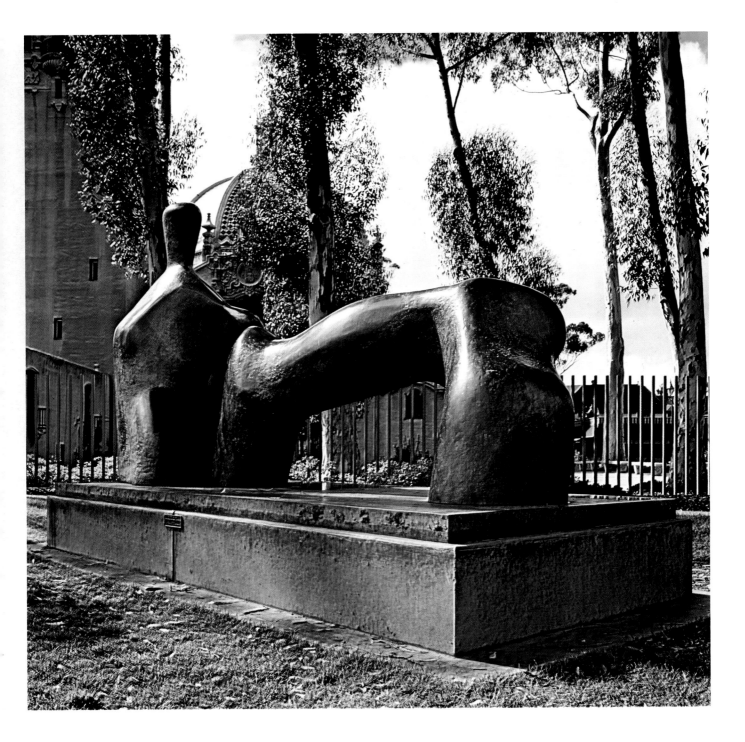

243

Stone Memorial, *1969*
Travertine marble
l. 71 in. (180.3 cm.)
Collection Mr. and Mrs. Paul Mellon,
Upperville, Virginia

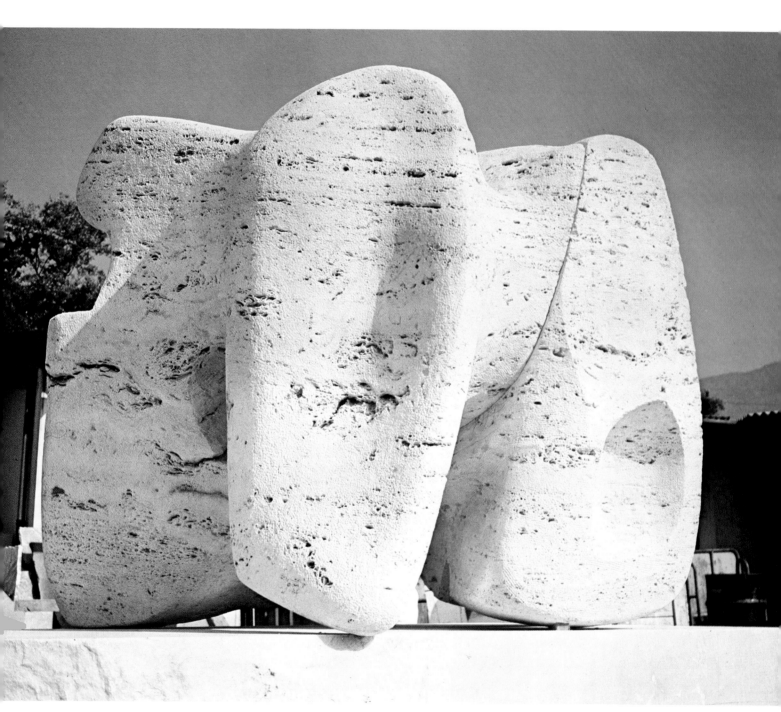

Pointed Torso, *1969*
Bronze
h. 26 in. (66.0 cm.)
The Artist

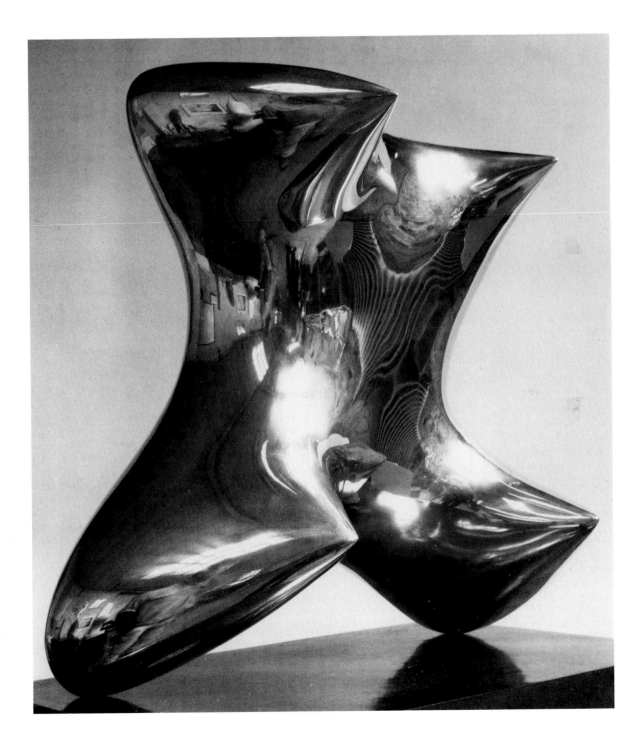

Maquette for Square Form with Cut
1969
Bronze
w. 8¼ in. (21.0 cm.)
Mr. and Mrs. Billy Wilder

Two Piece Points: Skull, *1969*
Fiberglass
h. 30 in. (76.2 cm.)
The Artist

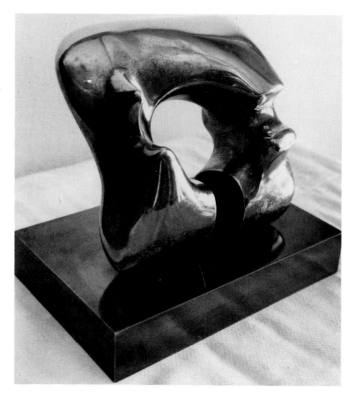

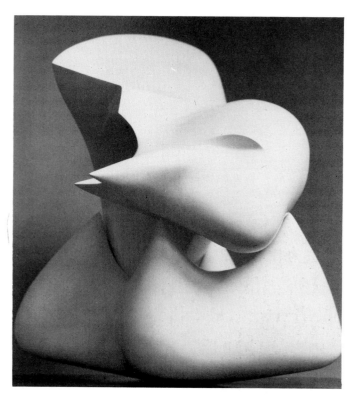

«The Gallery of Ontario has on its agenda a large expansion of the buildings and its facilities. I suggested to Mr. Ross that the Gallery would be interested in having a Moore Gallery in Toronto with a separate building, suitably located and facing a proposed new square in full view of our new City Hall. A sum of money in excess of $1,000,000 could be raised and allocated for this purpose. . . . I would like to point out that a handsome Moore Gallery and Sculpture Court on the site of our own Gallery would be most meaningful, not only to Toronto, but to this whole continent which holds your work in the highest esteem.

«In the city there are close to one hundred pieces of your works, and many would be donated to the Gallery and added to the ones you might donate, so that we could assemble a very imposing group of your creations.

«I hope you do not think I am presumptuous in writing. However, our Gallery would be interested in establishing a home for your sculptures which would befit their importance and would adequately present their development and evolution.»

Since Moore had not yet completed all arrangements for his gift to the Tate Gallery, his initial replies were hesitant and cautious. Sam and Ayala Zacks paid a visit to Forte dei Marmi that summer. Meanwhile the Art Gallery of Ontario busied itself in organizing a major Moore exhibition from Canadian sources. It was to be held during British Week in Toronto—set for October that year. In a letter inviting Moore to attend the opening as guest of honor, Gallery Director W. J. Withrow wrote on August 11, 1967:

«I was quite overwhelmed and terribly excited about the possibility you discussed with Mr. Zacks, of a Moore Pavilion and/or sculpture garden as part of our expanded gallery complex. Mr. Zacks doubtless told you of the many fine examples of your work owned by Toronto

collectors. I am enclosing a note about the part of the exhibition which is made up of local loans for your interest.

«We are keeping this idea top secret. But I must tell you that we are tempted, in our excitement, to visualize a permanent display here in Toronto under the gallery's aegis which would be the most important Moore Centre in North America. It would in its concentrated form have tremendous impact—and logic. Toronto is the centre of English speaking Canada and this would do much to strengthen our cultural ties within the Commonwealth. I do pray that this dream can be realized.»

Moore declined the invitation to attend the opening, but in a letter to Zacks suggested that he might visit Toronto in December, following the unveiling of his *Nuclear Energy* piece at the University of Chicago. During a one-day visit to Toronto on December 4, substantive discussions were held between Moore and the Art Gallery's trustees and top staffers. In these talks, Moore apparently assured them he was willing to go forward with the proposed gifts provided that solutions to the problems of housing them suitably and details of the Moore Centre's operation could be reached by the board within a reasonable time.

By September 1968, Zacks was able to assure Moore that adequate financing had been obtained, both from private and public sources, and that Ontario's Premier John P. Robarts was wholeheartedly in favor of the project. On December 9, Moore wrote a formal letter to Edmund Bovey, who had succeeded Zacks as President of the Art Gallery. He expressed his «firm intention to donate to the Art Gallery of Ontario a sufficiently large and representative body of my work to make it worthwhile building a special pavilion or gallery for its permanent display.» Little more than a month later Bovey, accompanied by John Parkin and Bill Withrow, were out at Much Hadham to discuss the Moore Centre's proposed design. Moore allotted three full days to his visitors. Parkin recalls:

«One very happy day was spent in London going over various lighting systems. First we went to the Whitechapel Gallery because—while it's a modest little gallery—the top lighting quality and the quality of light washing of the walls was very important to Moore. We visited the Elgin Galleries at the British Museum to examine the objections he had to the display of these great sculptures. Later we went to the new Hayworth Gallery which has terrible lighting and reinforced Moore's view of what not to do. The problem there was the unbelievable textured background which is competitive with the art shown. It was the summation of all that could be wrong with a gallery in Moore's opinion. We also went to the Tate to discuss its expansion and its spaces for their Moore gift, later meeting separately with the architects who kindly showed us their plans. It was a terribly important day because we would see and hear Henry point and say: 'this is the kind of thing I approve—here is that sort of thing you should have in mind' or 'there is something we should avoid.' It was extremely important that Bill Withrow was along on this tour. When we got back to Toronto, I had a very clear idea about the general objectives for the Moore Centre's design which I could pass on to my senior colleagues and to Robert Hume, a staff member of the Art Gallery, trained in design, who had much to do with the liaison between our office, the gallery, and the artist in the development of the final plans.»

Parkin sees some historical reason as one of the motives for Moore's gift, the artist being a staunch Yorkshireman and Toronto's original name having been York. A Don and a Humber River flow through Toronto as well as through Yorkshire. When I visited there, I stayed at the York Hotel. But in my own opinion Moore was persuaded by the enthusiasm and the swiftness of his new Toronto friends in implementing the Moore Centre idea.

As plans for the Centre were nearing completion, Sam Zacks

became seriously ill, and in writing to him on December 18, 1969 Moore indicated his concern and his admiration:

«. . . that you should be at all concerned over anything but yourself shows marvelous spirit and the idealism of your nature.
«I want to tell you of Mr. Hume's visit, and how things are progressing, from my point of view, with the Moore Sculpture Centre.
«I am very pleased with the plans and photographs of the model which Mr. Hume brought me. He was here for two days and we were able to talk at great length about everything, and also Alan Wilkinson was with us so that he too is kept informed of what is happening. After Mr. Hume's visit I feel sure the Moore pavilion will be very well thought out, and very well achieved. We measured out in the field at the back of our house here the size of the large exhibition room, and I am very happy with its ample size and its proposed proportions—and I am sure his visit to me was necessary and very worthwhile.
«I have told Mr. Hume that I hope to combine a visit to Toronto at the same time as a visit to New York where I am having two exhibitions opening in mid-April. Mr. Hume said that before then he will be able to send more detailed plans and photographs of further developments.»

Shortly after undergoing major surgery, Sam Zacks wrote to Moore telling the artist that:

«My sustaining hope and push has come from the Moore pavilion.
«I am determined to do all I can to have the project come into realization. Yesterday afternoon, Ed Bovey, John Parkin and Bill Withrow were my first visitors. They brought along a model which really looks beautiful. The building must begin before mid-summer. We are informed that government agencies have all approved it.»

In the last letter he wrote to Moore, Zacks reported that the Art Gallery trustees had set up a fund to finance casting of several recent Moore pieces and told the artist of an informal visit paid him at home by Ontario Premier John Robarts. He also expressed his happy anticipation of Moore's scheduled mid-April visit which was never to be.

I learned from Withrow, an ardent admirer of Moore's work whose 1967 exhibition probably jelled the Moore Centre concept both in its backers' and the artist's minds, that Zacks had not only been central to the realization of the project during his lifetime but that he had left $500,000 to the Art Gallery's building fund in his will «with no strings attached.» Also willed to the Art Gallery and the Royal Ontario Museum were Zacks's extensive collections. His widow retains a life-time possession of those works she chooses to keep in her home. One of the galleries in the new Art Gallery of Ontario complex will be devoted to major modern works already released by her to the museum. The collection of ethnic art which Zacks collected will eventually go to the Royal Ontario Museum.

An October 1971 visit by the artist allowed him to discuss final details of plans for the Moore Centre. He also renewed his friendship with its planners. A special lunch was given in his honor at the York Hotel. His stay included discussions with members of the Museum staff and of the architectural firm concerned.

Withrow is pleased that, as plans for the Moore Centre evolved, the concept changed from creating merely a show place for the Moore gift to establishing a study center for all of twentieth-century sculpture.

«When we are dealing with Moore's work, it is not something that is only valid because of current interest. Moore didn't become important just for a few years when he was influencing so many young artists and then become unimportant. That's ridiculous. He has already passed into our history and, fortunately, he is still doing things that

will pass into our history. Let's hope he will continue for a good many years.

«On this project I look to the future, not just the now. I look at posterity from the public's point of view. In the same way we are now interested in Rodin and Michelangelo, future generations will be interested in Moore. I also look forward to expanding this to a twentieth-century sculpture study center. Just as there are institutes of art history in various parts of the world famous for their particular field, such as the Middle Ages, this will be, I suggest, famous for its twentieth-century sculpture material two or three hundred years from now.

«One of the conditions I am particularly happy about is that Mr. Moore has agreed that works that are not fragile—that excluded the plasters, of course—will be available for loan to other museums once they have been shown here in our initial exhibition. I hope for additional government funds so that the private monies raised for the Moore Centre can be applied to additional purchases which would round out our Moore Collection and to casting costs so that we can take advantage of Mr. Moore's very generous offer to give us at cost one copy of most of the things he casts in the future.»

In the recent *Homage to Henry Moore* book, Withrow explains that part of the first phase of the gallery's new building program will be a two-storey wing for the Henry Moore Centre. A recessed corner entrance will lead to the one hundred-foot Moore lecture theater on the main floor. There will be both ramp and elevator accest to the Moore sculpture gallery above—a large clear space cantilevered out over both ends of the theater unit. Adjacent to this display will be the Moore studio and the Moore prints and drawings gallery. To the south of this space will be a large double gallery housing the Sam and Ayala Zacks Collection.

Drawings and Prints

Henry Moore gave an edition of one hundred lithographs of Six Reclining Figures, 1973, *to the Los Angeles County Museum of Art on the occasion of its Fall 1973 exhibition.*

Shelter Drawing, *1941*
Watercolor, crayon, and ink
7 x 10 in. (17.8 x 25.4 cm.)
Vincent Price

Figures in Landscape, *1942*
Ink, crayon, pencil, and watercolor
14 15/16 x 21 3/4 in. (35.8 x 55.2 cm.)
The Santa Barbara Museum of Art,
Gift of Wright Ludington

Figures in Setting, *1942*
Crayon, charcoal, ink, and watercolor
17¾ x 16 15⁄16 in. (45.1 x 40.9 cm.)
The Santa Barbara Museum of Art,
Gift of Wright Ludington

Two Seated Figures,
Watercolor, pencil, and charcoal
21¼ x 25¾ in. (53.9 x 65.4 cm.)
Mr. and Mrs. Stanley K. Sheinbaum

The Artist's Studio, *1956*
Ink and pencil
11 x 7⅛ in. (27.9 x 18.1 cm.)
Mr. and Mrs. Morris Treiman

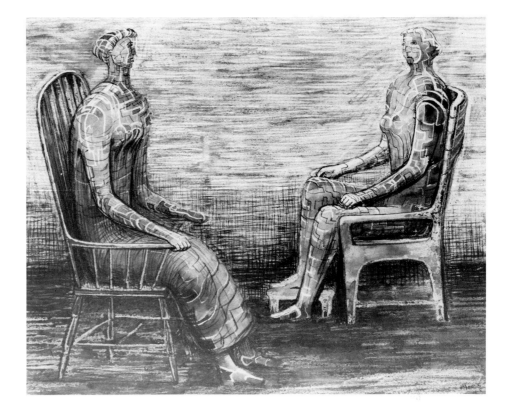

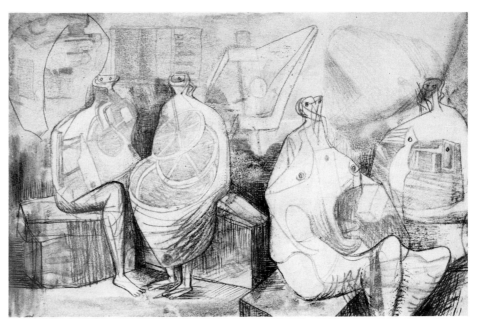

Seated Woman, *1959*
Pencil, charcoal, and gouache
9 x 11 in. (22.9 x 27.9 cm.)
Private Collection

Two Piece Reclining Figure: Points
1969
Etching
19½ x 14¾ in. (49.5 x 37.5 cm.)
Mr. and Mrs. Philip Gersh

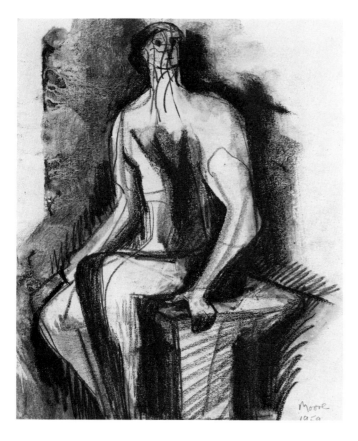

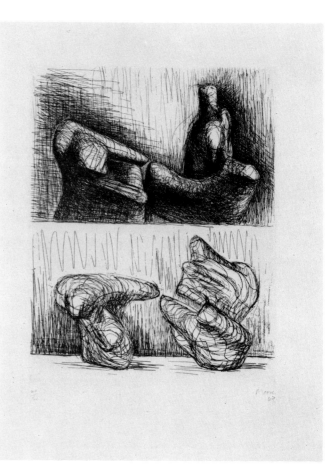

Ideas for Sculpture, *1969*
Etching
12 x 9½ in. (30.1 x 24.1 cm.)
Jerry Mayer

Ideas for Sculpture, *1969*
Etching
12 x 9½ in. (30.1 x 24.1 cm.)
Jerry Mayer

Elephant Skull, XXVIII, *1969-70*
Etching
20⅛ x 15½ in. (15.1 x 39.4 cm.)
Leon and Marion Wolcott

Elephant Skull, XV, *1969-70*
Etching
15½ x 20⅛ in. (15.1 x 39.4 cm.)
Leon and Marion Wolcott

Elephant Skull, XXVI, *1969-70*
Etching
15½ x 20⅛ in. (15.1 x 39.4 cm.)
Leon and Marion Wolcott

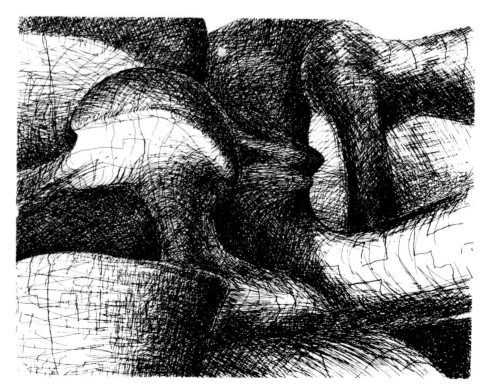

Appendixes and Bibliography

Henry Moore
in Southern California
Exhibition
Los Angeles County
Museum of Art
October 2 – November 18, 1973

Sculptures

1. *Snake,* 1924
 Marble
 h. 8 in., w. 6½ in., d. 5 in.
 (20.3 x 16.5 x 12.7 cm.)
 The Artist
 Illustrated page 39

2. *Reclining Figure,* 1930
 Bronze
 l. 7¼ in. (18.5 cm.)
 The Artist
 Illustrated page 40

3. *Composition,* 1934
 Bronze
 l. 17½ in. (44.5 cm.)
 The Artist
 Illustrated page 41

4. *Two Forms,* 1934
 Bronze
 h. 7¼ in. (18.5 cm.)
 The Artist
 Illustrated page 41

5. *Hole and Lump,* 1934
 Elmwood
 h. 22⅛ in. (56.2 cm.)
 The Artist
 Illustrated page 42

6. *Reclining Figure,* 1936-37
 (cast in 1959)
 Bronze
 h. 2⅝ in., l. 4¾ in., d. 2¼ in.
 (6.7 x 12.0 x 5.7 cm.)
 Mr. and Mrs. Bernard Greenberg

7. *Head,* 1937
 Stone
 h. 14 in. (35.6 cm.)
 The Artist
 Illustrated page 44

8. *Recumbent Figure,* 1938
 Lead
 h. 3½ in., l. 5¾ in., d. 2½ in.
 (8.9 x 14.6 x 6.4 cm.)
 Mr. and Mrs. Billy Wilder

9. *Stringed Figure: Bowl,* 1938
 (cast in 1967)
 Bronze and string
 l. 22 in. (55.9 cm.)
 Mr. and Mrs. Ted Weiner
 Illustrated page 44

10. *Stringed Figure,* 1939
 Bronze and string
 h. 10¼ in., w. 4¼ in., d. 2½ in.
 (26.0 x 10.8 x 6.4 cm.)
 Mr. and Mrs. Billy Wilder
 Illustrated page 47

11. *Mother and Child,* 1939
 Bronze, string, and wire
 l. 7½ in. (19.1 cm.)
 Dorothy and Richard Sherwood
 Illustrated page 45

12. *Reclining Figure,* 1939
 Bronze
 l. 11⅜ in. (28.9 cm.)
 The Artist
 Illustrated page 45

13. *Three Points,* 1939-40
 Bronze
 l. 7½ in. (19.1 cm.)
 Anonymous Loan
 Illustrated page 47

14. *Family Group,* 1944
 Bronze
 h. 6⅛ in. (15.6 cm.)
 Norton Simon Foundation

15. *Family Group,* 1944
 Bronze
 h. 5½ in. (14.0 cm.)
 The Fine Arts Gallery of San Diego

16. *Family Group,* 1944
 Bronze
 h. 6⅜ in. (16.2 cm.)
 Mr. and Mrs. Stanley K. Sheinbaum

17. *Family Group,* 1944 (cast in 1946)
 Bronze
 h. 5⅞ in., w. 4⅝ in., d. 2⅝ in.
 (14.9 x 11.7 x 6.7 cm.)
 Private Collection

18. *Family Group*, 1945
Bronze
h. 5¾ in., w. 4¼ in., d. 3 in.
(14.6 x 10.8 x 7.6 cm.)
Mr. and Mrs. Stanley K. Sheinbaum
Illustrated page 48

19. *Two Seated Women and a Child*,
1945
Bronze
6⅝ in. (16.8 cm.)
The Fine Arts Gallery of San Diego

20. *Family Group*, 1945
Bronze
h. 9½ in. (24.1 cm.)
Wright S. Ludington

21. *Three Standing Figures*, 1945
Bronze
h. 8¾ in. (22.2 cm.)
Mr. and Mrs. Hal Wallis
Illustrated page 85

22. *Reclining Woman*, 1945
Bronze
h. 4 in., l. 8 in., d. 2½ in.
(10.2 x 20.3 x 6.4 cm.)
Dr. Harold Torbert

23. *Reclining Figure*, 1945
Bronze
l. 7 in. (17.8 cm.)
Rita and Taft Schreiber

24. *Reclining Figure*, 1945
Bronze
h. 6½ in., l. 16 in., d. 5 in.
(16.5 x 40.6 x 12.7 cm.)
Mrs. Leona Cantor
Illustrated page 86

25. *Reclining Figure*, 1946
Bronze
h. 3½ in., l. 6½ in., d. 3¼ in.
(8.9 x 16.5 x 8.3 cm.)
Mr. and Mrs. Bernard Greenberg

26. *Family Group*, 1947
Bronze
h. 16 in. (40.6 cm.)
Mr. and Mrs. Frederick S. Weisman
Illustrated page 87

27. *Maquette for Standing Figure*
ca. 1950
Bronze
h. 10 in. (25.4 cm.)
Private Collection

28. *Rocking Chair No. 3*, 1950
Bronze
h. 12½ in., l. 10½ in., d. 4 in.
(31.8 x 26.7 x 10.2 cm.)
Private Collection
Illustrated page 88

29. *Rocking Chair No. 4: Miniature*
1950
Bronze
h. 6 in. (15.2 cm.)
Norton Simon Foundation

30. *Helmet Head No. 2*, 1950
Bronze
h. 13½ in., l. 10 in., d. 9½ in.
(34.3 x 25.4 x 24.1 cm.)
Dorothy and Richard Sherwood
Illustrated page 93

31. *Animal Head*, 1951
Bronze
l. 12 in. (30.5 cm.)
Rita and Taft Schreiber
Illustrated page 94

32. *Maquettes for Standing Figure*,
ca. 1950; *Maquette for Three
Standing Figures*, 1952
Bronze
h. 10 in., base 6 in. x 20 in.
(25.4 x 15.2 x 50.8 cm.)
Stanley Z. Cherry Family

33. *Standing Figure No. 2*, 1952
Bronze
h. 11 in. (27.9 cm.)
Private Collection

34. *Leaf Figure No. 3*, 1952
Bronze
h. 19½ in. (49.5 cm.)
Mr. and Mrs. Stanley K. Sheinbaum
Illustrated page 95

35. *Leaf Figure No. 4*, 1952
Bronze
h. 19½ in. (49.5 cm.)
Mrs. Dolly Bright Carter
Illustrated page 95

36. *Mother and Child on Ladderback
Rocking Chair*, 1952
Bronze
h. 8¼ in. (21.0 cm.)
Mr. and Mrs. Hal Wallis
Illustrated page 97

37. *Maquette for Reclining Figure
No. 2*, 1952
Bronze
l. 9¼ in. (23.5 cm.)
Mr. and Mrs. Stanley K. Sheinbaum

38. *Maquette for Reclining Figure
No. 4*, 1952
Bronze
h. 13¾ in., l. 14½ in., d. 21¾ in.
(34.9 x 36.8 x 55.2 cm.)
Private Collection
Illustrated page 96

39. *Maquette for Draped Reclining
Figure*, 1952
Bronze
h. 4 in., l. 7½ in., d. 3¼ in.
(10.2 x 19.1 x 8.3 cm.)
Private Collection

40. *Time-Life Screen: Maquette No. 4*
1952
Bronze
h. 7 in., l. 13 in. (17.8 x 33.0 cm.)
Mr. and Mrs. Ira Kaufman
Illustrated page 97

41.a,b *Hand No. 1; Hand No. 2*, 1952
Bronze
l. 13½ in; l. 13 in. (34.3 x 33.0 cm.)
Wright S. Ludington

42. *Seated Figure*, 1952-53
Bronze
h. 41 in. (104.1 cm.)
Mr. and Mrs. Frederick S. Weisman

43. *Maquette for Warrior—Without
Shield*, 1952-53
Bronze
h. 7¾ in. (19.7 cm.)
Mr. and Mrs. Stanley K. Sheinbaum
Illustrated page 98

44. *Three Standing Figures,* 1953
Bronze
h. 28 in. (71.1 cm.)
Norton Simon, Inc. Museum of Art
Illustrated page 138

45. *Reclining Figure No. 6,* 1954
Bronze
h. 4 in., l. 9 in. (10.2 x 22.9 cm.)
Rita and Taft Schreiber
Illustrated page 141

46. *Mother and Child: Petal Skirt,* 1955
Bronze
h. 6 in., w. 4⅛ in., d. 2 in.
(15.2 x 10.5 x 5.1 cm.)
Mr. and Mrs. Bernard Greenberg
Illustrated page 140

47. *Wall Relief: Maquette No. 2,* 1955
Bronze
h. 13 in., w. 18 in. (33.0 x 45.7 cm.)
Mr. and Mrs. Henry C. Rogers
Illustrated page 141

48. *Upright Motive No. 5,* 1955-56
Bronze
h. 84 in. (213.4 cm.)
Norton Simon Foundation

49. *Upright Motive: Maquette No. 6*
1955
Bronze
h. 12 in. (30.5 cm.)
Private Collection

50. *Upright Motive: Maquette No. 8*
1955
Bronze
h. 12 in. (30.5 cm.)
Mr. and Mrs. Norton S. Walbridge
Illustrated page 142

51. *Upright Motive No. 8,* 1955-56
Bronze
h. 78 in. (198.1 cm.)
Norton Simon Foundation

52. *Maquette for Reclining Figure,* 1955
Bronze
l. 6 in., d. 2½ in. (15.2 x 6.4 cm.)
Private Collection

53. *Reclining Figure,* 1956
Bronze
l. 96 in. (243.8 cm.)
Norton Simon, Inc. Museum of Art
Illustrated page 143

54. *Maquette for Mother and Child
No. 1: Reaching for Apple,* ca. 1956
Bronze
h. 6 in. (15.2 cm.)
Mr. and Mrs. Stanley K. Sheinbaum

55. *Mother and Child No. 4:
Child on Knee,* 1956
Bronze
h. 5¾ in., l. 6¾ in., d. 3 in.
(14.6 x 17.1 x 7.6 cm.)
Thomas Freiberg

56. *Mother and Child Against Open
Wall,* 1956
Bronze
h. 8 in. (20.3 cm.)
Norton Simon, Inc. Museum of Art
Illustrated page 144

57. *Draped Reclining Figure,* 1956
Bronze
l. 6½ in. (16.5 cm.)
Mr. and Mrs. Stanley K. Sheinbaum

58. *Maquette for Draped Reclining
Woman,* 1956
Bronze
l. 7 in. (17.8 cm.)
Mr. and Mrs. Stanley K. Sheinbaum

59. *Figure on Steps: Working Model
for Draped Seated Woman,* 1956
Bronze
h. 25½ in., w. 28 in., d. 26 in.
(64.8 x 71.1 x 66.0 cm.)
Mr. and Mrs. Ray Stark

60. *Maquette for Seated Woman,* 1956
Bronze
l. 6¾ in. (17.1 cm.)
Mr. and Mrs. Mark Robson
Illustrated page 142

61. *Maquette for Seated Figure Against
Curved Wall,* 1956
Bronze
w. 11 in. (27.9 cm.)
Bette and Marvin Freilich
Illustrated page 142

62. *Draped Seated Figure Against
Curved Wall,* 1956-57
Bronze
h. 9 in., w. 13 in., d. 7 in.
(22.9 x 33.0 x 17.8 cm.)
Mr. and Mrs. Billy Wilder

63. *Seated Figure on Square Steps,* 1957
Bronze
h. 9 in., w. 9½ in., d. 9¼ in.
(22.9 x 24.1 x 23.5 cm.)
Mr. and Mrs. William Fadiman

64. *Seated Figure on Circular Steps*
1957
Bronze
h. 6¾ in., w. 13 in., d. 6¾ in.
(17.1 x 23.0 x 17.1 cm.)
Private Collection
Illustrated page 146

65. *Armless Seated Figure Against
Round Wall,* 1957
Bronze
h. 11 in., w. 10 in. (27.9 x 25.4 cm.)
Private Collection

66. *Draped Reclining Figure,* 1957
Bronze
l. 29 in. (73.7 cm.)
Norton Simon Foundation

67. *Maquette for Reclining Figure*
ca. 1957
Bronze
h. 4 in., l. 8¼ in., d. 4 in.
(10.2 x 21.0 x 10.2 cm.)
Mr. and Mrs. Morris Treiman

68. *Reclining Figure,* 1957
Bronze
l. 27½ in. (69.9 cm.)
Norton Simon Foundation

69. *Maquette for Girl Seated Against
Square Wall,* 1957
Bronze
h. 9½ in., w. 6 in., d. 7¾ in.
(24.1 x 15.2 x 19.7 cm.)
Mr. and Mrs. Morris Treiman

70. *Girl Seated Against Square Wall*
1957-58
Bronze
h. 40 in. (101.7 cm.)
Norton Simon Foundation

71. *Draped Reclining Woman*, 1957-58
Bronze
l. 82 in. (208.3 cm.)
Norton Simon, Inc. Museum of Art

72. *Woman*, 1957-58
Bronze
h. 59 in. (149.9 cm.)
Mr. and Mrs. Ted Weiner
Illustrated page 181

73. *Three Motives Against a Wall No. 1*, 1958
Bronze
h. 18 in., w. 42 in.
(45.7 x 106.7 cm.)
Mr. and Mrs. Stanley K. Sheinbaum
Illustrated page 182

74. *Bird*, 1959
Bronze
l. 15 in. (38.1 cm.)
Mr. and Mrs. Ted Weiner
Illustrated page 182

75. *Relief No. 1*, 1959
Bronze
h. 88 in. (223.5 cm.)
Norton Simon, Inc. Museum of Art
Illustrated page 183

76. *Mother and Child: Hollow*, 1959
Bronze
h. 15 in. (38.1 cm.)
Mr. and Mrs. Ted Weiner
Illustrated page 183

77. *Headless Animal*, 1960
Bronze
l. 9½ in. (24.1 cm.)
Mr. and Mrs. Ray Stark
Illustrated page 185

78. *Two Seated Girls Against Wall* 1960
Bronze
h. 21½ in. (54.6 cm.)
Mr. and Mrs. Ted Weiner

79. *Two-Piece Reclining Figure: Maquette No. 1*, 1960
Bronze
h. 5¼ in., l. 9½ in.
(13.3 x 24.1 cm.)
Norton Simon
Illustrated page 187

80. *Two-Piece Reclining Figure No. 2*, 1960
Bronze
h. 51 in., l. 102 in.
(129.5 x 259.0 cm.)
Mr. and Mrs. Stanley K. Sheinbaum
Illustrated page 186

81. *Reclining Mother and Child* 1960-61
Bronze
l. 86½ in. (219.7 cm.)
Rita and Taft Schreiber
Illustrated page 91

82. *Two-Piece Reclining Figure No. 3* 1961
Bronze
l. 94 in. (238.8 cm.)
The Frederick S. Wight Art Galleries, University of California, Los Angeles, Gift of David E. Bright
Illustrated page 188

83. *Two-Piece Reclining Figure No. 4*, 1961
Bronze
l. 42 in. (106.7 cm.)
Rita and Taft Schreiber
Illustrated page 194

84. *Standing Figure: Knife Edge*, 1961
Bronze
h. 112 in., w. 46 in., d. 43 in.
(284.5 x 116.9 x 109.2 cm.)
Norton Simon, Inc. Museum of Art
Illustrated page 92

85. *Seated Woman: Thin Neck*, 1961
Bronze
h. 64 in., l. 40½ in., d. 32 in.
(162.6 x 102.9 x 81.3 cm.)
Mrs. Anna Bing Arnold
Illustrated page 193

86. *Draped Seated Figure: Headless*, 1961
Bronze
h. 8 in. (20.3 cm.)
Norton Simon

87. *Woman*, 1961
Bronze
h. 7 in. (17.8 cm.)
Mr. and Mrs. Ray Stark

88. *Three-Piece Reclining Figure: Maquette No. 1*, 1961
Bronze
l. 7¾ in. (19.7 cm.)
Mr. and Mrs. Ray Stark
Illustrated page 187

89. *Three-Piece Reclining Figure No. 1* 1961-62
Bronze
l. 113 in. (287.0 cm.)
Private Collection
Illustrated page 235

90. *Ear Piece*, 1962
Bronze
h. 7 in. (17.8 cm.)
Mr. and Mrs. Norton S. Walbridge
Illustrated page 235

91. *Maquette for Head and Hand*, 1962
Bronze
h. 7 in., w. 4 in., d. 3 in.
(17.8 x 10.2 x 7.6 cm.)
Mr. and Mrs. Billy Wilder
Illustrated page 236

92. *Helmet Head No. 4: Interior-Exterior*, 1963
Bronze
h. 18¾ in. (47.6 cm.)
Mr. and Mrs. Stanley K. Sheinbaum
Illustrated page 237

93. *Two-Piece Reclining Figure: Maquette No. 6*, 1964
Bronze
l. 9½ in. (24.1 cm.)
Mr. and Mrs. Norton S. Walbridge
Illustrated page 238

94. *Working Model for Three Way Piece No. 1: Points*, 1964
Bronze
h. 25 in. (63.5 cm.)
Norton Simon Foundation
Illustrated page 238

95. *Thin Standing Figure*, 1965
(cast in 1968)
Bronze
h. 7½ in. (19.1 cm.)
Mickey Gribin

96. *Two Three-Quarter Figures on Base*, 1965 (cast in 1969)
Bronze
h. 7¾ in. (19.7 cm.)
Private Collection

97. *Two-Piece Sculpture No. 7: Pipe*
1966
Bronze
l. 37 in. (94.0 cm.)
Mickey Gribin
Illustrated page 239

98. *Two-Piece Reclining Figure No. 9*
1968
Bronze
l. 98 in. (248.9 cm.)
Norton Simon, Inc. Museum of Art

99. *Maquette for Oval with Points*
1968
Bronze
h. 6 in., w. 5⅜ in., d. 3¾ in.
(15.2 x 13.7 x 9.5 cm.)
Mr. and Mrs. Billy Wilder
Illustrated page 240

100. *Maquette for Square Form with Cut*, 1969
Bronze
h. 7 in., w. 8¼ in., d. 5¼ in.
(17.8 x 21.0 x 13.3 cm.)
Mr. and Mrs. Billy Wilder
Illustrated page 246

101. *Pointed Torso*, 1969
Bronze
h. 26 in., l. 22½ in., d. 14 in.
(66.0 x 57.2 x 35.6 cm.)
The Artist
Illustrated page 245

102. *Two-Piece Points: Skull*, 1969
Fiberglass
h. 30 in., l. 27 in., d. 22½ in.
(76.2 x 68.6 x 57.2 cm.)
The Artist
Illustrated page 246

103. *Maquette for Reclining Figure: Arch, Leg*, 1969
Bronze
l. 7¼ in. (18.4 cm.)
Mr. and Mrs. Norton S. Walbridge

Drawings and Prints

104. *Metamorphosis of a Figure*, 1932
Crayon and ink
10 x 6¾ in. (25.4 x 17.1 cm.)
Vincent Price

105. *Sketch for Construction*, 1934
Watercolor, charcoal, and red chalk
10¼ x 14¼ in. (26.7 x 36.2 cm.)
Mr. and Mrs. Billy Wilder

106. *Figures*, 1940
Chalk, watercolor, pencil, and ink
Rita and Taft Schreiber

107. *Three Seated Figures*, 1940
Chalk and watercolor
11 x 15 in. (27.9 x 38.1 cm.)
Dorothy and Richard Sherwood

108. *Shelter Scene*, 1941
Watercolor, crayon, ink, and pencil
7½ x 11 in. (19.1 x 27.9 cm.)
Santa Barbara Museum of Art,
Gift of Ninfa Valvo to the
Donald Bear Memorial Collection

109. *Shelter Drawing*, 1941
Watercolor, crayon, and ink
7 x 10 in. (17.8 x 25.4 cm.)
Vincent Price
Illustrated page 255

110. *Figures in Setting*, 1942
17¾ x 16¹⁵⁄₁₆ in. (45.1 x 40.9 cm.)
Santa Barbara Museum of Art,
Gift of Wright Ludington
Illustrated page 256

111. *Figures in Landscape*, 1942
Ink, crayon, pencil, and watercolor
14¹⁵⁄₁₆ x 21¾ in. (35.8 x 55.2 cm.)
Santa Barbara Museum of Art,
Gift of Wright Ludington
Illustrated page 255

112. *Study for a Family Group*, 1944
Crayon, charcoal, and watercolor
Mr. and Mrs. Frederick Weisman

113. *Studies for Sculpture*, 1944
Watercolor
21 x 16 in. (53.3 x 40.6 cm.)
Norton Simon Foundation

114. *Studies for a Family Group*, 1946
Crayon, ink, and watercolor
8¼ x 6½ in. (21.0 x 16.5 cm.)
The Fine Arts Gallery of San Diego

115. *Sketches for Family Group*, 1949
Lithograph
21½ x 27½ in. (54.6 x 69.9 cm.)
Mr. and Mrs. Henry C. Rogers

116. *Family Group*, 1950
Lithograph
19 x 15 in. (48.3 x 38.1 cm.)
Mr. and Mrs. Leslie L. Johnson

117. *Red and Blue Standing Figures*
1951
Lithograph
12½ x 9½ in. (31.8 x 24.1 cm.)
Frank McCarthy

118. *Standing Leaf Figures*, 1951
Etching
6 x 9 in. (15.2 x 22.9 cm.)
Stanley Z. Cherry Family

119. *Two Seated Figures*
Watercolor, pencil, and charcoal
Mr. and Mrs. Stanley K. Sheinbaum
Illustrated page 257

120. *Figures on a Red Ground*, 1955
Watercolor, crayon, and pencil
9¼ x 7¾ in. (23.5 x 19.7 cm.)
Mr. and Mrs. Melville J. Kolliner

121. *Figures on a Grey Ground*, 1956
Watercolor, crayon, and pencil
9¼ x 11⅝ in. (23.5 x 29.5 cm.)
Mr. and Mrs. Melville J. Kolliner

122. *The Artist's Studio*, 1956
Ink and pencil
11 x 7⅛ in. (27.9 x 18.1 cm.)
Mr. and Mrs. Morris Treiman
Illustrated page 257

123. *Seated Figures*, 1957
Lithograph
21 x 14 in. (53.3 x 35.6 cm.)
Dr. Harold Torbert

124. *Seated Woman,* 1959
Pencil, charcoal, and gouache
9 x 11 in. (22.9 x 27.9 cm.)
Private Collection
Illustrated page 258

125. *Studies of Reclining Figure,* 1963
Lithograph
21 x 29 in. (53.3 x 73.7 cm.)
Dr. and Mrs. Werner Z. Hirsh

126. *Two-Piece Reclining Figure: Points*
1969
Etching
19½ x 14¾ in. (49.5 x 37.5 cm.)
Mr. and Mrs. Philip Gersh
Illustrated page 258

127. *Ideas for Sculpture,* 1969
Etching
12 x 9½ in. (30.1 x 24.1 cm.)
Jerry Mayer
Illustrated page 259

128. *Ideas for Sculpture in Landscape*
1969
Etching
12 x 9½ in. (30.1 x 24.1 cm.)
Jerry Mayer
Illustrated page 260

129. *Projects for Hill Sculpture,* 1969
Etching
12 x 9½ in. (30.1 x 24.1 cm.)
Jerry Mayer

130. *Elephant Skull,* 1969-70
Album w. 28 etchings
In folio 20⅛ x 15½ in.
(51.1 x 39.4 cm.)
Leon and Marion Wolcott
Illustrated pages 261-262

Addenda

Warrior's Head, 1953
Bronze
h. 10 in. (25.40 cm.)
Private Collection

Upright Motive: Maquette No. 4,
1955
Bronze
h. 11½ in. (29.2 cm.)
Private Collection

Architectural Project, 1969
Bronze
l. 25 in. (63.5 cm.)
Mrs. Leona Cantor

Henry Moore
Visits
to America

1946 Opening Museum of Modern Art Exhibition, New York. Visits Boston, Washington, D.C.

1953 New York, Sao Paulo, Mexico City. Wins International Sculpture Prize, Second Sao Paulo Biennale, Brazil; Alfonso Sato Soria executes mural after Moore's design at El Eco Museum, Mexico City.

1958 Receives Honorary Doctorate from Harvard University. Visits Boston and San Francisco.

1962 Opening of exhibition at Knoedler's, New York. Receives Lincoln Center Commission.

1965 Two visits to New York in connection with *Lincoln Center Piece* August and September; formal dedication on September 21.

1966 Receives Honorary Doctorate from Yale University, New Haven. Visits New York.

1967 Visits New York, Philadelphia, Chicago (for unveiling of *Nuclear Energy*). Honorary Doctorate, University of Toronto.

1970 Visits New York for installation and opening of dual exhibition at Marlborough and Knoedler Galleries.

1971 Visits Toronto, planning sessions for Moore Centre.

Exhibitions and Honors in America

1943	Buchholz Gallery (Curt Valentin)	New York
	Stendahl Gallery	Los Angeles
1946	Phillips Memorial Gallery—drawings	Washington, D.C.
	Retrospective Exhibition—Museum of Modern Art	New York
	Exhibition	Washington, D.C.
1947	Museum of Modern Art Retrospective	Chicago and San Francisco
1950	Galeria de Arte Mexicano—drawings	Mexico City
1951	Exhibition—Buchholz Gallery (Curt Valentin)	New York
1954	Exhibition—Curt Valentin Gallery	New York
1955	Exhibition of 50 drawings—University of Colorado	Boulder, Colorado
	Colorado Springs Fine Arts Center	Colorado Springs
1955 -56	Exhibition of 35 sculptures and 32 drawings—	
	Museum of Fine Arts	Montreal
	National Gallery of Canada	Ottawa
	The Art Gallery	Toronto
	Art Gallery Association	Winnipeg
	The Art Gallery	Vancouver
1957	Prize—Carnegie International	Pittsburgh
1958	Honorary Doctorate, Harvard University	Cambridge, Massachusetts
1959 -60	Exhibition—Arts Club of Chicago— sculpture and drawings	Chicago
1962	Exhibition—Knoedler Gallery	New York
	Lincoln Center Commission	New York
1963	Exhibition—Art Center, La Jolla	La Jolla
	Santa Barbara Museum of Art	Santa Barbara
	Los Angeles Municipal Art Gallery	Los Angeles
1964	Exhibition—Knoedler Gallery	New York
	Exhibition—Palacio de Bellas Artes— 32 sculptures, 39 drawings	Mexico City
1965	Exhibition—University of Arizona	Tucson
	Exhibition—Orleans Gallery— sculpture and drawings	New Orleans
1966	Honorary Doctorate, Yale University	New Haven, Connecticut
	The Archer unveiled—Nathan Phillips Square	Toronto
	Circulating drawings and sculpture show—	
	Smithsonian Institution	Washington, D.C.
	The Phillips Collection	Washington, D.C.
	De Cordova Museum	Lincoln, Massachusetts
	The Brooklyn Museum	Brooklyn
	The High Museum of Art	Atlanta
	The Denver Art Museum	Denver
	Brooks Memorial Art Gallery	Memphis

1966 *(continued)*

Philadelphia Museum of Art	Philadelphia
William Rockhill Nelson Gallery of Art	Kansas City
The Minneapolis Institute of Arts	Minneapolis
The Winnipeg Art Gallery	Winnipeg
The Detroit Institute of Arts	Detroit
Munson-Williams-Proctor Institute	Utica, New York

1967	Dedication of *Nuclear Energy,* University of Chicago (December 2)	Chicago
	Exhibition—lithographs and etchings	
	Rodin Museum	Philadelphia
	Honorary Doctorate of Laws, University of Toronto	Toronto
1967 -68	Exhibition—Art Gallery of Ontario	Toronto
	Confederation Art Gallery and Museum	Charlottetown, P.E.I.
	Arts and Cultural Centre, St. Johns	Newfoundland
	The National Gallery of Canada	Ottawa
1968	Albert Einstein Commemorative Award— Yeshiva University	New York
1970	Major Joint Exhibition—Knoedler and Marlborough Galleries	New York
1971	Honorary Doctorate of Letters, York University	Toronto
	Exhibition—*Elephant Skull Etchings*— Museum of Modern Art	New York

Major Sculptures in United States and Canadian Public Collections

1930 *Reclining Figure,* green Hornton stone, l. 37 in.—National Gallery of Canada, Ottawa
Reclining Figure, ancaster stone, l. 21 in.—The Detroit Institute of Arts

1931 *Mother and Child,* Cumberland alabaster, h. 18 in.—Joseph H. Hirshhorn Museum, Washington, D.C.

1932 *Composition,* beechwood, h. 13 in.—Atlanta Art Museum
Reclining Figure, carved reinforced concrete, l. 43 in.—The St. Louis Art Museum

1933 *Reclining Figure,* carved reinforced concrete, l. 30½ in.—Washington University, St. Louis

1934 *Two Forms,* pynkado wood, oak base, l. 21 in.—The Museum of Modern Art, New York

1935 *Sculpture,* white marble, l. 22 in.—Art Institute of Chicago

1935 -36 *Reclining Figure,* elm wood, l. 35 in.—Albright-Knox Art Gallery, Buffalo

1937 *Figure,* bird's eye marble, h. 20 in.—City Art Museum, St. Louis
Figure, bird's eye marble, h. 20 in.—Art Institute of Chicago

1938 *Reclining Figure,* lead, l. 13 in.—The Museum of Modern Art, New York
 Mother and Child, elm wood, l. 36 in.—The Museum of Modern Art, New York

1939 *Reclining Figure,* elm wood, l. 81 in.—The Detroit Institute of Arts

1939
-40 *The Bride,* lead and wire, h. 9⅜ in.—The Museum of Modern Art, New York

1945 *Two Seated Women and a Child,* bronze, h. 6¾ in.—Honolulu Academy of Art

1946 *Family Group,* bronze, h. 17⅜ in.——Phillips Memorial Gallery, Washington, D.C.

1948
-49 *Family Group,* bronze, h. 60 in.—The Museum of Modern Art, New York

1950 *Double Standing Figure,* bronze, h. 87 in.—Vassar College, Poughkeepsie, New York

1951 *Internal and External Forms,* bronze, h. 24½ in.—Rhode Island School of Design;
 Art Gallery of Toronto
 Reclining Figure: Internal and External Form, bronze, l. 21 in.—Museum of Fine
 Arts, Montreal

1952 *Time-Life Screen,* working model, l. 39¾ in.—Smith College Museum of Art,
 Northhampton, Massachusetts

1952 *Draped Reclining Figure,* bronze, l. 62 in.—Joseph H. Hirshhorn Museum,
-53 Washington, D.C.
 King and Queen, bronze, h. 64½ in.—Joseph H. Hirshhorn Museum,
 Washington, D.C.

1953 *Three Standing Figures,* bronze, h. 28 in.—Blanden Memorial Gallery, Iowa
 Reclining Figure No. 2, bronze, l. 36 in.—Winnipeg Art Gallery

1953 *Upright Internal and External Forms,* elm wood, l. 103 in.—Albright-Knox Art
-54 Gallery, Buffalo
 Reclining Figure: External Forms, bronze, l. 84 in.—Art Institute of Chicago;
 Museum of Fine Art, Toledo, Ohio; Museum of Fine Arts, Richmond, Virginia
 Warrior with Shield, bronze, h. 60 in.—Art Gallery of Toronto; Minneapolis
 Institute of Arts

1954 *Reclining Figure No. 4,* bronze, l. 23 in.—Joseph H. Hirshhorn Museum,
 Washington, D.C.

1955 *Upright Motive No. 1, Glenkiln Cross,* bronze, h. 132 in.—Joseph H. Hirshhorn
-56 Museum, Washington, D.C.; Amon Carter Museum, Fort Worth
 Upright Motive No. 2, bronze, l. 126 in.—Amon Carter Museum, Fort Worth
 Upright Motive No. 7, bronze, h. 126 in.—Amon Carter Museum, Fort Worth
 Upright Motive No. 8, bronze, h. 78 in.—Fogg Art Museum, Cambridge

1956 *Reclining Figure,* bronze, h. 96 in.—Norton Simon Inc., Museum of Art
 Figure on Steps, bronze, 25½ in.—Milwaukee Art Center

1956
-57 *Seated Figure Against Curved Wall,* bronze, l. 32 in.—Museum of Fine Arts, Boston

1957 *Working Model For* UNESCO *Reclining Figure,* bronze, l. 94 in.—Carnegie Institute,
 Pittsburgh; Art Institute of Chicago
 Seated Woman, bronze, h. 57 in.—Joseph H. Hirshhorn Museum, Washington, D.C.

1956
-60 *Upright Figure,* elm wood, h. 108 in.—Solomon R. Guggenheim Museum, New York

1957
-58 *Draped Seated Woman,* bronze, h. 73 in.—Yale University, New Haven, Connecticut

1958 *Three Motives Against Wall No. 1,* bronze, l. 42 in.—The Museum of Modern Art, New York

1959 *Two Piece Reclining Figure No. 1,* bronze, l. 76 in.—Albright-Knox Art Gallery, Buffalo

1960 *Two Piece Reclining Figure No. 2,* bronze, l. 102 in.—Museum of Modern Art, New York

1960
-61 *Reclining Mother and Child,* bronze, l. 86½ in.—Walker Art Center, Minneapolis

1961 *Seated Woman: Thin Neck,* bronze, h. 64 in.—Des Moines Art Center, Iowa
 Two Piece Reclining Figure No. 3, bronze, l. 94 in.—UCLA; Museum of Fine Arts, Dallas

1961
-62 *Three Piece Reclining Figure No. 1,* bronze, l. 113 in.—Los Angeles County Museum of Art

1962
-63 *Large Torso: Arch,* bronze, h. 78½ in.—The Museum of Modern Art, New York

1962
-65 *Knife Edge Two Piece,* bronze, 9 x 12 ft.—Queen Elizabeth Park, Vancouver

1963
-65 *Reclining Figure,* bronze, 18 x 28 ft.—Lincoln Center for the Performing Arts, New York

1964 *Three Way Piece No. 1, Points,* bronze, h. 76 in.—Columbia University, New York;
-65 Kennedy Square, Philadelphia
 Three Way Piece No. 2, Archer, bronze, h. 120 in.—Nathan Phillips Square, Toronto

1965
-66 *Nuclear Energy,* bronze, h. 144 in.—University of Chicago

1968 *Large Totem Head,* bronze, h. 95 in.—Museum of Fine Arts, Montreal
 Working Model for Vertebrae, bronze, l. 90 in.—Art Gallery of Toronto

1969
-70 *Reclining Figure: Arch Leg,* bronze, h. 172 in.—The Fine Arts Gallery of San Diego

1969 *Reclining Connecting Forms,* bronze, l. 84 in.—Storm King Art Center, Mountainville, New York

1961 *Stone Memorial,* travertine marble, l. 71 in.—National Gallery of Art,
-69 Washington, D.C.

1963 *The Arch,* bronze, h. 240 in.—Bartholemew County Public Library, Columbus,
-69 Indiana

Works
in United States
Public
Collections

Atlanta Art Museum

Blanden (Iowa) Memorial Gallery

Boston, Museum of Fine Arts

Boston, University of

Buffalo, Albright-Knox Art Gallery

Cambridge (Massachusetts), Harvard
University (Fogg Art Museum)

Chicago, Art Institute

Chicago, University of

Cleveland, Museum of Fine Arts

Columbus (Indiana), Bartholomew
County Public Library

Dallas, Museum of Fine Arts

Des Moines (Iowa) Art Center

Detroit, Institute of Arts

Fort Worth (Texas), Amon Carter
Museum of Western Art

Honolulu, Academy of Arts

Ithaca (New York), Cornell University
(White Art Museum)

Los Angeles, UCLA

Los Angeles, Los Angeles County
Museum of Art

Michigan, University of Michigan

Milwaukee, Art Center

Minneapolis, Institute of Arts

Minneapolis, Walker Art Center

Mountainville (New York), Storm King
Art Center

New Haven, Yale University Art Gallery

New York, Columbia University

New York, Lincoln Center of the
Performing Arts

New York, Solomon R. Guggenheim
Museum

Northampton (Massachusetts), Smith
College Museum of Art

Philadelphia Museum of Art

Philadelphia, Kennedy Plaza

Pittsburgh, Carnegie Institute

Poughkeepsie (New York), Vassar College

Princeton, Princeton University

Providence, Rhode Island School of Design

Richmond (Virginia), Museum of Fine Arts

Rochester (New York) University

St. Louis, Lambert Airport

St. Louis, City Art Museum

St. Louis, Washington University

San Francisco, Museum of Art

San Francisco, Golden Gateway Project

Toledo (Ohio) Museum of Art

Washington (D.C.), Phillips Memorial

Washington (D.C.), National Gallery

Washington (D.C.), Joseph H. Hirshhorn
Museum

Montreal, Museum of Fine Arts

Ottawa, National Gallery of Canada

Toronto, Art Gallery

Toronto, Nathan Phillips Square

Toronto, Moore Centre of 20th Century
Sculpture

Vancouver, Queen Elizabeth Park

Winnipeg, Art Gallery

Selected
Chronological
Bibliography

General

Read, Herbert. *Henry Moore Sculptor.*
London: Zwemmer, 1934.

Grigson, Geoffrey. *Henry Moore.*
Hardmondsworth: Penguin, 1943.

Read, Herbert. *Henry Moore, Sculptures
and Drawings.* London: Zwemmer, Lund
Humphries and Co., Vol. I, first edition
1944, second edition 1946, third edition
1949, fourth edition 1924-1948, edited
by David Sylvester, 1957; Vol. II—1948-
1954, first edition 1955, second edition
1965; Vol. III—1955-1964, edited by
Alan Bowness, 1965.

Sweeney, J. J. *Henry Moore.* New York:
Museum of Modern Art, 1946.

Argan, Giulio-Carlo. *Henry Moore.* Turin:
de Silva, 1948.

Walter, S. *Henry Moore.* Keulen: Walter,
1955.

Flemming, H. T. *Henry Moore:
Katakomben.* Munich: Piper Verlag, 1956.

Hodin, J. P. *Henry Moore.* Amsterdam:
de Lange, 1956.

————. *Henry Moore.* London:
Zwemmer, 1958.

Hofmann, W. *Henry Moore.* Schriften und
Skulpturen. Frankfurt a.M.: Fischer Verlag,
1959.

Reidl, P. *Henry Moore, König und
Königin.* Stuttgart: Reclam, 1957.

Neumann, Erich. *The Archetypal World of
Henry Moore.* New York and Routledge,
London: Bollingen Series LXVIII,
Pantheon Books, 1959.

Grohmann, Will. *Henry Moore.* Berlin:
Rembrandt Verlag, 1959; Italian version,
Milan: Il Saggiatore, 1960. New York:
Harry N. Abrams, Inc., 1960.

————. *The Art of Henry Moore.* London:
Thames and Hudson, 1960.

Sindelar, Dusan. *Henry Moore.* Prague:
SNKLU, 1961.

Hodin, J. P. *Henry Moore.* Buenos-Aires:
Carlos Hirsch, 1963.

Read, Herbert. *Henry Moore, a study of his
life and work.* New York: Praeger
Publishers, 1966.

Russell, John. *Henry Moore, Sculptures.*
Paris: Fernand Hazan, 1965

Hall, Donald. *The Life and Work of a
Great Sculptor: Henry Moore.* New York:
Harper & Row, 1966.

James, Philip. *Henry Moore on sculpture.*
New York: Viking Press, 1966.

Read, Herbert. *Henry Moore, Mère et
Enfant.* UNESCO, 1966.

David, Katalan. *Henry Moore.* Budapest:
Corvina, 1968.

Russell, John. *Henry Moore.* New York:
Putnam, 1968.

Hedgecoe, John. *Henry Moore.* New York:
Simon and Schuster, 1968.

Finn, David. *As the Eye Moves . . . a
sculpture by Henry Moore.* New York:
Harry N. Abrams, Inc., 1970.

Melville, Robert. *Henry Moore, Sculpture
and Drawings 1921/69.* London: Thames
and Hudson, 1970; New York: Viking,
1970.

Jianou, Ionel. *Henry Moore.* Bucharest:
Editura Meridiane, 1971.

Wilkinson, Alan. *The Drawings of Henry
Moore.* Alhambra, USA.: Borden
Publishing Co., 1970.

Argan, Giulio Carlo. *Moore.* New York:
Harry N. Abrams, Inc., 1972.

Fezzi, Elda. *Henry Moore, I Maestri del
Novecento.* Florence: Sansoni Editori,
1972.

Mitchinson, David. *Henry Moore Unpublished Drawings.* New York: Harry N. Abrams, Inc., 1972 (first published in Italian by Fratelli Pozzo).

San Lazzaro, G. di, et.al. *Hommage à Henry Moore.* Paris: XXe Siècle, 1972.

Carandente, Giovanni. *Henry Moore Exhibition Catalogue, Forte di Belvedere.* Florence: Il Bisonte Editori, 1972.

Cramer, Gerald; Grant, Alistair; Mitchinson, David. *Henry Moore, Catalogue of Graphic Work 1931-1972.* Geneva: Gerald Cramer, 1973.

Articles

"London letter." L. Gordon-Stables. *Art News* 29:17, May 9, 1931.

"Exhibition, Leicester Galleries." G. St. Bernard, *Atelier* I (Studio 101) 450 & June, 1931.

"Seven Sculptors." E. M. Benson. *American Magazine of Art,* 28:466-8, Aug., 1935.

New York Times 23:2, Oct. 12, 1937.

"Henry Moore, by H. E. Read." Review *Brooklyn Museum Quarterly* 27:70, April, 1938—Y. I. H. Bauer.

"Exhibition, Buchholz Galleries." *Art Digest* 17:14, 4-6, May 15, 1943.

New York Times II, 12:4, May 16, 1943.

"Mountainous sculptor draws; exhibition, Buchholz Gallery." *Art News* 42:12, May 15, 1943.

"Rival Greatest Sculptors." *Newsweek* 21:81-2, May 24, 1943.

"England's Moore." *Time* 41:71, June 7, 1943.

"English Sculptor." D. MacAgy. *Architect & Engineer* 154:4-6, Aug., 1943.

"Los Angeles exhibition." G. Clements, *Calif. Arts & Architecture* 60:4, Sept., 1943.

"Madonna, Modern Version." *Newsweek* 24:96, Dec. 18, 1944.

"Madonna for St. Matthew's, Northampton." K. M. Clark, *Magazine of Art* 37:247-9, Nov., 1944. Reply W. Hussey 39:165, Apr., 1946.

"Henry Moore." E. M. Neumeyer. *Arts & Architecture* 62:30-1, & Oct., 1945.

"Henry Moore by G. Grigson." Review *College Art Journal* 6 no. 1:72-4, 1946.

"Henry Moore: sculpture & drawings, ed. by H. E. Read." Review *College Art Journal* 1:72-4, 1946. *Magazine of Art* 38:242, Oct., 1945.

New York Times 23:1, Nov. 27, 1946.

"America's first view of England's first sculptor at Museum of Modern Art." A. M. Frankfurter. *Art News* 45:26-9, & Dec., 1946.

"Arrives in the U.S." *Art Digest* 21:13, Dec. 1, 1946.

"Art in England Today." J. T. Soby. *Saturday Review of Literature* 29:76, & Dec. 7, 1946.

"England Sends us a Controversial Artist." E. Newton. *New York Times Magazine,* pp. 22-3, Dec. 15, 1946.

New York Times 27:2, Dec. 18, 1946.

"Carver." *New Yorker* 22:18, Dec. 21, 1946.

New York Times II, 12:1, Dec. 22, 1946.

"Introducing Mr. Moore and Mr. Delvaux." R. M. Coates. *New Yorker* 22:51-2, Dec. 28, 1946.

"Moore Modernism." *Newsweek* 28:70, Dec. 30, 1946.

"Not Beauty." *Time* 48:40+, Dec. 30, 1946.

"Introduction to Henry Moore." G. Richter. *Art in America* 35:4-18, Jan., 1947.

"Exhibition, Leicester Galleries." C. F. Gordon. *Studio* 133:26, Jan., 1947.

"Modern Briton impresses with his aesthetic vitality's exhibition at Museum of Modern Art." *Art Digest* 21:9, & Jan. 1, 1947.

"British Sculptor." N. F. Busch. *Life* 22:77-80, Jan. 20, 1947.

"Sculpture & Drawings exhibition at New York's Museum of Modern Art." *Architectural Forum* 86:130, & Feb., 1947

"England's most noted sculptor." *Design* 48:14-15, Feb., 1947.

"Art." C. Greenberg. *Nation* 164:164-5, Feb. 8, 1947.

"Art." W. Murrell. *New Republic* 116:38-9, Feb. 17, 1947.

"Quotations by the sculptor." Portrait *Arts & Architecture* 64:21-3, Mar., 1947

"Moore comes to America." J. D. Morse. *Magazine of Art* 40:96-101, Mar., 1947.

"Moore: positive and negative." R. M. Pearson. *Art Digest* 21:29, Mar. 15, 1947.

"Madonna & Child in Church of St. Matthew, Northampton." *Art News* 46:20-1, Apr., 1947.

"Henry Moore." K. Blackshear. *Chicago Art Institute Bulletin* 41:43-7, & Apr., 1947.

"Interviewed by B. Rosenthal." *Arts & Architecture* 64:33, & May, 1947.

New York Times 20:1, May 23, 1947.

"For Tomorrow's Collector." *Hobbies* 52:157, June, 1947.

"Exhibition at San Francisco Museum of Art." *Architect & Engineer* 170:9, July, 1947.

"Henry Moore: The reclining — figure." F. S. Wight. Bibliog. *Journal of Aesthetics and Art Criticism* 6:95-195, Dec., 1947.

"Morning After the Blitz (drawing) bought by Hartford." *Art News* 47-36, Sept., 1948.

"Holes of Henry Moore: on the function of space in sculpture." R. Arnheim. *Journal of Aesthetics and Art Criticism* 7:29-38, Sept., 1948.

"Drawings & — at Roland, Browse & Delbanco." *Art News* 47:63, Dec., 1948.

"St. Louis Buys Reclining Woman." *Art Digest* 23:17, April 1, 1949.

New York Times II, 8:1, May 8, 1949.

"Sculptures & Drawings at Buchholz Gallery." *Art Digest* 23:9, May 15, 1949.

"Yorkshire Pudding." *Time* 53:81, May 16, 1949.

"Portrait." *Interiors* 108:27, June, 1949.

"Churchman discusses art in the church." W. Hussey. *Studio* 138:80-1, Sept., 1949.

"Four transoceanic reputations." H. McBride. *Art News* 49:26-9, & Jan., 1951.

"Moore's apertures shown at Buchholz Gallery." *Art Digest* 28:15, March 15, 1951.

"Art Galleries." R. M. Coates. *New Yorker* 27:57, Mar. 17, 1951.

"Henry Moore's metal sculpture." K. Clark. *Magazine of Art* 44:171-4, May, 1951.

New York Times VI, 30:1, May 6, 1951.

"To have retrospective at the Tate." *Art News* 50:54, June, 1951.

"Exhibitions at the Tate and the Leicester Galleries." *Studio* 142:62, Aug., 1951.

"Henry Moore." R. Le May. *Studio* 142:190, Dec., 1951.

"Reclining figure acquired by The Museum of — Academy of Art." S. A. Snyder. *Detroit History of Arts: Art Quarterly* 15 no. 3:270, 1952.

"Visit to Henry Moore." R. M. Alfrod. *Rhode Island School of Design Museum Notes* 9:(3-4), Jan., 1952.

"Henry Moore's bronze: *Interior Exterior*." R. M. Alford. *Rhode Island School of Design Museum Notes* 9:(4), May, 1952.

New York Times 31:2, Sept. 25, 1952.

"Sculptor in Modern Society." *Art News* 51:24-25, Nov., 1952.

"Film review; new documentary on Henry Moore." H. M. Franc. *Magazine of Art* 46:138, Mar., 1953.

"Exhibition, Boston Institute of Contemporary Art." *Art Digest* 27:11, Apr. 1, 1953.

"Art & Religion." *Art Digest* 28:9, Dec. 15, 1953.

"Sutherland-Moore exhibition in Vancouver." *Canadian Art* II no. 2:77, 1954.

New York Times II, 10:3, Feb. 28, 1954.

"Moore bronzes at the Leicester Galleries." *Art News* 53:47, Mar., 1954.

"New Directions." *Time* 63:72, Mar. 1, 1954.

New York Times 9:2, Mar. 6, 1954.

"Chat with Moore in his exhibition of bronzes at Leicester Galleries." *Art Digest* 28:14-15, Mar. 15, 1954.

New York Times II, 10:3, Mar. 28, 1954.

"Mexico-mural at Mexico City's El Eco." M. Lukin. *Art Digest* 28:19, Aug., 1954.

"Work of Henry Moore." C. Falkenstein. *Arts & Architecture* 71:11, & Sept., 1954.

"Deposed royalty bronze sculpture, *King & Queen*, removed from office building lobby." *Interiors* 114:165, Nov., 1954.

New York Times 25:5, Nov. 2, 1954.

New York Times II, 10:1, Nov. 7, 1954.

"Exhibition of 32 new and interesting creations at Curt Valentin Gallery." *Art Digest* 29:22, Nov. 15, 1954.

"Art galleries; exhibition of sculptures at The Valentin." R. M. Coates. *New Yorker* 30:114, Nov. 20, 1954.

"Exhibition at the Curt Valentin Gallery." *Art News* 53:49, Dec., 1954.

"Moore & Hepworth, a comparison of their sculpture." D. Lewis. *College Art Journal* no. 4:314-19, 1955.

"Recent Show at the Valentin Gallery." *Art & Architecture* 72:30, Feb., 1955.

New York Times VI, 38:3, Mar. 20, 1955.

"Warrior with Shield." R. S. Davis. *Minneapolis Historical Bulletin* 44:25-31, July, 1955.

"Warrior with Shield, bronze sculpture acquired by Minneapolis Institute of Arts." *Arts* 30:9, Oct., 1955.

"*King & Queen* from the Keswick collection at Dumfries, Scotland." J. Langsner. *Arts & Architecture.* 72:20-1, Dec., 1955.

"London; exhibition at Leicester Galleries." P. Heron. *Art* 30:12, Jan., 1956.

"Meaning & Symbol in 3 modern artists, Edvard Munch, Henry Moore, Paul Nash." G. F. W. Digby. Review *College Art Journal* 15 no. 3:284-5, Jan., 1956.

"Henry Moore, ex-revolutionary." E. Newton. *New York Times Magazine,* p. 28+, May 13, 1956.

"Sculpture through the Camera Eye: Reclining Figure, 1939." photographs and commentary by C. F. Laughlin. *Arts* 30:21-5, June, 1956.

New York Times 1:4, June 13, 1956.

"Sculpture Outside." *Time* 70:70-1, Aug. 12, 1957.

"Dublin letter; plan for Yeats memorial." G. Fallon. *America* 98:46, Oct. 12, 1957.

"Internal & External Forms and Two Figures...." S. L. Faison, Jr. *Buffalo Gallery Notes* 21 no. 3:6-11, Summer, 1958.

New York Times 10:3. June 13, 1958.

"Henry Moore, Sculptor in the English tradition." Y. Langsner. *Arts & Architecture* 75:10-11, Aug., 1958.

"Pittsburgh bicentennial international: the prize awards." G. B. Washburn. *Carnegie Magazine* 32-333, Dec., 1958.

"Henry Moore's UNESCO statue." W. J. Strachan. *Studio* 186:170-5, Dec., 1958.

New York Times II, 15:3, Mar. 22, 1959.

"Famous Shaper of Stone." *Life* 46:107-8+, Apr. 13, 1959.

"Henry Moore, sculpture in Canada; with French summary." A. Jarvis. *Canadian Art* 16:82-7, 153, May, 1959.

New York Times 22:2, June 29, 1959.

"Heads, figure & ideas, with a comment by G. Grigson." Review W. Ames. *College Art Journal* 18 no. 4:370-1. Summer, 1959; *Connoisseur* (Am. ed.) 142:261, Jan., 1959.

"Henry Moore, by J. P. Hodin." Review *Studio* 158:32, July, 1959. P. Rouve.

"Archetypal World of Henry Moore." by E. Neumann. Review *Commonweal* 70:502-3, Sept. 11, 1959. B. Kaufman.

"Maker of Images." *Time* 74:78-82+, Sept. 21, 1959.

"Sculpture in the ascendant in London exhibitions." A. Bowness. *Arts* 34:18, Nov., 1959.

"UNESCO house appraised: The Art." J. E. Burchard. *Architectural Record* 127:154-6, May, 1960.

"London Letter: sculpture renaissance." J. Russell. *Art in America.* 48 no. 2:106-8, Summer 1960.

"New accessions: Reclining Figure (External Form)." *Toledo Museum News* no. 3:69, Summer 1960.

"Three works in Masters of Modern Art Exhibition." G. S. Whittet. *Studio* 160:117, Sept., 1960.

"Archetypal world of Henry Moore by E. Neumann." Review *Art Journal* 20 no. 2:120, Winter 1960-61. Y. Schmier; *Canadian Art* 16:287, Nov., 1959.

"Two early works by H. Moore." M. C. Reuppel. *St. Louis Museum Bulletin* 45 no. 4:87-9, 1961.

"Dedication of the Moore figures at Lambert airport plaza." A. C. Ritchie, *St. Louis Museum Bulletin.* 45 no. 4:90-2, 1961.

"Mooresday." J. Russell. *Art News* 59:47, Jan., 1961.

"Decade of Moore's work at the Whitechapel." A. Bowness. *Arts* 35:16-17, Feb., 1961.

"Art of Henry Moore, by W. S. ———." Review *Connoisseur* (Am. ed.) 147:49, Mar., 1961.

"Exhibition at the Whitechapel art gallery." G. S. Whittet. *Studio* 161-106, Mar., 1961.

New York Times 22:7, Mar. 9, 1961.

New York Times 42:1, May 2, 1961.

New York Times 5:7, May 5, 1961.

"Art of Henry Moore, by W. Grohmann." Review *Art Journal* 20 no. 4:252, Summer 1961. J. P. Hodin.

"Art for Investment." G. Savage. *Studio* 162:36, July 1961.

"Artist & the Book." *Studio* 162-119, Sept., 1961.

"Show at the New London Gallery." G. S. Whittet. *Studio* 162-103, Sept. 1961.

"Art News from Paris." P. Schneider. *Art News* 60:52, Nov. 1961.

"Henry Moore on a Dutch Hilltop: the new sculpture park at Otterlo." L. Herrmann. *Connoisseur* 148:303-5, Dec. 1961.

"Henry Moore's World; interview." ed. by C. Lake. *Atlantic* 209:39-45, Jan. 1962.

New York Times 2:6, Jan. 28, 1962.

"Form of Space." J. Canaday. *New York Times Magazine,* p. 99, Mar. 18, 1962.

"Henry Moore at Knoedler Galleries." *Arts* 36:32, Mar., 1962.

"Rougher Moore." *Time* 79:70, Mar. 23, 1962.

New York Times II, 19:1, Mar. 25, 1962.

"Tougher Side." *Newsweek* 59:84, Mar. 26, 1962.

"Exhibition at Knoedler Gallery." *Art News* 61:10, May, 1962.

"Exhibition at Knoedler." S. Tillim. *Arts* 36:82-4, May, 1962.

"Exhibition at the Knoedler Gallery." *Progressive Architecture* 43:88, May, 1962.

"Exhibition at Knoedler's." D. Ashton. *Art & Architecture* 79:4, June, 1962.

New York Times 30:3, July 25, 1962.

New York Times 18:6, Aug. 10, 1962.

"Contemporary British & Canadian Art." A. F. Page. *Detroit Historical Bulletin*, 42 no. 9, Autumn 1962.

"Amon Carter Museum of Western Art acquires three 11 ft. high bronzes." *Architectural Forum* 117:13, Sept. 1962.

"Major sculpture commissions for Moore, Paisa." *Art News* 61:9, Sept., 1962.

"Exhibition at New London Gallery." G. S. Whittet. *Studio* 164-157., Oct., 1962.

"Henry Moore, sculptural innovator." H. F. Collins. *School Arts* 62:36-7, Oct., 1962.

"Moore explains his universal shapes." V. Russell and J. Russell. *New York Times Magazine*, pp. 60-1+, Nov. 11, 1962.

"Artistic process as qualitative problem solving." D. W. Eckes, *Journal of Aesthetics & Art Criticism*, 21 no. 3.284, Spring 1963.

New York Times 38:2, Aug. 28, 1963.

"On the Shore with Moore." *Life* 55:73-4+, Sept. 6, 1963.

"Letter from London; exhibition of H. Moore's and F. Bacon's works." M. Painter-Downes. *New Yorker* 39:100+, Sept. 7, 1963.

"Henry Moore." H. J. Seldis. *Art in America* 51:56-9, Oct. 1963.

"Bond Street, Baltersea." G. Baro. *Arts* 38:32, Oct. 1963.

"Paintings & Sculpture in the collection of Mrs. Mark C. Steinberg." W. N. Elisendrath, Jr. *Connoisseur,* 154:270, Dec. 1963.

"Market for Modern Art." G. Savage. *Studio* 167:130, Mar., 1964.

"Genius of Michelangelo as seen by Moore; ed. by D. Sylvester." *New York Times Magazine,* p. 16-17+, Mar. 8, 1964.

"Henry Moore: sculpture against the sky." *Studio* 167:178-85, May, 1964.

New York Times II, 21:5, June 14, 1964.

"Exhibition at the Knoedler Gallery." *Art News* 63:11, Sept., 1964.

"In the London Galleries." J. Russell. *Art News* 63:49, Sept., 1964.

New York Times 24:6, Dec. 17, 1964.

"Phenomenon of British Sculpture." C. S. Spencer. *Studio* 169-98, 105, Mar., 1965.

"Henry Moore, sculptor." *Harper* 230:59-61, Apr., 1965.

New York Times 38:1, July 13, 1965.

New York Times II, 21:8, July 18, 1965.

New York Times 41:8, Aug. 25, 1965.

New York Times 35:1, June 14, 1965 and 41:5, Aug. 25, 1965.

New York Times II, 19:4, Aug. 29, 1965.

"Sculpture and Drawings, ed. by A. Bowness with introduction by H. Read." Review of Vol. 3 *Studio.* 170:134, Sept., 1965.

"Heroic Bather." *Time* 86:60, Sept. 3, 1965.

New York Times 59:1, Nov. 16, 1965.

"Henry Moore in New York." *Connoisseur,* 160:247, Dec., 1965.

"Sculpture returns to Athens: the first Panathenae of world sculpture." C. S. Spencer. *Studio* 170-235, Dec., 1965.

"Profiles." D. Hall. *New Yorker* 41:66-8+, Dec. 11; 59-60+, Dec., 1965.

"Drawing and Sculpture." M. Levy. *Studio* 171:26-9, Jan., 1966.

New York Times 43:5, Mar. 24, 1965.

New York Times II, 30:3, Mar. 27, 1966.

New York Times 42:2, June 14, 1966.

New York Times VII, p. 47, July 10, 1966.

"Drawings shown at the Marlborough." E. Lucie-Smith. *Studio* 172:196, Oct., 1966.

New York Times 24:1, Oct. 29, 1966.

"Showing at the Marlborough New London Gallery." G. Whittet. *Studio* 170:37, Oct., 1966.

New York Times 29:3, Feb. 28, 1967.

New York Times 29:4, Feb. 28, 1967.

"Henry Moore on Sculpture: a collection of the sculptor's writings and spoken words." ed. by P. H. Janus, Reviews and *Connoisseur,* 164:192-3, Mar., 1967 and *Studio* 172:160, Sept., 1966. M. Ayrton.

New York Times 42:1, Mar. 9, 1967.

New York Times II, 29:1, Mar. 12, 1967.

"Visit to H. Moore." *Art Journal* 26 no. 3:282, Spring 1967.

"Exhibition at Brooklyn Museum." *Arts* 41:55, Apr., 1967.

"Newscan." *Arts Canada* 42: sup. 2, Apr., 1967.

"Monuments, tombstones and trophies, Museum of Contemporary Crafts, New York." N. Loftis. *Craft Horizons* 27:52, May, 1967.

"Henry Moore's reflections on sculptures." A. Elsen. *Art Journal* 26 no. 7:352-8, Summer 1967.

"Rodin's 'walking man' as seen by H. Moore." A. Elsen. *Studio* 174:26-31, July, 1967.

New York Times VII, p. 6, July 23, 1967.

New York Times 61:1, Aug. 11, 1967.

"Four books on Henry Moore." J. P. Hodin. *Art Journal* 27 no. 1:116, Fall 1967.

New York Times 40:1, Oct. 4, 1967.

"Henry Moore on sculpture: a collection of the sculptor's writings and spoken words, ed. and introduction by P. B. Janus." Review *Arts* 42:15, Nov., 1967. C. Robins.

"Bronze image of power." *Architectural Forum* 128:45, Jan., 1968.

New York Times 44:1, Apr. 5, 1968.

New York Times 44:4, Apr. 8, 1968.

New York Times 22:1, Apr. 29, 1968.

"Recent sculpture by Henry Moore." *Studio* 176-22-3, July, 1968.

"Letter from London; birthday exhibition at Tate Gallery." M. Painter-Downes. *New Yorker* 44:66, Aug. 3, 1968.

"Sculpture must have life." *Newsweek* 72:86-7, Aug. 12, 1968.

New York Times 23:2, July 20, 1968.

New York Times II, 23:1, Aug. 4, 1968.

"Henry Moore, a 1968 assessment." J. F. Mills, *Connoisseur* 169:180-9, Oct., 1968.

"Moore at the Tate." W. Tucker. *Studio* 176:124, Oct., 1968.

"Henry Moore by J. Russell." Review *Studio* 176:226, Nov., 1968. S. R. Leirtt.

"Sculptor's view of man and space." A. C. Ritchie. *Saturday Review* 51:43-4, Dec., 14, 1968.

New York Times 93:4, Dec. 20, 1968.

New York Times 36:1, Dec. 26, 1968.

"Baden-Baden: Henry Moore." G. Schurr. *Connoisseur* 170:34, Jan., 1969.

"On the scene." C. Barnes. *Holiday* 45:16, Feb., 1969.

"Henry G. Moore; photographed and ed. by John Hedgecoe." Review *Connoisseur* 170:176, Mar., 1969.

"Henry Moore by D. Sylvester." Review by M. Last. *Art News* 68:20, Oct., 1969.

"Henry Moore Exhibition in Tokyo." *Studio* 178:151, Nov., 1969.

"Henry S. Moore, ed. by J. Hedgecoe." Review by W. S. Rusk. *Art Journal* 29 no. 2:262 and Winter, 1969-70.

"Exhibition at Knoedler & Marlborough-Gerson." *Art in America* 58:149, Mar., 1970.

"Sculptors as book illustrators: contemporary French beau-livre." W. J. Strachan. *Connoisseur,* 176:160, Mar., 1970.

"Henry Moore and the shape of things." E. O. Hauser. *Readers' Digest* 96:136-41, Apr., 1970.

New York Times 50:1, Apr. 10, 1970.

New York Times 52:1, Apr. 15, 1970.

New York Times II, 27:1, Apr. 26, 1970.

"Moore: bronzes at Marlborough, carvings at Knoedler." G. Baro. *Arts* 44:26-9, May, 1970.

"Mellow master." *Time* 95:72-3, May 11, 1970.

"Marlborough-Gerson and Knoedler Galleries, New York exhibits." C. Ratcliff. *Art International* 14:137, Summer 1970.

"Exhibition at Knoedler & Marlborough Galleries." *Art News* 69:65, Summer 1970.

"Moore at Basle." G. Schurr. *Connoisseur* 174:201, July, 1970.

"Sculpture at Princeton." *Art Journal* 30 no. 1:56, Fall 1970.

"Henry Moore, by D. Sylvester." Review R. E. Krauss. *Art Bulletin* 52:337-40, Sept., 1970.

"Dublin streets, broad and narrow." P. Stone. *Country Life* 148:644, Sept. 10, 1970.

"In the galleries, Montreal, early September." B. Lord. *Arts Canada* 27:86, Oct., 1970.

"Monolith and modernist sculpture." P. McCaughey. *Art International* 14:19-24, Nov., 1970.

"Acquisitions of modern art by museums." *Burlington Magazine* 122:777, Nov., 1970.

"It's nice to be a pioneer; visit to H. Moore's studio." J. P. Anderson. *School Arts* 70:30-3, Dec., 1970.

"Moore in Multiple View." *Saturday Review* 54:44-5, Apr. 3, 1971.

"Marlborough fine art gallery, London; exhibit." J. Burr. *Apollo* 93:511, June, 1971.

"Marlborough fine art gallery, London; exhibit." K. Roberts. *Burlington Magazine* 113:420, July, 1971.

"Year in review for 1970 with catalogue of acquisitions." S. E. Lee. *Cleveland Museum Bulletin* 58:25, Fall 1971.

"Etchings; Marlborough graphics, London, exhibit." P. Gilmour. *Connoisseur* 178:72, Sept., 1971.

"Henry Moore, *Three Way No. 2: Archer.*" E. B. Hennings. *Cleveland Museum Bulletin* 58:235-8, Oct., 1971.

"Hakone open-air museum, Tokyo; exhibit." *Art International* 15:64, Dec., 1971.

"Talking about sale-rooms." F. Davis. *Country Life* 150:1786, Dec. 23, 1971.

"Henry Moore: sculpture and drawings 1921-1969." By R. Melville. Review by J. Piper. *Architectural Review* 151:195-6, Mar., 1972.

"Forte di Belvedere, Florence, exhibit." *Art and Artists* 7:14, May, 1972.

"Is it Nature or is it Moore?" M. Batterberry and A. Batterberry. *Harper's Bazaar* 105:52-3, June, 1972.

"Henry Moore at Home." N. Skurka. *New York Times Magazine,* p. 32-3, July 23, 1972.

"Henry Moore's elephant skull etchings." H. J. Seldis. *Art International* 16:42-4, Summer 1972.

"Forte di Belvedere, Florence, exhibit." *Burlington Magazine* 114:423, June, 1972.

"Dialogue in Stone." R. Hughes. *Time* 100:48-9, Aug. 14, 1972.

Photograph Credits

Dust Jacket: David Finn

Title page: Courtesy of the artist

page 8 John Swope

12 John Swope

14 John Swope

20 John Swope

25 Fotografico I. Dessi; courtesy of the artist

27 Errol Jackson; courtesy of the artist

32 Courtesy of Perry Rathbone

35 The Museum of Modern Art; courtesy of the artist

39 Courtesy of the artist

40 *Top,* W. Hartmann, courtesy of the artist; *bottom,* courtesy of The National Gallery of Canada, Ottawa

41 *Top and bottom,* courtesy of the artist

42 *Left and right,* courtesy of the artist

43 Courtesy of the Albright-Knox Art Gallery

44 *Left,* courtesy of the artist; *right,* John Gebhart

45 *Top,* John Gebhart; *bottom,* courtesy of the artist

46 Courtesy of The Detroit Institute of Arts

47 *Left,* John Gebhart

48 Courtesy of Mr. and Mrs. Stanley K. Sheinbaum

54 Dr. Frank Stanton

60 Courtesy of the artist

66 Eliot Elisofon, *Life* magazine

72 Courtesy of the artist

80 *Top, bottom left, and bottom right,* courtesy of The Museum of Modern Art

85 Courtesy of the artist

86 Courtesy of the artist

87 Courtesy of Mr. and Mrs. Frederick S. Weisman

88 *Left,* Paulus Leeser; courtesy of Vassar College

89 Courtesy of Harry N. Abrams, Inc.

90 Courtesy of the Amon Carter Museum of Western Art

91 John Gebhart

92 Courtesy of the Norton Simon, Inc. Museum of Art

93 Lidbrook; courtesy of the artist

94 John Gebhart

95 *Left and right,* courtesy of the artist

97 *Top,* John Gebhart; *bottom,* Louise van der Veen, courtesy of the artist

98 Courtesy of the artist

111 Charles Gimpel; courtesy of the artist

130 Courtesy of the artist

137 Courtesy of the Toledo Museum of Art

138 *Left,* courtesy of the Albright-Knox Art Gallery; *right,* Frank J. Thomas, courtesy of the Norton Simon, Inc. Museum of Art

139 Courtesy of the Minneapolis Institute of Arts

140 John Gebhart

141 *Top,* courtesy of the artist; *bottom,* John Gebhart

142 *Left,* courtesy of The Fine Arts Gallery of San Diego; *right top,* courtesy of the artist; *right bottom,* Frank J. Thomas

143 Courtesy of the Carnegie Institute

144 Frank J. Thomas, courtesy of the Norton Simon, Inc. Museum of Art

145 Courtesy of The Solomon R. Guggenheim Museum

150 Courtesy of the Norton Simon, Inc. Museum of Art

159 V. E. Nelson; courtesy of the artist

172 Errol Jackson; courtesy of the artist

178 John Swope

181 Courtesy of the artist

182 Courtesy of the Palm Springs Desert Museum

183 *Left,* courtesy of the Palm Springs Desert Museum; *right,* courtesy of the Norton Simon, Inc. Museum of Art

184 Courtesy of The St. Louis Art Museum

185 Courtesy of Mr. and Mrs. Ray Stark

186 Courtesy of the artist

187 *Top,* courtesy of Norton Simon; *bottom,* courtesy of Mr. and Mrs. Ray Stark

188 Courtesy of the University of California, Los Angeles

189 Ezra Stoller © Esto; courtesy of the Lincoln Center for the Performing Arts

190 John D. Schiff; courtesy of Columbia University

191 Sandi Kronquist; courtesy of the University of Chicago

192 Courtesy of The St. Louis Art Museum

193 John Gebhart

194 John Gebhart

197 John Swope

202 Courtesy of the artist

207 Courtesy of the artist

223 Courtesy of the artist

230 Courtesy of the artist

233 Courtesy of the Art Gallery of Ontario

235 *Top,* courtesy of The Fine Arts Gallery of San Diego; *bottom,* John Gebhart

236 Steven Poucher

237 Courtesy of the artist

238 *Top,* courtesy of The Fine Arts Gallery of San Diego; *bottom,* courtesy of the artist

239 John Gebhart

240 Steven Poucher